TONY WOROBIEC

CREATIVE PHOTOGRAPHY IDEAS
USING ADOBE PHOTOSHOP

75 WORKSHOPS TO ENHANCE YOUR PHOTOGRAPHS

D&C
David and Charles

For David, Lucy, Owen and Morgan

ACKNOWLEDGMENTS

As ever, when attempting to produce a book of this nature, I am dependent on the help and expertise of a variety of people. I am particularly grateful to Freya Dangerfield who initially commissioned this book, and to the constant guidance I received from Verity Muir and Hannah Kelly. Jo Lystor has done a great job designing this book. It was always going to be a complicated task but she really has established a wonderful sense of clarity and order. I look forward to doing more books with her. Gratitude is also owed to Ame Verso whose remarkable editing skills once again appear to have changed a pig's ear into something resembling a silk purse.

I must also thank several close friends who helped in various ways: to Susan Brown for offering guidance with the several high-key techniques, to Ken Hawkins for arranging the lighting for the studio shots, and to Graham Dew who produced the images and text for the excellent workshop on Joiners. The day I spent with Greg Duncan proved particularly useful especially with regard to plug-in filter options, however I must reserve special thanks to my good friend Keith Smith who patiently read through the text and as a consequence made many very useful changes and corrections.

I would also like to thank the numerous individuals who kindly agreed to model, particularly Christina L. Green, Olivia Ames, Juliet Barry, Roberto Dominguez, Josh Prior, Louisa Riddington, Will Spackman, Rebecca Statham, Terry Wareham, Catrin Waugh Baker and finally Rhiannon Waugh Baker. I am sincerely grateful to you all.

CONTENTS

INTRODUCTION

Creative Photography Ideas Using Adobe Photoshop features a variety of popular and less well-known techniques presented in a workshop format so that you are able to select particular projects you wish to follow. The workshops vary, starting with basic colour and tonal controls, progressing to quite sophisticated composites. Whether you are an experienced user of Photoshop, or someone starting out, this book should prove an invaluable guide.

In the early days of Photoshop, filters were often viewed with suspicion, but increasingly photographers are learning that they offer wonderful opportunities for truly innovative photography, particularly when used with other Photoshop facilities. Moreover, with the advent of Smart Filters, much of this work can now be done non-destructively. This book positively encourages you to explore the creative opportunities that so many of the Photoshop filters offer.

Black-and-white photography used to be the preserve of those able to dedicate an entire space to a darkroom, but now impressive monochrome images can be created in Photoshop. With the wonderful selection of papers currently available, the results are indistinguishable from true darkroom prints. What this book also does is to alert you to the many traditional darkroom techniques that are enjoying something of a revival. Furthermore, the author has sought to place some of these techniques within their historical context.

In searching for a personal style, many photographers are looking outside conventional photography and are exploring exciting alternatives such as pinhole cameras, cross-processing or Polaroid. These exciting processes reveal their own unique, highly idiosyncratic marks and the author shows you how you can create these fascinating effects in Photoshop.

It is not always necessary to make sweeping changes to your image; generally just a minimum amount of work is required such as correcting a sloping horizon, cloning out unwanted detail or possibly you may want to apply the best and most up-to-date sharpening techniques. This book covers all that you need to know.

By way of contrast, why not give your imagination a real workout? Whether you are an admirer of Rene Magritte or Salvador Dali, Photoshop encourages you to explore the surreal. Some photographers believe that this style of work is beyond them, but what this book aims to do is to show you simple, relatively easy methods that anyone can follow for producing stunning images. If this style of photography interests you, start by collating images from a variety of sources. Allow your imagination free rein and as you conceive your ideas, sketch them out so that you can plan what shots still need to be taken. Carefully storing them into folders makes the task of creating composites considerably easier. No matter where you are, you will constantly see elements that can be used, even if you cannot immediately see how. The featured illustrations are simple by design to ensure that every reader understands the principle, but as you assimilate them you should be able to create composites of great complexity, possibly applying a variety of these techniques within a single image. Acquired skills should be transferable, and this book gives you the confidence to apply techniques learned in one workshop and use them in others.

Each of the workshops are illustrated using a comprehensive sequence of step-by-step screengrabs. The idea of these is to guide you through the processes; where necessary, important areas of the dialog have been highlighted. While the author has chosen to illustrate most of the techniques using Photoshop, he is aware that there is other editing software available and has referenced these programs when appropriate. He has also added advice regarding the kind of images that are likely to best work with many of the workshops covered. Whether you need a bit more tutoring using Photoshop or just inspiration, this is the book for you.

CHAPTER 1: MAKING SIMPLE TONAL AND COLOUR CHANGES

The principal purpose of Photoshop is to allow the user to make accurate tonal and colour adjustments, which it is able to do extremely well. Using the many selection methods coupled with a host of Adjustment Layers, you should be able to 'interpret' your file in any way you wish.

01 MANIPULATING CONTRAST USING CURVES

Photoshop has numerous editing tools, but Curves is possibly the most flexible and is fundamental when aiming to change the tone or contrast of an image. To access Curves go to *Layer > New Adjustment Layer > Curves.*

Start image. This is a typical image likely to be shot when using a DSLR. While all the important shadow and highlight detail has been captured, the image still appears a tad dull.

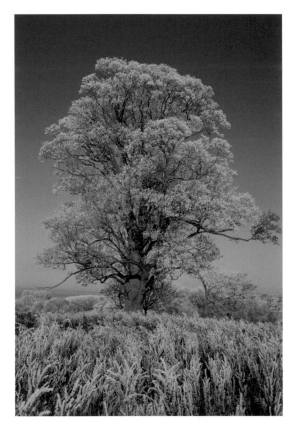

Using Curves. Curves offers the most versatile set of controls for making both colour and tonal adjustments in Photoshop. When you call up Curves, the graph will default to a straight diagonal line indicating 0 (black) to 255 (white). The horizontal axis of the graph represents the input values, while the vertical axis represents the output or adjusted values. Contrast is controlled by the incline of the curve: the steeper it is, the greater the contrast; the shallower it is, the lower the contrast.

Reducing contrast. In order to reduce contrast, select and drag the darkest point upwards, and then select the lightest point along the graph and drag it downwards, so that the incline of the overall graph is reduced.

tip

While Curves is not available in earlier versions of Photoshop Elements, it can be added by accessing a simple Smart Curves plug-in available from www.adobe.com

Increasing contrast. To do this, apply an 'S' curve. Select a point about a quarter of the way down the diagonal line and carefully drag the point slightly upwards. This will have the effect of lightening the image. Then, select a point about a quarter of the way up the diagonal line and pull the curve gently downwards.

Midtones. The next task is to think about the midtones; once again these can be either lightened or darkened merely by placing an 'anchor' in the middle of the curve and pulling it upwards to lighten the midtones and downwards to darken them.

Selective adjustment. Using Curves you can be very specific about which part of the tonal range you wish to alter. You might find the highlights are fine and only the darker tones require attention. In this case, peg the lightest part of the curve by placing an anchor a quarter of the way down the curve and a second one halfway down. With the lightest tones pegged, you are now free to manipulate just the darker tones. In this example I chose to increase contrast using the 'S' curve, but only in the darker tones.

Finished image. Once you get used to Curves, you will quickly appreciate just how flexible it can be. While there was reasonably good contrast in the darker tones, the lighter ones appeared flat. By pegging the shadow detail and then creating an 'S' curve in the lighter areas, I have been able to increase contrast, but in a very controlled way.

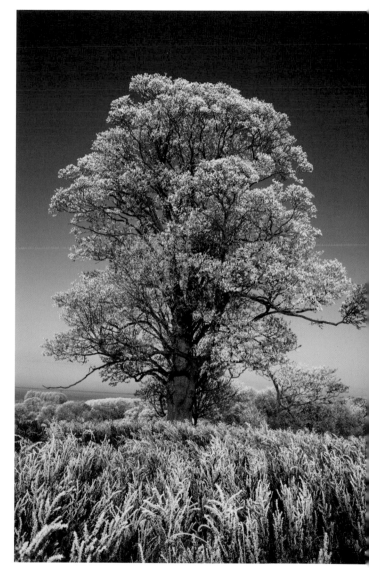

02 BOOSTING CONTRAST USING LEVELS

Many experienced Photoshop users see Levels as the poor relation to Curves for making tonal changes, but it does have its advantages. Certainly if you have come into digital imaging with darkroom experience, you will find Levels almost instinctive; it really is the simplest method for making tonal and colour adjustments. Levels positively encourages you to work with a histogram as it is an integral part of the process.

HOW LEVELS WORKS

In the Levels dialog (*Layer > New Adjustment Layer > Levels*) there are three sliders under the graph. The shadow slider (represented by the black point on the left) determines how dark the image becomes. The highlight slider (represented by the white point on the right) establishes the highlights. Finally, the Gamma slider (the grey point in the centre) lightens or darkens the midtones and is particularly important in establishing the overall mood of the image. The graph represents the darkest part of the picture through to the lightest on a scale of 0–255. For maximum contrast, the graph should span the entire tonal range from 0 to 255, but of course that is not always desirable. Levels does have an Auto setting and a variety of Custom presets, but if you really want to understand contrast and tonality, it is best to avoid these options. Finally, colour adjustments can be made by scrolling the Channel option.

For maximum contrast, but without 'clipping' the highlights, the image should reveal just the tiniest element of detail in both the darkest shadow and the lightest of the highlights. The best way of achieving this is to use the Eyedropper tools – black, grey and white – as described in the workshop steps that follow.

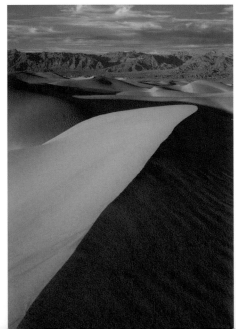

Start image. When taking this photograph, I was more concerned with getting the composition right and as a consequence I marginally underexposed. While this was partly rectified in the Raw Converter (see Making Adjustments Using Adobe Camera Raw in Chapter 4), this image still lacks contrast. Looking at the histogram (see How Levels Works box) tells me all I need to know; the tonal values are bunching in the middle with no perceptible information in the lightest and darkest areas.

Step 1. Use the white Eyedropper tool and select the lightest part of the image that still reveals discernible detail. Click the mouse button and the entire image will be remapped consistent with the lightest tone you have selected.

Finished image. The task was to increase contrast yet still retain detail in both the shadows and highlights. This has been achieved by establishing a lightest and darkest point using the Eyedropper tools. In the final image, the hues are also marginally warmer.

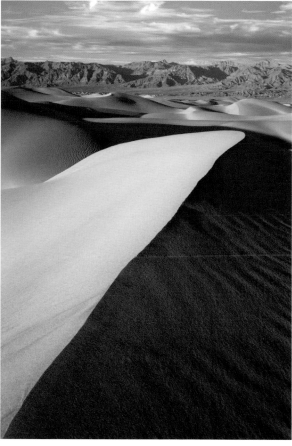

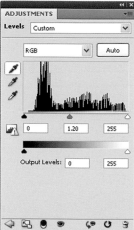

Step 2. Use the black Eyedropper tool, but this time select the very darkest part of the image which still reveals some shadow detail, no matter how marginal. Click the mouse button and this will then establish the darkest point in your picture but equally important, a full tonal range will be established, and as a consequence contrast will be improved.

Step 3. Use the grey Eyedropper tool to set the mood. With the lightest and darkest points set, you are still able to achieve an image that principally comprises lighter tones, or darker tones depending on its position. Experiment to see how the grey Eyedropper tool can alter the mood of the image. This method does not only affect brightness, but can also affect colour.

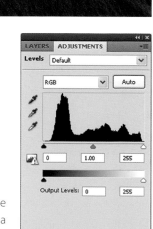

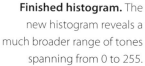

Finished histogram. The new histogram reveals a much broader range of tones spanning from 0 to 255.

03 INCREASING AND DECREASING SATURATION

In addition to contrast, adjusting the saturation is another important way you can improve the image. Saturation refers to the intensity of the colour; this can be increased to make the colours appear more vivid, or decreased so that they appear muted. These controls allow you to determine the mood of the image. This adjustment can be made in several ways but the most popular is Hue/Saturation. To access this, go to *Layer > New Adjustment Layer > Hue/Saturation*.

THE HUE/SATURATION DIALOG

This is more sophisticated than some might believe, as it possesses some powerful options.
• **Preset.** By scrolling these you will be offered a variety of options including Increase Saturation, Increase Saturation More, and Strong Saturation. If you are working on an Adjustment Layer, you can experiment without degrading the image.
• **Master.** The Master drop-down allows you to pinpoint a specific channel so if you want to increase the saturation of the sky for example, you can work only on the Blue and Cyan channels.
• **Hue.** Ignore the Hue slider as this will uniformly change the colour balance of the image, and

there are better ways of doing this. The Hue slider is better employed when toning monochrome images (see Creating a Lith Effect in Chapter 2).
• **Saturation.** By dragging the Saturation slider to the right, the colours will be intensified incrementally, but make sure you don't overdo this as the effect can be ghastly. By dragging it to the left the colour is decreased.
• **Lightness.** This is another feature within this dialog that is best left untouched. It controls the brightness of the image, but this can be more effectively done with other Photoshop options such as Levels or Curves.

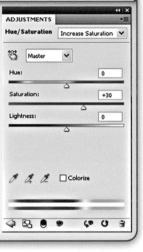

Start image. The colours clearly require boosting.

Finished image. It pays to be cautious when increasing saturation, which is why it is always good practice to make an Adjustment Layer. In this example I used the Saturation slider.

DECREASING SATURATION

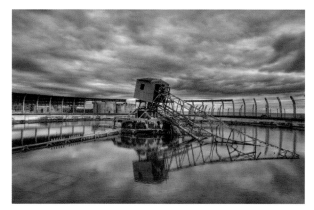

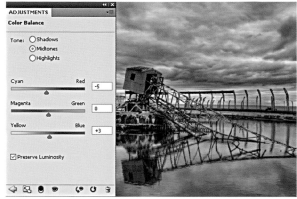

Start image. The industrial nature of this image suggests that a much more sombre approach is required. While I do not want to convert it entirely to monochrome, subduing the colours would be more in keeping with the mood.

Step 1. Using the Saturation slider, I reduced colour intensity by -25. While the image still retains the original colours, the mood of the image changes. I then specifically selected the Red and Yellow channels separately, in order to reduce the intensity of the colour of the rusting structures.

Step 2. In order to cool the image further I made a second Adjustment Layer, selected Color Balance and added 5 of Cyan and 3 of Blue. I then flattened and saved.

Finished image. Having the capacity to increase, or as in this case reduce saturation, allows us the opportunity to 'interpret' an image. Even the slightest change can make a very definite statement.

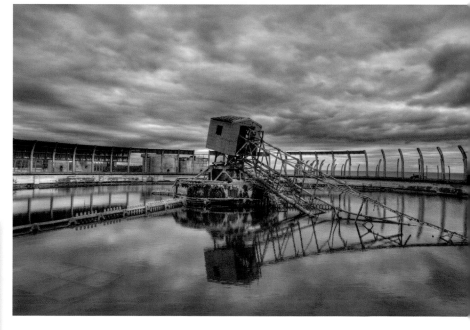

tip

You may wish to boost the saturation in just parts of the image. To do this, use the Sponge Tool set to Saturate on a Duplicate Layer. It also helps to reduce the Flow to below 50%.

04 DEALING WITH COLOUR CASTS IN PHOTOSHOP

The colour of an object constantly changes according to the ambient lighting conditions. Generally a DSLR camera can read these variations using its Automatic White Balance (AWB) facility, and in 99 per cent of cases it will be correct, but occasionally it can let you down. Colour casts are most evident in white or grey areas. The presence of a colour cast is not desirable, but there are various ways it can be removed.

tip

One effective method of preventing colour casts is to use a grey card for metering from when shooting. This might prove particularly useful if shooting JPEG as you do not have as many post-capture correction options as you do with Raw.

Start image. Artificial lighting is the single most common cause of a colour cast. Determining whether the light source is fluorescent or tungsten is not always easy and as a consequence, mistakes are made. In this example, there is an overall amber cast and areas that should have appeared grey are olive green.

Method 1: Variations. Using Variations, you are able to make both colour and tonal changes by selecting from a sequence of thumbnail options. Simply go to *Image > Adjustments > Variations*. Make sure you are working on a Duplicate Layer. The Variations dialog defaults to Midtones, and presents the image with its current colour cast as Current Pick. You will be presented with various other colour and tonal alternatives. Don't just rely on the Midtones options, but explore the Highlights, Shadows or even the Saturation variations as well.

Method 2: Auto Color. Another very simple method is to use Auto Color: go to *Image > Auto Color*. Once again, start by making a Duplicate Layer. This method sometimes works, but you are allowing an important decision to be made by a default process, when possibly a more critical eye is required.

Method 3: set grey point in Levels. A colour cast is best countered by ensuring that those areas that should be a neutral grey have no bias towards colour whatsoever. A good way to achieve this is by using Levels. Make an Adjustment Layer, select Levels then, using the middle Eyedropper, click on a part of the image you think should be a neutral grey. Watch the image change, almost like magic. Try experimenting on various areas until you achieve the correct colour balance.

Method 4: using Color Balance. Don't always feel that you need to use an automated method to solve a problem. As *you* can detect the colour cast, then *you* should be able to determine when it is corrected. One easy way to achieve this is to use Color Balance. Make an Adjustment Layer, select Color Balance and set about countering the cast you can see.

Method 5: using Channels in Levels. A final, more accurate method for solving a colour cast problem, is to use the Levels channels. Open Levels in the usual way, and select the Red channel. While depressing Alt, select the Shadow slider and move it inwards until some information appears on the white screen; then move the slider backwards a fraction. Next, repeat this process, but this time using the white slider. The screen will appear black. Having solved the Red channel, repeat this process for the Green and Blue channels. While this is a lengthy process, it will achieve the goal of presenting a perfectly balanced colour image.

Finished image. To achieve this change I used Channels in Levels. As a consequence, the overwhelming amber colour cast has been removed and the overall colour balance appears more neutral.

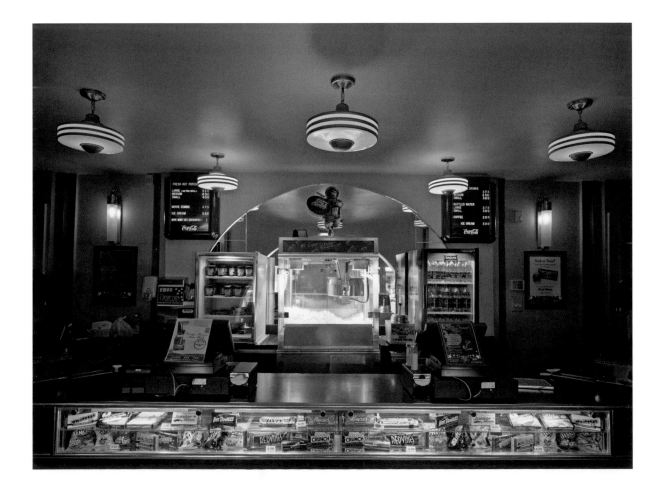

05 DEALING WITH COLOUR CASTS IN ACR

If you are shooting in Raw, the most direct method for correcting a colour cast is through the Raw Converter. Adobe Camera Raw (ACR) is a plug-in downloaded from Adobe at www.adobe.com.

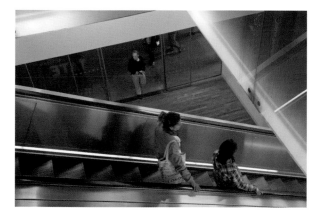

Start image. Shooting an interior illuminated by artificial lighting is a classic situation where one is likely to encounter a colour cast. I wanted to capture the two figures on the escalator and did not have time to set a correct White Balance. As a result, there is a strong yellow/orange cast.

Method 1. In the Raw Converter, the most direct option is to use the White Balance tool. Correcting the white balance is a matter of identifying those areas of the image that you know should register as white, or as a neutral grey. If the image has a cast, it will be most evident in those areas. By selecting the White Balance tool (the icon that looks like a colour picker in the Toolbar) specify

an area that should be white or grey and the lighting will be adjusted automatically. You may need several attempts before you get it right.

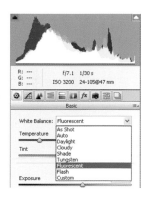

Method 2. Sometimes it is not easy to identify those areas that should be grey, particularly through a heavy colour cast. A simple method for resolving this is to scroll the White Balance drop-down. The image in the preview will always default to 'As shot'. Your first option is to select Auto. In this example, as the interior was clearly illuminated by artificial lighting, I selected Fluorescent and Tungsten in turn to see which delivered the best results. As a simple guide, tungsten lighting normally delivers an orange/yellow cast, while fluorescent bulbs produce a green/yellow one. Matters are sometimes complicated because an interior can be illuminated by both light sources.

Finished image. Using the White Balance tool, I selected the beam in the top left of the picture, which I knew should be grey. This sometimes needs two or three goes before a perfectly cast-free image materializes, but it is a process that is entirely under your control.

tip Another method is to adjust the Temperature slider. The slider ranges from 2,000°K bluish (cold) to 50,000°K yellowish (warm). By adjusting the slider, simple but effective changes can be made.

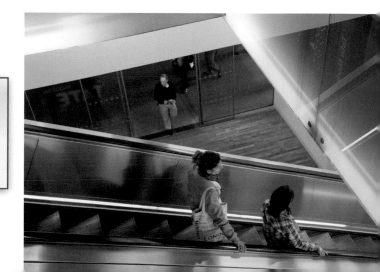

06 USING GRADIENT AND QUICK MASK

Unless you have every aspect of the lighting under your control in a studio situation, then the illumination of an image is likely to appear uneven. This problem most commonly occurs when photographing landscapes. As the sky is often far brighter than the foreground, the sky can appear insipid. You can use a graduated filter, but sometimes even this is not enough. But providing there is sufficient detail in the sky, and the histogram is not bunching excessively to the right, this can easily be resolved in Photoshop.

Start image. While the reflected water appears well exposed, the sky by comparison is too pale. Despite having used a graduated filter at the taking stage, I have still not established the tonal balance I was hoping for.

Step 2. Using the cursor, drag a line from the top of the image to the bottom; a graduated ruby-lith film will appear over the area that will not be affected by any of the anticipated changes. This also ensures that any changes made will be incremental.

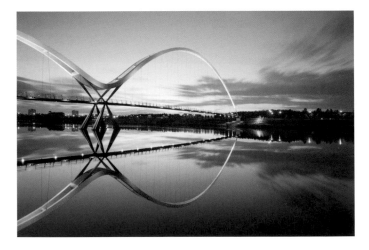

USING PHOTOSHOP

Step 1. With the Foreground/Background Colors defaulted to black and white, select the Quick Mask icon at the bottom of the Toolbar (ensuring that it is still coloured pink), then select the Gradient tool set to Black to White and Linear.

tip

While in this example I dragged the cursor down the entire image, thus ensuring that half the image was masked, I could have restricted the mask to a much smaller part of the image by controlling how far I dragged the cursor.

Step 3. To confirm this as a selection, click the Quick Mask icon once again. The 'marching ants' that denote a selection will appear. While it may appear at this stage as if a hard selection has been made, it is graduated.

Step 4. Finally, make an Adjustment Layer and select Curves. Here, not wishing to over darken the bank of the river in the middle of the picture, I decided to peg that part of the curve and just darken the light and midtones (see Manipulating Contrast Using Curves).

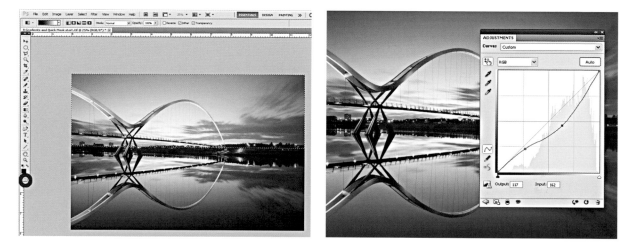

Finished image. Often when applying tonal changes to an image, there is no need to make detailed selections. Light fall-off tends to be gradual, therefore making a gradient selection using Quick Mask and then redressing the tonal balance often proves to be the best solution.

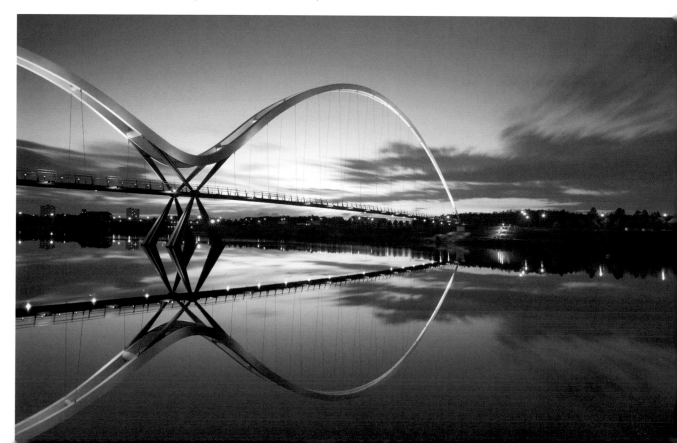

HORIZONTAL GRADUATED SELECTIONS

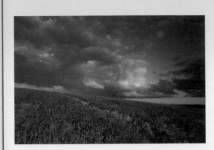

Start Image. Unevenly illuminated left to right.

While in the previous example I have applied the Gradient Mask to darken the sky, there will be many occasions when an image appears unevenly illuminated from left to right or right to left. For example this poppy field appears well lit on the left, while the area to the right is not.

By dragging the cursor horizontally rather than vertically, I have been able to make a graduated selection on the right-hand side of the image. By applying Curves, this tonal imbalance has been easily addressed.

Whether the lighting imbalance appears from the top of the image to the bottom, or as in this example from left to right, using Quick Mask and the Gradient tool is the simplest and most effective method for resolving this. It is of course possible to fine-tune this by painting on a black or white Layer Mask to modify the gradient effects, for example if you are including a mountain in your shot and do not wish to see it affected by the changes.

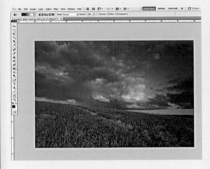

Only the right side of the image has been selected.

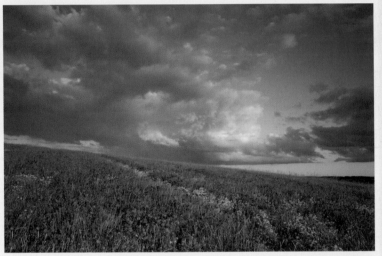

Finished Image. By making a graduated selection horizontally, the unevenness of the illumination can be addressed using Curves.

USING THE RAW CONVERTER

Start image. While I was able to get a good exposure for the sky, the bottom half of this image appears unacceptably dark. This image was photographed hand-held at night.

Step 1. When you open your file in the Raw Converter, a dialog will appear offering numerous options including Exposure, Brightness, Contrast and Saturation. While there are others, these four are best suited to making controlled colour and tonal changes. In this example, as the top of the image is well exposed, only the bottom needs changing; to make a graduated selection click the Gradient tool.

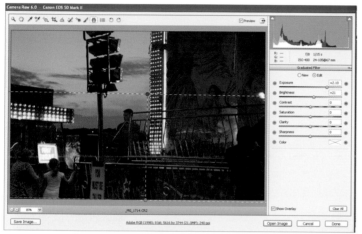

Step 2. Two round pegs will appear on screen. In order to lighten the bottom half of this image, I ensured that the green peg remained anchored to the base of the image and then dragged the red peg halfway up the image. This selection can easily be rotated, should you wish to make a horizontal rather than a vertical selection. The Exposure and Brightness sliders can then be used to lighten the selected area incrementally.

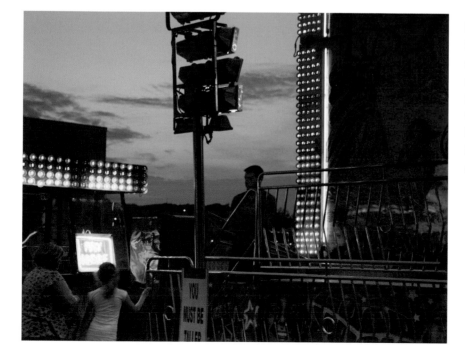

Finished image. Often when trying to retrieve underexposed shadow detail, the incidence of Noise becomes far more apparent. By working directly with a Raw file within the Raw converter, changes can be made without unduly degrading the image.

07 ADDING A GRADUATED COLOUR FILTER

Adding a graduated colour to an image is usually done in camera, simply by attaching the appropriate filter, however there will be numerous occasions when the effect of this filter is insufficient, or you do not have it to hand. Fortunately, simulating the effects of a graduated filter in Photoshop is straightforward.

Start image. Had I been at this location just five minutes earlier, I would have enjoyed an even more dramatic sky. By the time I had arrived, a thin cloud had appeared and had started to veil the intensity of the setting sun. While there are some standard warming and cooling preset filters available on a Photo Filter Adjustment Layer that are worth experimenting with, what is required here is a customized filter specific to this image.

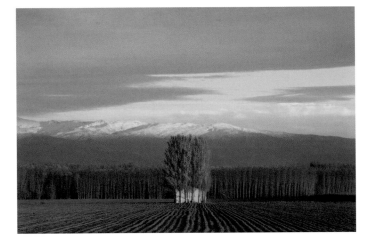

Step 1. Make a Duplicate Layer and then create a New Layer. With this new layer active, select the Gradient tool from the Tools palette. In the Options bar at the top of the screen, click the Gradient Preview to open the Gradient Editor.

Step 2. Select the Neutral Density filter from the presets (which spans dark to transparent). To make this Gradient more specific, click the Color Stop at bottom left and double click to open the Color Editor. For the purposes of this task I selected #6ec3eb. Click on the Gradient, which opens the Gradient dialog box. Hover the pointer over the gradients and a pop-up will appear.

Step 3. Here the Location was set to 55%. Drag the left-hand stop to the right, which roughly approximates the proportion of sky to landscape. The Color Stop on the right was selected and by double clicking, I opened the Color Editor once again. I opted for #e8c189. Move the right-hand stop to the left. I now have a custom Gradient, which spans 55%, blue to orange, with the remaining 45% transparent.

Step 4. Using the Gradient tool, drag the cursor from the top of the image to the bottom. This should give you a gentle graduated blue-to-orange hue, which only affects the sky. In order to increase the intensity of this, try using either Darken or Multiply in the Blending Mode. If you wish to reduce it, decrease the Opacity.

> **tip**
>
> Another solution is to use the Gradient Fill Adjustment Layer. In the Gradient Fill dialog box, click on the Gradient to enter the Gradient Editor, create a New Gradient, set up the colours as outlined and apply.

Finished image. The preset Photo Filters available in Photoshop are certainly useful, but sometimes it can prove more effective when you design your own filters, customized to the task in hand. Using a Gradient Map is one way of achieving this.

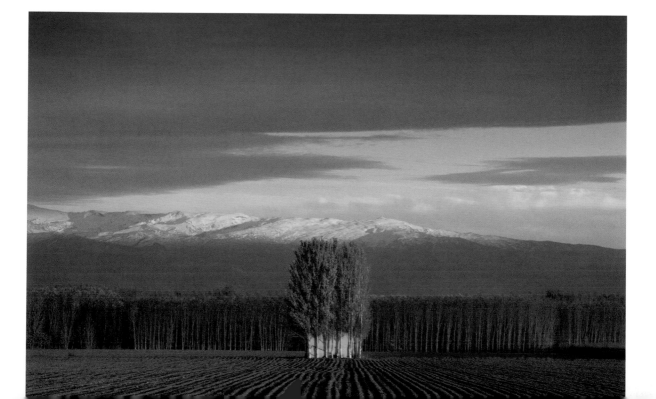

08 CREATING A HIGH DYNAMIC RANGE (HDR) IMAGE

The advantages of DSLR cameras are numerous, but if they possess one flaw, it is the inability to deal with high contrast. Essentially, most sensors cannot handle images with bright highlights and dark shadows at the same time – detail is lost in one or the other. So how do we resolve this problem? Simple: by making various exposures of the same location – typically by taking one showing an 'average' reading, another that ensures all the highlights are fully captured, and a final shot that aims to underexpose in order to reveal all available shadow detail.

HDR IN PHOTOSHOP

While there are several examples of software that deal specifically with HDR, this facility exists on recent versions of Photoshop.

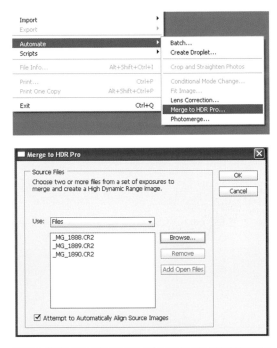

Step 1. Go to *File > Automate > Merge to HDR Pro*. When the HDR Pro dialog appears, select *Browse > My Documents* and then choose the folder containing the images you wish to work with. Ideally it is best that your images are retained as Raw files as this will offer you the best latitude, although excellent results can also be achieved using JPEGs, providing the range of the initial exposures are sufficiently varied. Ensure that Attempt to Automatically Align Source Images is ticked and then hit OK.

Step 2. The Merge to HDR Pro dialog will appear with your source files at the bottom. In this example I have chosen three, although more could have been selected if they had been required. A default HDR image will appear within the dialog preview, but of course you will have ample opportunity to change that if you wish. To make further adjustments, use the various sliders to the right of the dialog. Some of these are particularly powerful and can radically alter your image; before experimenting with them, use the sliders within the Tone and Detail setting.

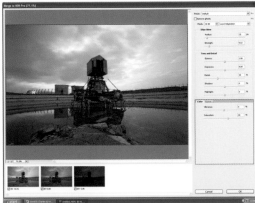

tip

Various manufacturers are now offering cameras with in-camera HDR imaging capabilities, but these do not compare in terms of flexibility and control with doing this post camera.

SLIDERS AND PRESETS

To attain a successful HDR file, it is important to establish the maximum lightest and darkest points; this is achieved by using the Shadow and Highlight sliders. Once this is completed, you have the option of using the Gamma and Exposure sliders to establish the overall tonality of the image. The Gamma slider is very useful for setting the mood, although once this is done, the role of the Exposure slider is largely superfluous, as it governs the overall tonality. The Detail slider has value insofar as you are able to heighten or subdue textural detail, but it is best used with caution. If you are seeking a bizarre and otherworldly effect, then the Edge Glow slider has something to offer, although if you are seeking an even more creative effect, you may wish to experiment with the various presets, which can substantially alter the character of your image. For example, fantastic results can be achieved when using the Photorealistic or Surrealistic options.

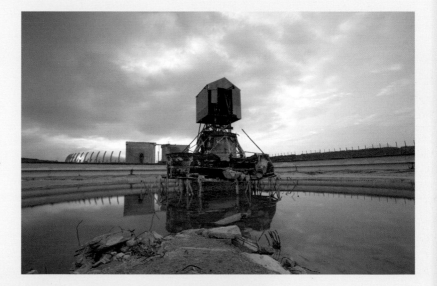

Photorealistic preset. Use this option when all that is required is an image that reveals a comprehensive tonal range. When used in conjunction with the Shadow and Highlight sliders, you should be able to achieve a tonally balanced image.

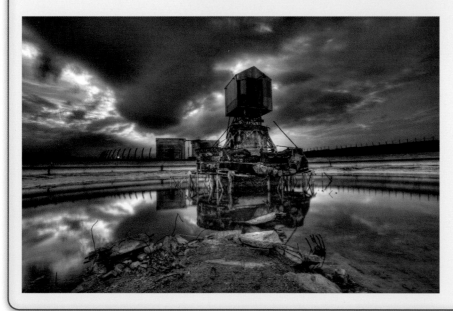

Surrealistic preset. In this example I have opted for the Surrealistic preset, which tends to exaggerate the tonal values. If you choose this option select your subject with care, as it has the capacity to create a strangely evocative atmosphere. The pathos of this scene is heightened by the dark and moody sky.

09 HDR USING TONE MAPPING IN PHOTOMATIX PRO

There are various HDR plug-ins that offer excellent alternatives to Photoshop including Picturenaut (www.hdrlabs.com) and FDR Tools Basic (www.fdrtools.com), but Photomatix is generally considered the industry standard. Its basic version can be downloaded from www.hdrsoft.com, but if you wish to be a little more ambitious, I would strongly suggest you go for the Photomatix Pro package, a sophisticated piece of software that positively encourages creativity.

Start images. Often some of our most disappointing images are taken on overcast days. The contrast between the sky and the foreground is too great for the sensor to cope with – it either exposes correctly for the foreground and burns out the sky, or vice versa, exposing the sky correctly and underexposing the foreground. The purpose of Photomatix Pro is to extract the best tonal profile from each of these files and composite them into one 'super' file.

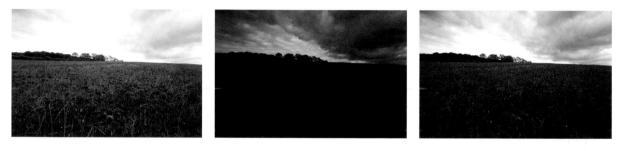

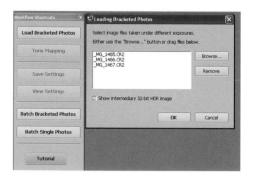

Step 1. In Photomatix Pro, select Load Bracketed Photo or Generate HDR image (this depends on the version of Photomatix you are using), go to Browse and then open the files you wish to use. Ideally these should be Raw files. In this example I have selected just three, but I could have used more if I needed to.

Step 2. By selecting OK, the Preprocessing Options or Generate HDR Options dialog will appear (again depending on which version you are using). Make sure that the Align source images box is ticked; you should also select 'by correcting horizontal and vertical shifts' or 'by matching features'. Generally I find the latter to be the best option. Tick Reduce chromatic aberrations then hit OK.

Step 3. You will then open a complicated dialog offering an array of options. Ironically the most useful of these is hidden behind Show More Options; open this and you will see the White Point, Dark Point, and Gamma sliders which work in much the same way as Levels sliders (see Boosting Contrast Using Levels). The presets at the bottom of the dialog are particularly interesting. In this example I have chosen to use Painterly. The preset thumbnails offer you an overview of the effect. Final options you may wish to consider can be found under Show Advanced Options. Making adjustments using the Saturation sliders can introduce an interesting edginess to the image. When you are happy, select Process.

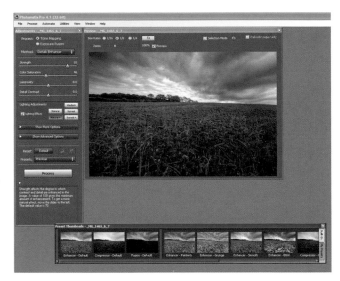

tip

If you find the effect of any of the presets overwhelming, reduce them using the Strength slider, which is found at the top of the Photomatix Pro dialog.

Finished image. Photomatix Pro not only helps you to overcome the exposure shortcomings of a DSLR camera, but it is also a positive means of achieving a personal style. Here, I have chosen to dramatize the sky in order to introduce an element of contrast to the poppies in the foreground. I then cropped in order to improve the proportions of the image.

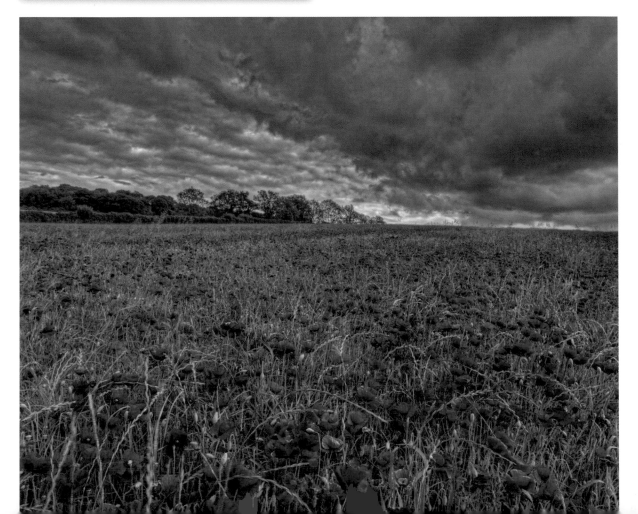

10 CREATING AN HDR FILE MANUALLY

Some photographers feel that tone-mapping using HDR software is just too elaborate and want to do something much simpler using their own version in Photoshop. It is perfectly possible to create the effects of HDR manually; in fact in many cases this might be the best solution. As ever, it is important to start with two separate files that cover the entire exposure range; it is possible to work with three files, although if you take sufficient care at the capture stage, this is rarely required.

Start images 1 & 2. By taking a light reading off the sand, I have been able to get an accurate exposure for the foreground, but this has been at the expense of the sky, which appears pale and insipid. I made a second exposure, but this time, by taking a light reading off the sky, the compelling drama I witnessed becomes much more apparent. This is only achieved by underexposing the foreground.

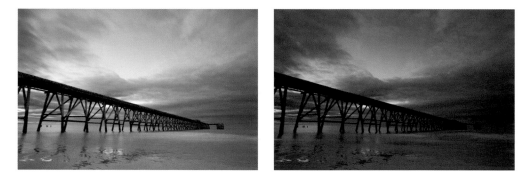

Step 1. Open Start image 2, select Quick Mask and then the Gradient tool set to Black to White and Linear. Drag the cursor from the bottom to the horizon. I wanted most of the sky from this file so a large part of it is selected. The ruby-lith layer indicates only the area that will *not* be selected.

Step 2. By clicking on the Quick Mask icon (which at this stage appears clear), a selection is made. While it might appear disproportionately large, it is important to remember that this is a graduated selection, i.e. its opacity weakens incrementally from the top to the bottom.

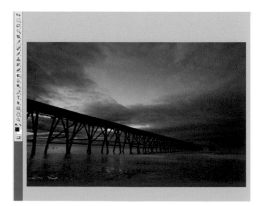

Step 3. With both files on screen, use the Move tool to drag the selected darker sky from Start image 2 over Start image 1, pressing the Shift key to ensure the two files sequence. Start image 1 now becomes the Background Layer, while Start image 2 becomes Layer 1. While the sky is improved, the pier is darker than I would have wished. Moreover, some darkness from Layer 1 has permeated the foreground.

Step 5. Finally, in order to fine-tune the detail in the pier, it is important to reveal the lighter tones from the Background Layer. Select the pier using the Magic Wand tool set to + and Feather this by 2 pixels, Contract by 2 pixels then go to *Select > Save Selection* and name it 'pier'. With the Layer 1 mask still active select a smaller, soft Brush tool set to black and carefully remove the darker tones in the pier.

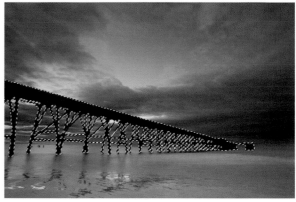

Step 4. To restore the lighter tones of the beach, add a Layer Mask to Layer 1, then select a soft Brush tool set to black. Start with a large Brush size (try 500 pixels), set on Soft, using an Opacity of 60%. The secret is to make one single pass over the area you wish to lighten. As you do, the Brush tool will reveal the lighter tones from the Background Layer.

Finished image. I took two carefully metered shots, one for the sky and another for the foreground, safe in the knowledge that I could combine the two files in Photoshop afterwards. The slight distortion caused by using a wide-angle lens was addressed by applying Skew in the Transform menu.

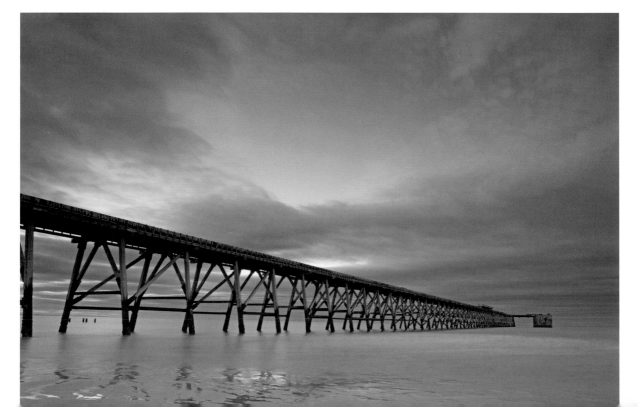

11 CREATING AN HDR IMAGE FROM A SINGLE RAW FILE

Shooting Raw has considerable advantages and one of these is the capacity to make an HDR image from a single file. When you shoot Raw, you are able to capture a greater tonal range and colour gamut than is possible when shooting JPEG. As soon as you open the Raw Converter and experiment with the many exposure options, you will be surprised by how much detail your DSLR has captured.

INCREASING LATITUDE

If taking multiple shots proves impossible, you should be able to create three separate files by using the Exposure slider in the Raw Converter. As well as using the Default exposure, create two further files, one showing a +2.00 exposure and a second showing a -2.00 exposure. The increased latitude available within these three files should deal with most eventualities. Remember also that many DSLR's have an Exposure Compensation, Bracketing mode or AEB setting, which can be programmed to give you three separate exposures. This can prove particularly useful when shooting portraiture or street photography.

Start image. Unless you are using a corrective filter at the time of taking, this is a typical landscape shot. Because of the relatively high contrast between the sky and the foreground, I had the option of metering for the sky but risked underexposing the foreground, or as in this case getting the foreground right, but ending up with an insipid sky. Fortunately I shot it in Raw.

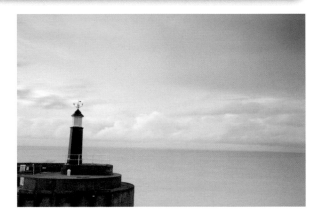

Step 1. Having accessed my folder through Bridge, I opened the file into Photoshop, without making any adjustment, although I made sure that no shadow detail had been lost. I then re-opened the same file, but this time I decided to make some tonal adjustments using the Raw Converter; I reduced the exposure by dragging the Exposure slider to the left. As the image darkened, some of the shadow detail was lost but the important thing was to ensure that this second file retained good highlight detail.

Step 2. With both files on screen, use Quick Mask and the Gradient tool set to Linear, and make a selection of the sky from the darker file and then use the Move tool to drag this selection over the lighter image, while depressing the Shift key. This ensures that both files are synchronized. While the sky will appear well exposed, some of the features appearing above the horizon, including the lighthouse, will appear too dark.

Step 3. With Layer 1 active, I used the Polygonal Lasso tool feathered by 2 pixels and made an accurate selection of the part of the lighthouse that appears above the horizon. A Layer Mask was added and with this active, I used a soft Brush tool set to black and carefully lightened it.

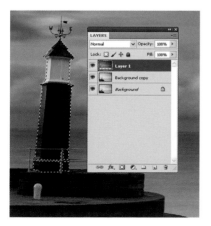

Step 4. With Layer 1 still active, the selection was inversed (*Select > Inverse*), and using a soft Brush tool set to black with an Opacity of 40%, I carefully lightened the area just below the horizon. If you overdo this, set the Brush tool to white to paint out the mistake.

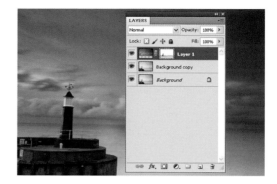

Finished image. The layers were then flattened, the horizon straightened and the final image cropped for aesthetic purposes. By shooting Raw, your file will have sufficient information to allow you to make an HDR file.

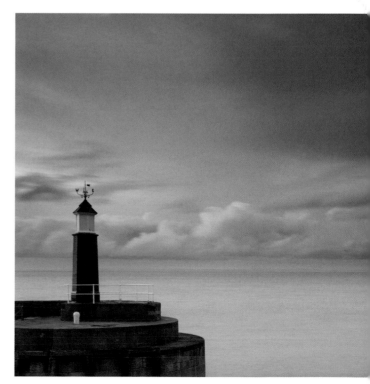

12 MAKING LOCAL COLOUR AND TONAL CHANGES USING SELECTIONS

Making accurate selections and then making changes is one of the most fundamental Photoshop skills. There are numerous methods for achieving this, but the two most popular are the Lasso and Magic Wand tools. The Lasso tool is best used when a simple selection is required. The Magic Wand tool works best when selecting an area that has common colour or tonal values. When making a difficult selection, you may be required to use both.

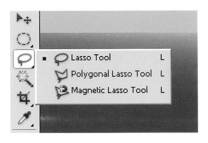

THE LASSO TOOL

This tool offers three options: the Lasso tool, the Polygonal tool and the Magnetic Lasso tool. The **Lasso tool** is useful to make only a generalized selection, requiring little accuracy and so is not ideal when selecting complicated shapes or areas with straight edges. Once you have completed a selection, you can add to it by depressing the Shift key, or if you want to remove some of the selection, press the Alt key.

For many tasks, the **Polygonal Lasso tool** is a much better option; while this is ideal for dealing with straight edges, it can also be used to select regular curves as well, although the more demanding the curve, the more clicks will be required. Whenever you use this tool, always Feather to a minimum of 2 pixels.

The most sophisticated of the three options, the **Magnetic Lasso tool** is able to recognize areas revealing tonal or colour contrasts. This tool detects the outline of an area or object, and places anchor points along the defined edge. The Frequency option, located in the Menu bar, adds a further refinement to this tool.

Lasso selection. The area to be selected contains varying tones and colours. As there is a hard edge separating the car in the foreground from the background, the Polygonal Lasso, feathered by 2 pixels, is the best tool to use.

Finished image. A very accurate selection can be made using the Polygonal Lasso tool; this has allowed me to darken that part of the image using Curves (see Manipulating Contrast Using Curves).

THE MAGIC WAND TOOL

The Magic Wand tool works by selecting areas of similar colour or tone. The area of similarity can be expanded or contracted by altering the Tolerance level, which is found in the Menu bar. The selection can be expanded by holding down the Shift key or contracted with the Alt key. If you are making a difficult selection, select a low Tolerance, but make multiple selections with the Add to Selection icon selected. By ticking Contiguous in the Menu bar, only the pixels of the same colour within the area you have selected will be targeted. If you make a mistake and select too much, go to *Edit > Step Backward* (Control Z) and you will return to the previous selection.

Magic Wand selection. The irregular shapes created by these palms trees are easily selected using the Magic Wand tool because the tones are consistent. After making a difficult selection, it is good practice to save the selection by going to *Selection > Save Selection* and giving it a name.

Finished image. Having made an accurate selection of the palm trees using the Magic Wand tool, I was able to apply the Shadows/Highlights command (see Making Tonal Adjustments Using the Shadows/Highlights Command), which has allowed me to reveal considerably more shadow detail.

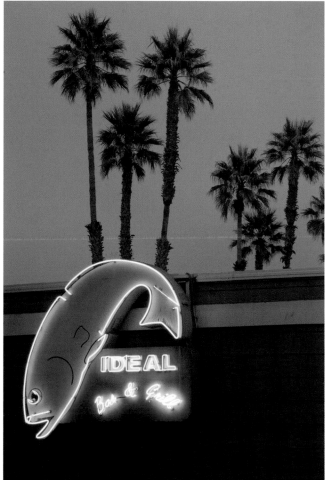

THE QUICK SELECTION TOOL

Only available in editions of Photoshop CS3 and beyond, this is another excellent selection tool. Very similar to the Magic Wand tool insofar as it recognizes areas of similar colour, it also allows you to control the selection by varying the brush size – invaluable when making demanding selections. If you select too much, hold down Alt to subtract from the selection. To fine-tune a selection, use Refine Edge, which was introduced to Photoshop in CS5 (see Creating a Composite Using Refine Edge in Chapter 6).

13 MAKING SELECTIONS USING COLOR RANGE

Of all the selection tools in Photoshop, none is quite as flexible as Color Range. It is able to make either a 'soft' or a 'hard' selection, in one specific area, or in various. The Color Range command is able to select a specific colour or colour subset, within an existing selection, or within the entire image. It is this flexibility that makes Color Range such a valuable tool.

Start image. I was stunned by the beauty of the dawn light over the canyons, and was particularly smitten by the contrast between the orange and blue in the sky. As these are complementary colours, I wanted this contrast to be apparent.

Step 1. As I was likely to make quite substantial changes, I made a Duplicate Layer by dragging the file down to the Create New Layer icon and called this new layer 'Color Range'. I then went to *Select > Color Range* and a new dialog appeared.

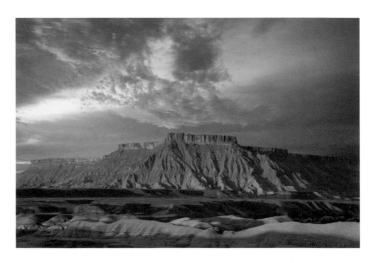

Step 2. Using the Color Sampler, I clicked onto a representative area of blue that I wanted to change, then expanded the selection by dragging the Fuzziness slider to the right. The white area within the small black-and-white screen indicates the extent of the selection. Hit OK and a selection is made. As with any other selection, use the Lasso tool set to minus to subtract any unwanted areas.

Step 3. When making changes in skies, it is important that the edges of selected areas are blurred, so I feathered this by going to *Selection > Modify > Feather* using a Radius of 40 pixels.

Step 4. I made an Adjustment Layer, and selected Color Balance. Color Range restricts the changes to just the pale grey areas I wanted to alter. By increasing both the Blue and the Cyan sliders, an enhanced colour contrast has been introduced.

Step 5. Color Range can be used within a selection. I wanted to boost the shadows in the lower half of the picture, so I made a graduated selection using the Quick Mask and Gradient tool (see Using Gradient and Quick Mask), while restricting the selection to just the bottom 20 per cent of the image.

Step 6. I then returned to Color Range and, using the Color Sampler, selected an area of shadow detail within the selection from the bottom portion of the image. I hit OK and a selection was made; I feathered it by just 5 pixels. Finally I made

a second Adjustment Layer, selected Curves, and then I gently pulled the diagonal line downwards, ensuring that only the darkest areas in the bottom of the image were affected.

Finished image. The advantage of Color Range is that it offers so much flexibility. I have been able to increase contrast by selecting and intensifying only the blues in the sky. Moreover, I have been able to boost contrast by selecting just the shadow detail in the bottom portion of the image, without increasing contrast elsewhere.

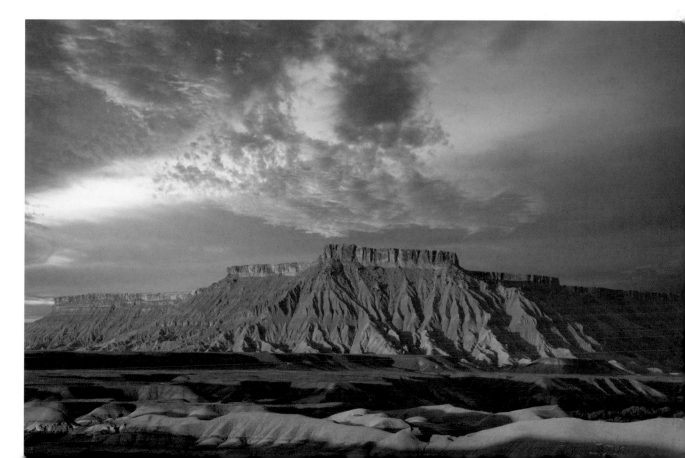

14 DODGING AND BURNING USING A GRAY FILL LAYER

The most common method for applying local changes to an image is first to make a selection but there are occasions when something less specific is required. You may want to darken a corner for example, or just a part of the sky. These kinds of changes are better done using the Dodge and Burn tools, which respectively lighten and darken tones. In order to use these tools non-destructively, the required changes should be made on a Gray Fill Layer.

Start image. Photographed at night, there were always going to be tonal problems. Parts of the image appear dull, while other areas appear too contrasty. Making conventional selections is not going to be possible.

Step 1. Click on the Add New Layer icon at the bottom of the Layers palette or go to *Layer > New Layer* from the menu. This will produce a transparent layer.

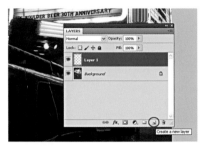

Step 2. Fill this new layer with 50% grey by going to *Edit > Fill* and select 50% Gray from the drop-down menu. The image will now disappear behind a grey layer. By going to Overlay in the Blending Mode, the image will reappear. You could also try Soft Light or Hard Light.

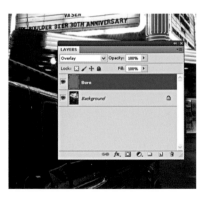

Step 3. Create a second New Layer and fill this with 50% Gray; this now gives you two separate layers to work on, one to lighten and another to darken. As all subsequent work will be restricted just to these two layers, the process can be achieved entirely non-destructively.

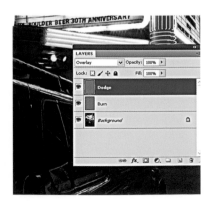

Step 4. 'Burn in' areas. To achieve this, set the Foreground/Background Colors to the default black and white, select a soft Brush tool set to black and paint those areas you wish to darken. This can be achieved with considerable accuracy. As you are working on a 50% Gray layer, nothing darker than 50% grey will be affected.

By clicking the eye icons adjacent to each of the layers you can toggle the layers on and off which will allow you to see how each layer is improving the image.

tip

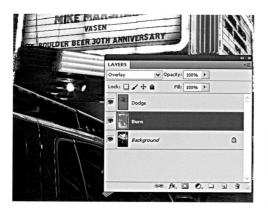

Finished image. There are numerous methods for altering the tones in an image but by Dodging and Burning, you are able to be much more instinctive. Using a Gray Fill Layer allows you to do this non-destructively.

Step 5. To 'dodge' or lighten parts of the image, activate the Dodge layer and select foreground white. Once again by carefully applying the required areas with Brush tool, very subtle tonal changes can be made. If there are parts you are not happy with, this can easily be remedied by applying a black brush on the Dodge layer, or a white brush on the Burn layer. Whether you are burning or dodging, it is important to start with a relatively low Opacity setting; start with 10%, and if that proves ineffective try gradually increasing its strength.

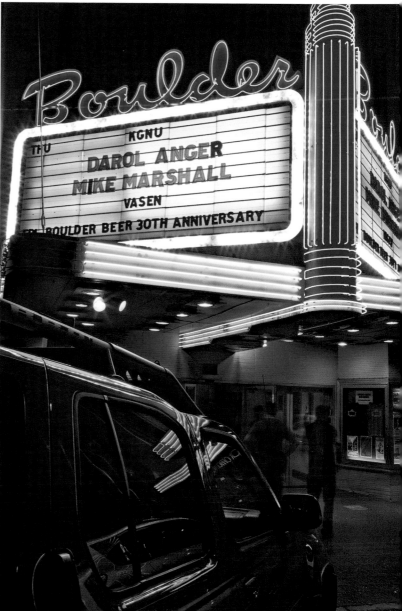

15 MAKING TONAL ADJUSTMENTS USING THE SHADOWS/HIGHLIGHTS COMMAND

Introduced in CS3, the Shadows/Highlights command appears to address all our tonal problems, but because it is not available as an Adjustment Layer some users are reluctant to use it because it cannot be applied non-destructively. One solution is to work on a Duplicate Layer, but one of the great advantages of using an Adjustment Layer is that it can be revisited and changed at any time. One method for overcoming this shortfall is to convert it to a Smart Object.

Start image. This is a typical image that can benefit from using the Shadows/Highlights command. The shadows appear heavy, while the highlights within the kiosk require more detail.

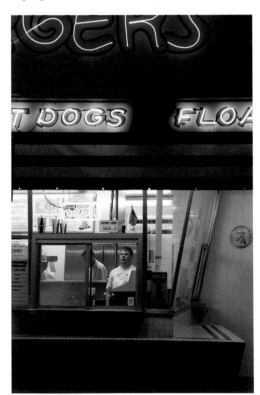

Step 1. Before accessing the Shadows/Highlights command, convert the image layer to a Smart Object. The advantage of this is that you can highlight an individual layer. Having selected a layer, go to the Layers palette menu and select Convert To Smart Object. A small badge icon will appear on the layer thumbnail.

Step 2. With the Smart Object layer active, go to *Image > Adjustments > Shadows/Highlights*. With your layer in Smart Object mode, most of the other options are greyed out. The Shadows slider defaults to 35%, which is usually considerably more than you need. I adjusted the slider to 13%.

Step 3. Having applied the Shadows/Highlights command, if you now look at the Layers palette, Shadows/Highlights now appears below the Smart Object and has effectively become an Adjustment Layer. If you double click Shadows/Highlights in the Layers palette, the dialog reappears. You are now able to apply Shadows/Highlights non-destructively.

Step 4. Adjust the lighter tones using the Highlight slider. The areas inside the kiosk appear bleached out, particularly those near to the 'open' sign. This is remedied by dragging the Highlights Amount to 50%. Once again, it does help to have the histogram on screen. Obviously, if the highlights are totally burnt out, then no amount of adjustment can bring them back.

Step 5. By selecting the Show More Options box, further adjustments are made available, including a Midtone Contrast slider. Having lightened the darker tones while darkening the lighter tones, some of the sparkle of the image is lost. A gentle application of this slider increases overall contrast. In this example I added +15.

Finished image. The Shadows/Highlights command is a particularly easy facility to use, and can be applied non-destructively when it is converted to a Smart Filter. By lightening the shadows within the exterior of the kiosk while adding further detail to the highlights inside, the tonal profile of this image has been substantially improved.

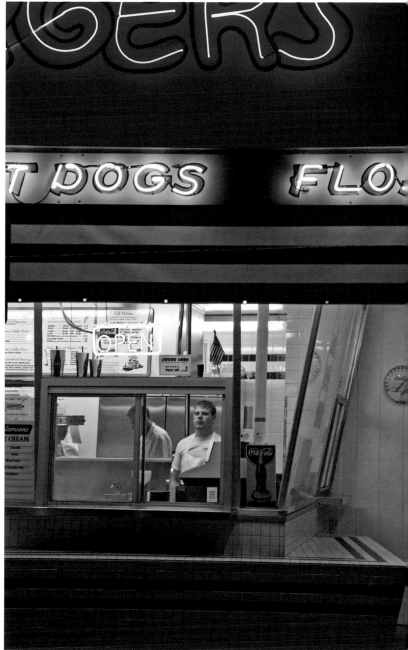

16 PRODUCING HIGH-KEY IMAGES

High-key images concentrate on the lightest tones, producing delicate images that are notoriously difficult to achieve. It is a matter of ensuring that the tones appear pale, while making sure that they do not burn out to bald white. One reason why it is so difficult to produce a true high-key image is because the metering system on most cameras is programmed to give a notional 18 per cent grey. While this works in most situations, the metering system can easily be fooled by very bright or dark situations. Fortunately, this can easily be remedied in Photoshop.

Start image. This is a classic underexposed image taken in a high-key situation. As the camera's metering system was giving me a reading for 18 per cent grey, it has come out darker than I was expecting. This could be remedied using Levels, but as I am dealing with such a delicate tonal range, a less radical process is required. In order to induce a more 'romantic' feel, a slight softening of the image could also prove helpful.

Step 1. The first part of the process is best done in the Raw Converter. Make the required changes but then select the Clarity slider at the bottom of the palette and drag it as far as you can to the left (-100). This will greatly soften the image. Open the image in Photoshop. Return to the Raw Converter, select the same image, but this time drag the Clarity slider to the right (+100), then open this file in Photoshop. You should now have a soft and a sharp version of the same image.

Step 2. With both files on the screen, drag the sharp version over the soft version while holding down Shift, so that the soft file becomes the Background Layer, while the sharp one becomes Layer 1. At this stage you can work in one of two ways. With Layer 1 active, make a Layer Mask, choose a large soft Brush tool and selectively reveal the blurred detail of the Background Layer. Alternatively, as I have done here, I went to the Blending Mode and selected Soft Light. All the tones lighter than 50% grey appeared subtly softer while the smaller areas of dark remained very sharp.

Start image histogram. A quick look at the histogram and you can see that it is bunching largely in the middle. I can afford to move the tones to the right without incurring blown-out highlights.

Step 3. A quick check of the histogram at this stage shows that the tones can still be lightened further. To achieve this, I made an Adjustment Layer and with the Foreground Color set to white, I selected Solid Color. The entire image appears white. By adjusting the Opacity slider to 10–15%, the image re-emerges but is subtly lightened.

Step 4. I made a further Adjustment Layer, and selected Levels. As most of the tonal adjustments had been made, it only required a slight tweak. Finally, in order to improve the composition of the image, I cropped it square, and then applied a thin black border using Canvas Size (see Adding Further Borders and Edges in Chapter 5).

Finished image. A true high-key image retains a special magic. If you select the right subject, the results can be stunning.

Finished image histogram. All the tonal values have been substantially lightened, without degrading the image. I have been able to retain just a tiny element of dark, which offers an interesting contrast.

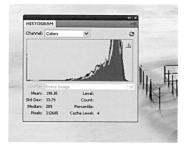

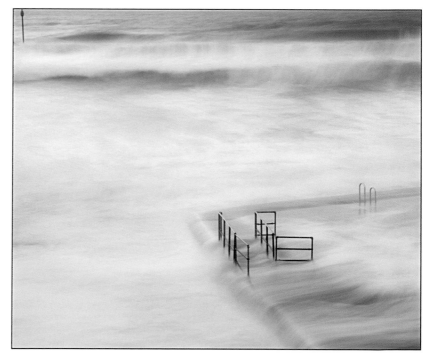

17 ADDING A SOFT FILTER EFFECT

Credit to modern lenses, but occasionally an image appears too sharp. Our recollections are more vague but when we see the image on screen, it appears too harsh. What we were seeking was a gentler impression. There are several Photoshop filters that can produce the required result, however the weakness of these is that they are universally applied. There are 'smarter' methods for producing a more ethereal image.

Start image. This beautifully wooded scene certainly has potential, but with its busy intersecting branches and richly saturated autumnal hues, it is perhaps offering us too much. I was seeking a simpler, more subdued interpretation.

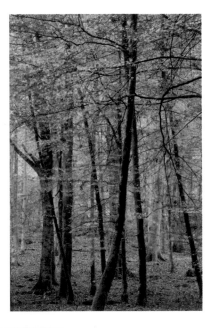

Step 2. The next stage is to lighten the image. Using the method described in Producing High-Key Images, make an Adjustment Layer, select Solid Color and, using the Color Picker, select white. Bring the image back by applying either Overlay or Soft Light and reduce the Opacity to between 10 and 20%.

Step 3. Make a further Adjustment Layer and select Curves. It is important not to degrade the darkest tones at this stage, so peg the curve a quarter of the way up the diagonal line, then click a point halfway along and gently pull the curve upwards. Check the histogram as you do not want blown-out highlights.

Step 1. Make a Duplicate Layer and name this new layer 'Blur'. With this new layer active, go to *Filter > Blur > Gaussian Blur* and apply a Radius of 40 pixels. Hit OK. Select Lighten from the Blending Mode and then reduce the Opacity to 80%. At this stage, the image will assume a pleasantly soft appearance.

Step 4. Make another Adjustment Layer and select Hue/Saturation. Your aim is not to remove the colour totally, just to subdue it; try reducing the Saturation by 30–35 while increasing Lightness by 5 (see Increasing and Decreasing Saturation). Don't worry if the colours look flat, as the final adjustment will pep them up.

Step 5. It is important that there is a full tonal range, albeit just a minimal trace of black. Using Levels, drag the Shadow slider inwards so that it just clips the darkest point, while dragging the Gamma slider to the left so that the overall lightness is retained. Fine-tune each layer until you reach an aesthetically pleasing solution.

Finished image. By radically lightening the tones and reducing colour, a more 'romantic' feel has been introduced.

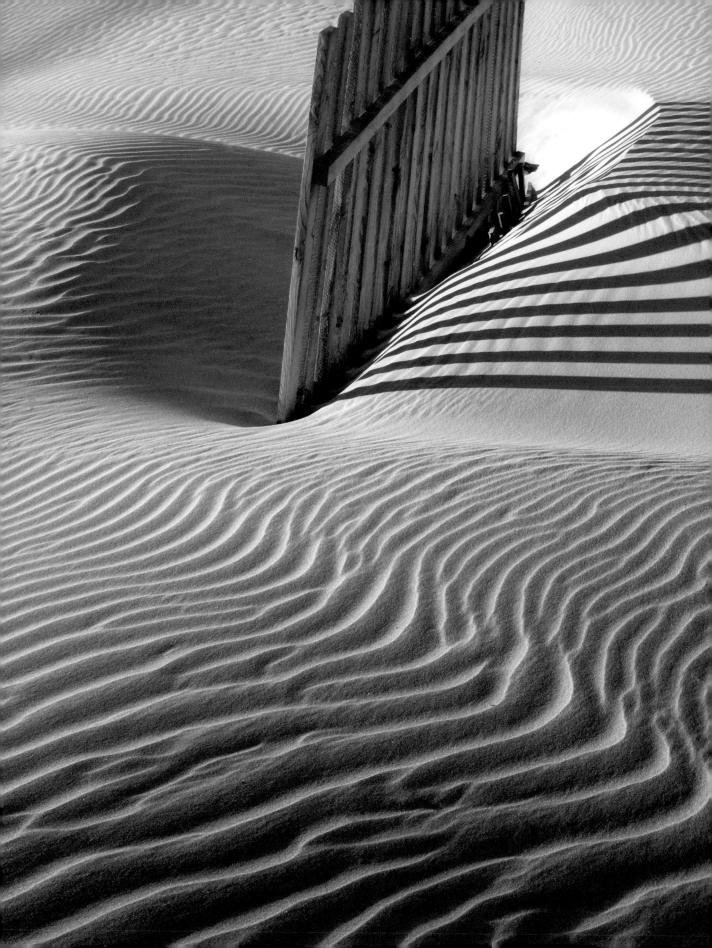

CHAPTER 2: MONO EFFECTS

One of the best ways of changing an image is to convert it to monochrome. We live in a world of colour, so making that change to black and white immediately introduces a certain abstract quality. But more importantly, by producing monochromatic images, we are reconnecting with a rich tradition that goes back to the dawn of photography. Colour has been with us for a long time and yet the allure of black and white remains as strong as ever.

18 CONVERTING A FILE TO MONOCHROME

Ironically it is far better to convert a RGB file (ideally a Raw file) to black and white than it is to use the monochrome facility on your camera, as in this way you are retaining the full image quality. The simplest method for converting an RGB file to black and white is either to desaturate the image or to convert it to Grayscale. Neither of these produce satisfactory results; I would suggest that you opt for one of the following methods instead.

tip

If you randomly select and desaturate an image you might be disappointed; what works well in colour will not necessarily work as a monochrome. Use the camera's monochrome option, and if you like what you see, retake the image in RGB, but convert the image in Photoshop. If you are shooting Raw, setting the camera to Black and White allows you to see the image in mono but still retain it in RGB.

Start image 1. Often the most difficult task is identifying a file that will make a good monochrome. The strong tonal contrast, the obvious graphic qualities and a general lack of colour would suggest that this should translate well as a black-and-white image.

Method 1: Convert to Lab Color. An interesting, and quite a popular method that many Photoshop users prefer, is to use Lab Color; this should be available on most versions of Photoshop. Open the Channels palette for reference. To convert your file, go to *Image > Mode > Lab Color*. This has the effect of separating monochrome from colour, which should be visible in the Channels palette.

To remove the colour information, select the Lightness Channel, but then convert the image to Grayscale. This method offers advantages over simply converting the image to Grayscale as it retains good shadow detail and exceptionally smooth midtones.

Method 2: use the Black and White command. All Photoshop versions from CS3 onwards feature the Black and White command. To access it, make an Adjustment Layer and select Black and White. This dialog offers six sliders; Reds, Yellows, Greens, Cyans, Blues and Magentas; these allow you to fine-tune the tonal values of your converted black-and-white image. So, for example, if you want to lighten or darken a blue sky, use the Cyans and Blues sliders. The principle is very similar to Channel Mixer except that the Black and White command adjusts the actual colours in the image. Put simply, when using the Red slider in Channel Mixer, all the colours are adjusted to a greater or lesser degree. However, when

using the red slider in the Black and White command, Photoshop is able to identify only those parts that are red and responds accordingly. This command also has a useful range of Default settings that you may wish to experiment with; they replicate the effects of a red, yellow, green or blue filter, which can prove particularly useful.

ADJUSTMENTS

Black & White — Default

Default

Blue Filter
Darker
Green Filter
High Contrast Blue Filter
High Contrast Red Filter
Infrared
Lighter
Maximum Black
Maximum White
Neutral Density
Red Filter
Yellow Filter

Custom

Tint

Reds:

Yellows:

Greens:

Cyans:

Blues:

Magentas:

Finished image 1. The high contrast, coupled with the strong interplay of light and dark, help to make this a successful black-and-white image.

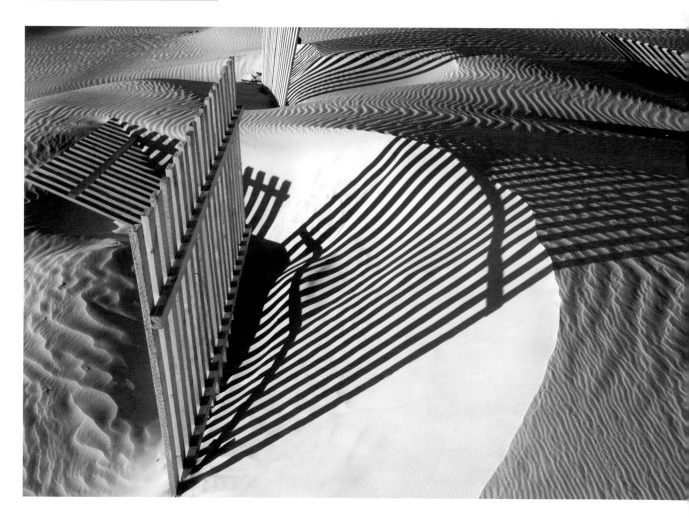

Method 3: Use the Channel Mixer. If your version of Photoshop does not include the Black and White command, a good alternative is to use the Channel Mixer. This also retains the image in RGB.

Step 1. Go to *Image > Adjustments > Channel Mixer*. If your version has Channel Mixer as an Adjustment Layer, it is preferable to use that instead as the changes can be made non-destructively. Select the Monochrome box and the image will immediately default to black and white. By moving the three colour sliders, you are able to adjust the tonal values of each of the colour channels. Rather than move the sliders randomly, think carefully how each of the channels can alter the tonal values of the image. The blue slider, for example, will greatly alter the tonal values in a sky picture.

Step 2. It is important that the total percentage of all three channels adds up to 100%. Less than that and you compromise shadow detail; more than that and highlights can appear burnt out.

Step 3. To fine-tune this technique, try using Color Mixer in conjunction with Hue/Saturation. With your Background Layer active, make a second Adjustment Layer by selecting Hue/Saturation, so that the Hue/Saturation layer is below the Channel Mixer layer. By scrolling Master, the six colour channels will appear. Select each of the channels you wish to alter and use the Hue slider to tweak the respective tonal values. Do not expect to see huge differences, as this is an exercise in fine-tuning. Occasionally it also helps to use the Saturation slider as well, although excessive use of either of the sliders can cause parts of the image to posterize.

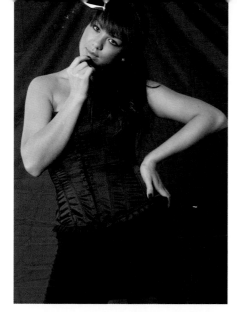

Start image 2. While this image clearly exhibits strong tones, the colour makes only a limited impact, and therefore should make an excellent image to be converted to black and white.

Method 4: Using the Raw Converter. If you shoot Raw (and the reasons for doing so are numerous), then you do have the option of converting your image in the Raw Converter. Once again the great advantage of using this method is that it is entirely non-destructive. Each Raw Converter is slightly different dependent on the make of camera, but look for the option that offers HSL/Grayscale. With this option open, you will be presented with eight colour sliders that allow you to fine-tune the tonal values with considerable precision. Make sure that the Convert to Grayscale box is ticked.

Method 5: using external software. Finally, an increasing number of monochrome enthusiasts are using software other than Photoshop to make their conversions, particularly Nik Software Silver Efex Pro (www.niksoftware.com). This software boasts unique algorithms offering an impressive tonal range. In addition to a very effective conversion facility, it has a number of interesting presets that allow you to mimic specific black-and-white films, although I sense you need to have been a darkroom enthusiast to truly appreciate the value of this.

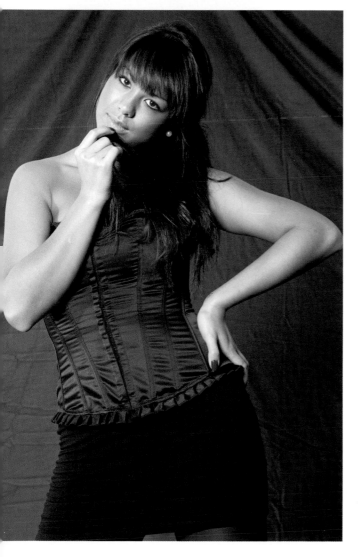

Finished image 2. The contrast between the model's flesh tones with her dark clothing and the dark background becomes much more apparent when this is presented as a black and white.

Mono Effects <<

19 SEPIA TONING

Having spent time desaturating an image, some might consider it rather perverse to want to re-introduce colour again, but that is to miss the point. A monochrome image concentrates the mind on the tonal values, while colour often has an emotional impact. Being able to harness both is certainly a skill worth pursuing. Moreover, in the digital age it is worth reconnecting with increasingly forgotten darkroom techniques.

SEPIA OPTIONS TO MISS

Sepia is the classic of all toning techniques, and it is possible to achieve sepia effects without ever having to use Photoshop. Most DSLR cameras now offer a sepia option, as indeed do most Raw Converters, although I would give both these options a miss. Sepia is not a specific hue and can range from copper to ochre. Moreover, the strength of the toning needs to vary according to the image you are working with, while split toning is another option available to you; none of these subtleties can be achieved when using a default option. There are countless methods for achieving a sepia effect, but the following two are my favourite.

obliterated the Background Layer, but by selecting Soft Light from the Blending Mode, the image re-emerges. Another alternative is to use Overlay. The strength of the sepia toning can often appear rather overwhelming, but by using the Opacity slider, the effects can be incrementally reduced.

Start image. It certainly pays to think carefully about which images are likely to work best with this technique. Sepia introduces a suggestion of nostalgia so something aggressive or harsh would not be suitable. This informal shot of a bride has been desaturated in Photoshop using the Black and White command.

Finished image. The naturally warm hue lends itself to this informal portrait.

Method 1: Using Color Fill. Open the file, make an Adjustment Layer and select Solid Color. Scroll the colour bar and select a hue between yellow and orange and then use the Color Picker tool to fine-tune your selection; a good starting point is Red 210, Green 165 and Blue 90. The Solid Color layer will have at this stage completely

Method 2: Using Curves.

Start image. While this image lacks the romantic feel of the previous portrait, it is still a suitable subject for sepia toning, although a slightly more 'gritty' approach is required. By split toning the image so that the toning is restricted to the darker tones, a greater sense of depth can be added.

Step 2. In order to counter the red, scroll the RGB box again and select the Green channel. While containing the lightest part of the curve, gently pull it upwards until a pleasing sepia effect is achieved in the darkest parts of the image.

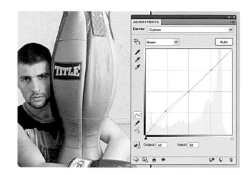

Finished image. A sepia split tone was difficult in the darkroom, but is easily applied using Curves.

Step 1. Start with your desaturated image in RGB mode. Make an Adjustment Layer, select Curves and by scrolling the RGB box, select the Red channel. To create a 'split-toned' effect (i.e. restrict the toning effect only to the darker tones), peg the lighter part of the curve, but then pull the remaining part of it upwards.

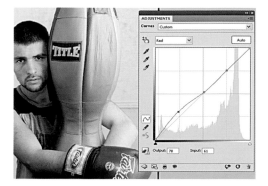

20 BLUE TONING

While considering some of the traditional darkroom techniques, another one that catches the eye is blue toning. I would suggest that you look at the many stylish magazines or CD covers which feature tastefully blue-toned images. Paradoxically, it was never an easy technique to master in the darkroom, but nothing could be easier in Photoshop.

Start image. It helps to give some thought to what will make an appropriate blue-toned image. Blue is a cold colour, therefore a subject one would normally associate with warmth, a sandy beach for example, might not make an ideal subject. Taken on a cold and misty afternoon, the content makes this an ideal image for the blue-toned effect.

Method. Start with an image in RGB mode, convert it to monochrome using the Black and White command, and then increase contrast by using Levels (see Converting a File to Monochrome). Apply a second Adjustment Layer and select Hue/Saturation. Make sure that the Colorize box is ticked. Drag the Hue slider along the colour bar until you achieve the precise blue you require; anywhere between 215 and 220 will work. Often the blue appears too strong, but this can be tempered by reducing the saturation.

Finished image. This blue-toned version has all the attributes of the original colour image, but none of its weaknesses. While the cold wintry feel is retained, a much stronger graphic quality is introduced.

When blue toning, always err on the side of subtlety – use the Saturation slider to subdue the effects of the toning.

21 COPPER TONING

The final 'classic' darkroom technique involves toning the image copper. In common with all toning techniques, whether created traditionally or in Photoshop, it does help to match the process with the subject.

Start image. This image was desaturated using the Black and White command. It was then cropped to a square format and a fine black border was added using Canvas Size (see Adding Further Borders and Edges in Chapter 5). It is important that your file is retained in RGB mode.

Method. There are various methods for achieving a copper effect, but an easy one is to use Color Balance. Make an Adjustment Layer, select Color Balance, and a simple dialog featuring three sliders will appear. Ensure that Midtones is selected and Preserve Luminosity is ticked. Add 25 of Red, 5 of Green and 5 Yellow; this should give you a plausible copper-toned image.

Finished image. The model in this example had wonderfully coppery hair, which this process appears to have enhanced.

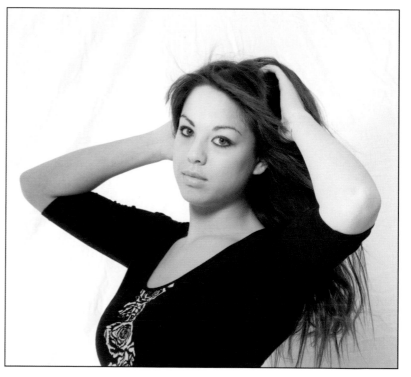

tip

Do remember when digitally 'toning', the methods used are interchangeable. It is perfectly possible to achieve a copper tone by using Hue/Saturation, for example.

22 DUAL TONING USING DUOTONE

Another darkroom tradition that seems to have retained its popularity is a process known as dual toning. Not dissimilar to split toning, it is a process that places two quite different colours at opposite ends of the tonal scale. It helps to give your picture that vintage, classic look. It is a process that can be easily mimicked in Photoshop using Duotone.

Start image. This image is perfect for dual toning as the strong lines and full range of tones will work well with the toning effects.

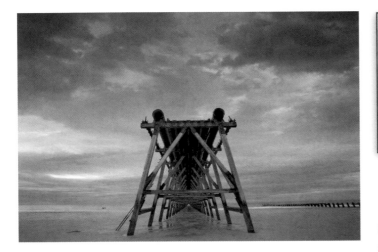

tip

Dual toning introduces a certain enigmatic yet timeless quality to images, as the colours can never be considered 'realistic'. For this technique it is best to choose a starting image that has strong graphical qualities and a good tonal range.

Step 1. Duotone is an excellent facility for dual toning, however you will need to convert your image to Grayscale: *Image > Mode > Grayscale*. Then go to *Image > Mode > Duotone*. When using Duotone, you will need to use two 'inks' plus the defaulted black ink. Start by selecting Tritone from the Type drop-down menu and then select two further colours for inks two and three.

Step 2. In order to achieve to positive dual tone, select two quite different colours. To achieve this scroll the vertical colour bar and use the picker to select the general area of colour you require. You will then be presented with a variety of subtle variations of the selected hue. Usually it is best to select one of the lighter hues.

Step 3. Once both 'inks' have been applied, the image can appear muddy, as both colours are impacting the full tonal range simultaneously; they need teasing out. To achieve this, click on the Curves icon to the left of the ink box and the Curves palette will appear. Select the curve for Ink 2 and use it to restrict the effects of the colour to just one part of the tonal range (the highlights for example). To balance this, select the curve for Ink 3 and manipulate it so that it only affects the darkest tones (see Manipulating Contrast Using Curves in Chapter 1). Get this right and the results can be stunning.

Finished image. You should be able to achieve some wonderfully creative results by dual toning in this way. When using Duotone select two quite contrasting 'inks', otherwise the split will not be obvious.

tip

Dual toning can also be achieved using Color Balance. Work on an Adjustment Layer and in the Colour Balance dialog select Shadows from the Tone box. Enter 30 Blue and 30 Cyan, then select Highlights and enter 30 Yellow and 40 Red. This will mimic a traditional copper/blue split.

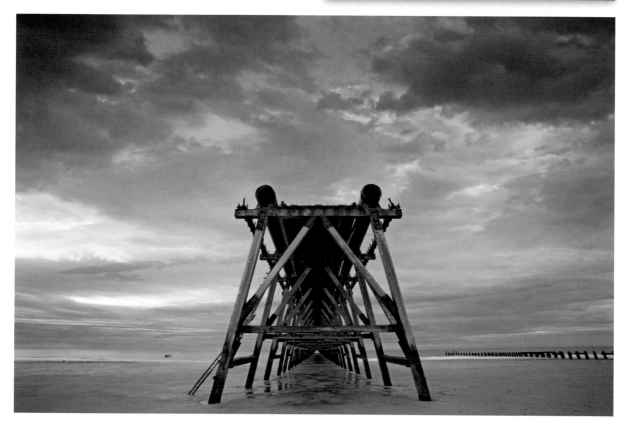

23 CREATING AN INFRARED EFFECT

Traditionally, in order to achieve an infrared image you needed a specialized infrared film; with the advent of DSLR cameras this requirement more or less disappeared, but the desire to produce infrared images has not waned. As well as in-camera techniques (see box) the infrared effect can be also achieved in Photoshop.

IN-CAMERA INFRARED

There are two well-recognized methods for producing the infrared effect digitally in-camera. The first requires attaching a specialized filter over the camera lens, which filters out normal light and only allows the infrared wavelength to reach the sensor; the drawback with this method is that these filters are virtually opaque and require very lengthy exposures. The other alternative is to have the sensor in your camera removed and replaced with a specialized infrared one, although if you only own one camera, this might seem a drastic solution. The post-processing solution is undoubtedly your best bet!

Start image. While the stereotype of an infrared image often features green foliage and blue skies, the process is far more flexible than that. Infrared film is sensitive to any living organism that shows up as light or white.

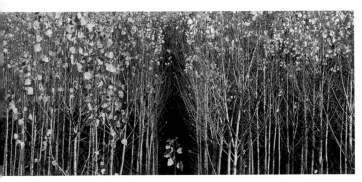

Step 1. Your first option is to use the Infrared preset in the Black and White command. Make an Adjustment Layer; select Black and White, Infrared. I find this produces blown-out highlights and prefer to use a more hands-on process.

Step 2. If you find that does not work, return to the Default option, and use the Channel sliders to create that distinctive infrared effect. In this example, I increased the Yellow and Green by dragging the sliders to the right. If I had included a blue sky, then I would have reduced the Blue and the Cyan channels by the same amount. It is important to understand that there is no definitive adjustment as it depends on the image you are working with; this is best achieved by eye.

Step 3. It helps at this stage to convert to Smart Filter, select the top layer, and while depressing the Alt key, go to *Layer > Merge Visible*. This will create a new layer that combines all the layers in the layer stack. Convert this to a Smart Filter by going to *Filter > Convert to Smart Filter*. The advantage of this is that it allows you to make alterations to any subsequent filter effects you wish to add, without affecting the original image.

Step 4. The hallmark of traditional infrared film was the presence halation; to achieve this effect in Photoshop, go to *Filter > Blur > Gaussian Blur*. I set Radius of 15 pixels, which has the effect of completely blurring the entire image, but by selecting Overlay from the Blending Mode, this will restrict the severity of the Gaussian Blur just to the extreme highlights.

Nik Software's popular monochrome package Silver Efex Pro also has tools for creating an infrared effect. Go to www.niksoftware for details.

tip

Step 5. Finally, a bit of tonal fine-tuning will be required at this stage. With Layer 1 still active, go to *Image > Adjustments* and select the Shadows/Highlights command. This gives you the opportunity of increasing or decreasing contrast, depending on the final result you are after. In this example, I chose to reduce it. In order to simulate the grittiness that characterizes infrared films, I added 15% Noise. Finally, as the image had light areas bleeding out into the edges, I added a thin black border using Canvas Size (see Adding Further Borders and Edges in Chapter 5).

Finished image. Infrared is a truly charming photographic technique producing strangely enigmatic, high-key images. It is a process that can be very easily simulated in Photoshop.

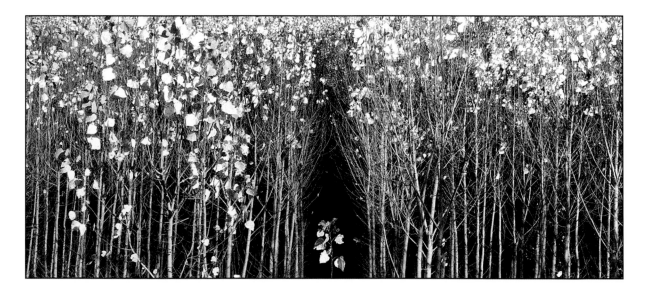

24 CREATING A LITH EFFECT

Another much-loved darkroom technique, this relies on grossly exposing the printing paper and then developing it in a weak solution of lith developer, hence its name. The hallmarks of this exquisite technique are strong, gritty shadows countered by creamy, delicate highlights.

Start image. The lith effect works with all kinds of images, portraits, landscapes and of course, still lifes. In common with most monochrome techniques, it helps if the image reveals a positive tonal range.

Step 1. Make a Duplicate Layer and name this second layer 'lith'. While this layer is active, desaturate it using the Black and White command. Here, I slightly lightened the plant using the Yellow and Green channels. The most charming feature about lith prints are their lovely warm hues; to achieve this make an Adjustment Layer and select Hue/Saturation. Ensure that the Colorize box at the bottom of the palette is ticked and then drag the Hue slider to between 20 and 30. Essentially what you are aiming for is a subtle caramel, although the precise colour of a lith print is governed by the paper used, the length of the exposure and the developer used, so there is a degree of latitude.

Step 2. Another defining characteristic of a lith print is the flat midtones. Make another Adjustment Layer and select Brightness/Contrast. If you are using a Photoshop version more recent than CS2, make sure that the Use Legacy box is ticked, and then drag the Contrast slider to the left by -50. This should considerably reduce the overall contrast of the image.

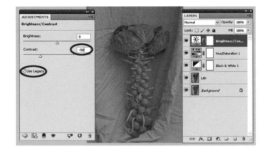

Step 3. The entire image should look very flat at this stage. In order to beef-up the shadows, make another Adjustment Layer and select Curves. Anchor the lightest quarter, then peg the darkest quarter to the base. Carefully pull the midtone section of the curve upwards; start with an Output of 135 and an Input of 122. If the image still lacks punch, apply Soft Light from the Blending Mode.

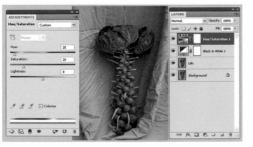

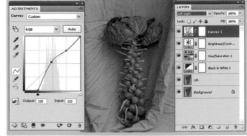

Step 4. To create the grittiness of a lith print, make a new layer (*Layer > New Layer*), then fill it with 50% grey (*Edit > Fill > 50% Gray*). This layer will block out the image. To simulate the grain effect, go to *Filter > Noise* and apply 140%. Make sure the Monochrome box is ticked. In order to reduce the severity of the grain, use Gaussian Blur set to 0.4 (*Filter > Blur > Gaussian Blur*). To re-introduce the image, apply Soft Light from the Blending Mode. At this point, the entire image appears grainy.

Step 5. In order to replicate a lith effect, the grain needs to be restricted just to the darkest areas. With this Layer still active, select Color Range and use the Color Sampler to select the darkest areas. Fine-tune the selection using the Fuzziness slider. Feather this selection by 5 pixels. Finally add a Layer Mask and this will restrict the grain effect just to the darkest areas. This is also a good opportunity to revisit each of the layers so that you can properly fine-tune each of the stages.

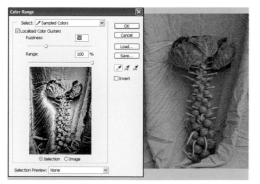

Finished Image. The harsh, gritty shadows are countered by delicate highlights, which are the defining characteristics of a typical lith print. It is important that you choose your subject wisely for this interesting but sometimes uncompromising technique.

25 CREATING A DIGITAL CYANOTYPE

As one of the earliest known photographic techniques, pioneered by Sir John Herschel in the 1840s, the cyanotype required painting a light-sensitive emulsion directly onto watercolour paper and then contact printing the negative, usually under glass, directly from it. Its defining characteristics are fringed borders and, of course, its vibrant blue colour.

Start image. Techniques such as cyanotypes work best with simple, uncluttered subjects. This graphic flower head should be ideal.

Step 3. With both files on screen, use the Move tool to drag the image over the paintbrush layer. The Paintbrush layer becomes the Background Layer, while the image becomes Layer 1. A bit of re-sizing might be needed to ensure that Layer 1 fits comfortably over the Background layer. To achieve this go to *Edit > Transform > Scale*. With Layer 1 active, make an Adjustment Layer, select Curves and lighten both layers ensuring that all black areas appear dark grey.

Step 1. Creating a fringed background can more easily be done by hand than it can in Photoshop. All you need is a paintbrush, some dark paint and a sheet of paper. Apply the paint in a rough and ready way, making no attempt to disguise the brush marks. When it is dry, copy your artwork using a flatbed scanner or the macro setting on your camera.

Step 2. Open the painted paper file in Photoshop, desaturate it and make sure that it remains in RGB mode. Open the image you wish to work with, desaturate this second file, ensuring that it also remains in RGB mode. I used Levels to boost contrast a little. Ensure the two files are roughly the same size.

Step 4. Make a second Adjustment Layer and select Color Balance. With the Midtones highlighted enter -62 Cyan and +95 Blue. Cyanotypes are typically quite vibrant, but should you wish to temper the strength of the blue, then open a third Adjustment Layer, select Hue/Saturation and tone it down using the Saturation slider. You should normally get a good balance between the Background Layer and Layer 1, but if the image appears to lack clarity, experiment with either Screen or Lighten in the Blending Mode.

Finished image. Part of the skill of creating an effective digital cyanotype is matching the subject with a suitable background. In this example the spikey nature of the flower is complimented by the brusque informality of the painted layer.

tip

The size of the image is important. As an authentic cyanotype is created by contact printing from a negative, it does help to reflect this in the size of your final image. Traditionally medium and large format film would vary; the most common were 6 x 6cm, 6 x 7cm, 5 x 4in and 8 x 10in; digitally produced cyanotypes should reflect these dimensions.

26 ADDING GRAIN FOR A FILM NOIR EFFECT

The quality of capture in many DSLRs is so good that even when using a high ISO, the image appears smooth and Noise-free. But some moody monochromic images benefit from grain. The cinematic tradition of Film Noir dates back to the 1940s and 50s, and tended to celebrate a low-key, black-and-white style. Many contemporary photographers have found inspiration in this tradition and have developed ways of introducing similar qualities into their own work.

Start image. Images with a hint of melodrama seem to work well with this style of photography. This portrait, set against a dramatic sky, appears wonderfully suited to this uncompromising technique.

Step 1. I made an Adjustment Layer, selected the Black and White command, and converted the image to monochrome. I then made another Adjustment Layer, selected Levels and increased contrast by drawing in both the Shadow and Highlight sliders. While this resulted in the shadows and

highlights being clipped, it added to the slightly degraded quality I was after. The Gamma slider was slightly moved to the right in order to darken the mood of the image.

Step 2. When applying any image-changing filter, it is important that the process is done non-destructively. To do this, I made a new layer (*Layer > New Layer*) and named it 'Grain Layer'. I then filled this Layer with 50% grey. To do this go to *Edit > Fill* and scroll the Use drop-down menu for 50% Gray. Hit OK and a grey layer will appear over the entire image. All subsequent work will be done on this layer.

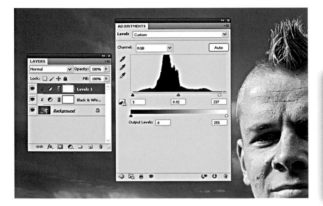

tip While this technique has been successfully completed using Photoshop, there are various plug-ins that specialize in recreating a wide range of monochromatic techniques. Possibly the most popular of these is Nik Software; for further details go to www.niksoftware.com

Step 3. To bring the image back, set the Blending Mode to Overlay, which treats 50% grey as a 'transparent' colour allowing you to use different filter effects on the 50% grey layer without having to edit the Background Layer. To add grain, go to *Filter > Texture > Grain*. In the Grain Filter dialog, increase contrast and select the Enlarged Grain Type. In order to remove the colour in the grain, go to *Edit > Fade Grain*, or alternatively go to *Image > Adjustments > Desaturate*.

Step 5. To add more emphasis I decided to darken the corners. To create a vignette, I used the Elliptical Marquee tool to select a large area around the portrait and then inversed this and feathered it by 150 pixels. In order to darken the corners, I made an Adjustment Layer, selected Curves and gently pulled the curve downwards. Finally a small amount of Unsharp Mask was applied to give the grain added crispness (see Sharpening the Image in Chapter 4).

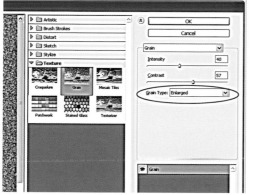

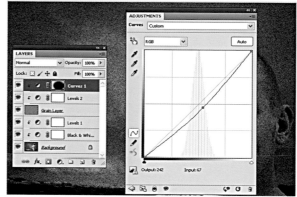

Step 4. Having introduced the grain, the image might appear flat at this stage. Make another Adjustment Layer, select Levels, and you will immediately see that the histogram is peaking in the mid-tones. To add contrast, pull both the Shadow and Highlight sliders inwards.

Finished image. The Film Noir style creates a definite mood reminiscent of the dark movies of the 1940s and 50s. It certainly is one of those techniques that requires a most careful choice of subject.

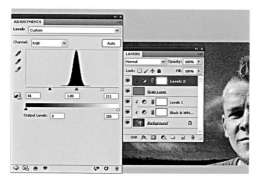

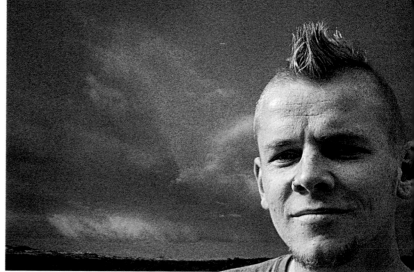

27 GOING FOR GOLD

Solarization (the Sabattier effect) is a traditional darkroom process that resulted from briefly exposing the film to light during development. It is a technique that is characterized by strange tonal inversions and the formation of thin black or white lines appearing between adjacent highlights and shadows. There are two ways of producing an interesting solarized effect; the first requires using Curves while the second can be achieved using the Blending Mode.

Start image. Start with an image that shows a good tonal range. If it is too flat, try increasing contrast using Curves. After cropping this image, I desaturated it by going to *Image > Adjustments > Desaturate*. Don't bother fine-tuning the image at this stage, because the solarization process will put pay to your good work.

Method 1: using Curves. Make an Adjustment Layer and select Curves. Start by clicking on the midpoint of the curve and pull it gently upwards. Next select two points, one a quarter and another three-quarters of the way down the curve and pull them downwards. Finally, select the darkest point of the curve and drag it upwards so you have a 'W' shape. This is a useful start. The extent of the solarization will be dependent on the tonal values of the image you are working with, so a bit of tweaking might be required. The more you exaggerate the 'W' the greater the contrast.

Method 2: using the Blending Mode. Make a Duplicate Layer then invert it by going to *Image > Adjustments > Invert*. This is where a certain measure of subjectivity will be required. Try scrolling the various Blending Mode options to see which gives the best results; once again the tonal values of each individual file will have a bearing. Lighten, Darken, Difference and Pin Light all offer interesting possibilities.

Go for gold. Having solarized your image using either of the two methods, make an Adjustment Layer and select Solid Color. Use the picker to select a golden yellow. A good hue to start with is Red 210, Green 165 and Blue 90. Apply Overlay from the Blending Mode and reduce the Opacity to 40%. The image will re-emerge with the model appearing as if she has been cast in gold.

Finished image. To finish the image off I added a border (see Adding Further Borders and Edges in Chapter 5). Visually there are strong parallels between the reflective surfaces of metal and a solarized effect. You may wish to develop this by applying different toning techniques.

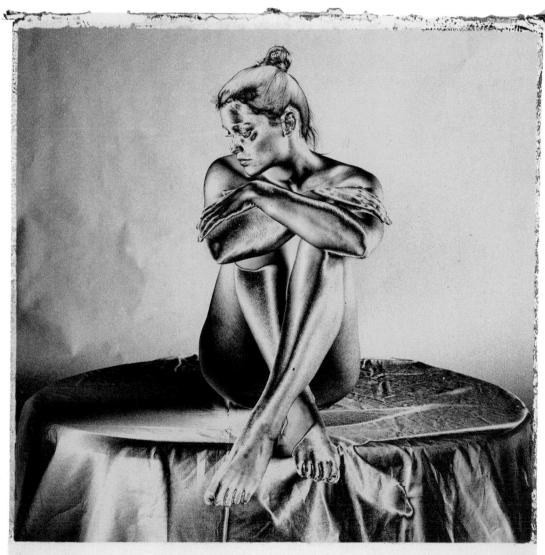

28 SELECTIVE COLOURING

The tradition of selectively hand-colouring a monochrome print dates back to the dawn of photography, but it still retains its appeal. The technique appears most effective when only a small part of the print is coloured. Traditionally, the technique required patiently and skilfully applying dyes directly onto the surface of the print but today doing it in Photoshop is a comparative breeze.

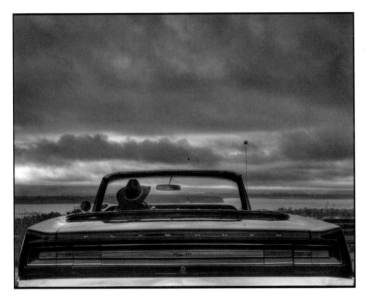

in Chapter 5). A Duplicate Layer was made which I named 'Mono'. With this layer active an Adjustment Layer was made and the Black and White command selected. As I wanted to feature the taillights, the Red slider was selected and then dragged slightly to the left in order to darken them.

Step 2. Add a Layer Mask. In order to colour the taillights, select a soft Brush tool set to black. Carefully paint the taillights to reveal the colour detail from the Background Layer. If you find the Brush tool strays into areas that should remain monochrome, reset the Brush to white and paint back the detail. It helps to use Zoom when doing this.

Start image. Often when we view an image, we are disappointed because it offers us too much colour. This picture of an urban cowboy and his car is a typical example. When photographing this, I was drawn to the red taillights and was largely unaware of the other surrounding colours.

Step 1. I started by cropping this image to make it squarer. As the rear bumper is very light in tone and appears on the edge of the image, I added a black border using Canvas Size (see Adding Further Borders and Edges

Step 3. Black-and-white images are much more forgiving when making positive tonal changes. In order to concentrate the eye on the main areas of interest, a vignette was applied to the top corners. The Elliptical Marquee tool was used to draw a large oval. This selection was then inversed and the bottom section was removed using the Rectangular Marquee tool set to minus, resulting in an arch. This selection was feathered by 250 pixels.

Step 4. In order to darken the top corners, I made another Adjustment Layer and selected Curves. I clicked on the diagonal line and gently pulled it downwards. The contrast of the area immediately surrounding the driver needed increasing slightly, so I made a rough selection using the Lasso tool feathered by 100 pixels. Contrast was added using Levels by gently drawing the Highlight and Shadow sliders closer together (see Boosting Contrast Using Levels in Chapter 1).

Finished image. By featuring just the taillights, a strong graphic element is introduced. The great advantage of adding just a small amount of colour is that you can have the best of both worlds. Nothing draws the eye quite as effectively as red, but at the same time the evocative tones of black and white express a mood that colour simply cannot match.

CHAPTER 3: CREATIVE USE OF FILTERS

It is too easy to become disparaging about Photoshop filters, and there are certainly examples where they have been applied randomly, sometimes with disastrous results. But if applied with care, they really can be used to enhance your image greatly; in this section, we will look at several methods you may wish to consider.

29 IMPROVING A PORTRAIT USING BLUR FILTERS

There will be countless times when an image appears too sharp and requires softening; this is particularly apparent when shooting portraiture, when often every spot and blemish is highlighted, which does not flatter the subject. Gaussian Blur and Surface Blur are both popular Photoshop filters and are excellent methods for softening backgrounds and enhancing skin tones.

Start image. When planning this portrait, I specifically asked the model to wear a black top, which I could set against a dark background; the idea was that his lighter skin tones would appear to glow when set against a low-key background. Despite opting for a large aperture, the texture in the background has proven to be an unwelcome distraction.

Step 1. Open your image in Photoshop and then make a Duplicate Layer. The first task is to make a selection of the background. As there are no obvious colour or tonal variations, there is no need to be too precise. The usual Quick Selection or Magic Wand tools were largely ineffective, so I used the Polygonal Lasso tool feathered by 2 pixels instead. Save the selection just in case you need to return to it later (*Select > Save Selection*).

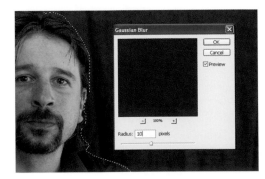

Step 2. With the Duplicate Layer active, go to *Filter > Gaussian Blur*. Which setting you select will partly depend on the size of your file, but start with a pixel Radius of 10, and increase it if you think it helps, although you will encounter banding if you overdo this.

Step 3. With the Duplicate Layer still active, reverse the selection by going to *Select > Inverse*. With just the portrait selected, go to *Filter > Blur > Surface Blur*. This filter has been designed to smooth skin tones, while preserving edge detail. Use the Radius slider to govern the level of blur while using the Threshold slider to determine how far it spreads. The effect can have the appearance of an airbrushed painting, but don't worry as this can easily be tempered.

Step 4. The task now is to retrieve some of the detail from the original file. Make a white Layer Mask, and with this highlighted, select a small soft Brush tool set to black at 75% Opacity and carefully remove parts of the Duplicate Layer to show detail from the Background Layer. It is important to work on those areas around the eyes, mouth, nose and hair.

> If you overdo this part of the process, simply change your Brush colour to white and rectify the mistake. You may also wish to slightly reduce the Opacity between the two layers.
>
> **tip**

Step 5. Eyes often appear a little darker than we sometimes imagine, largely because they are located within a recess. In order to add a little sparkle, make a New Layer, fill with 50% Gray, apply Overlay and then use a soft small Brush tool set to white, in order to lighten the whites of the eyes (see Dodging and Burning Using a Gray Fill Layer in Chapter 1).

Finished image. Whether you are a fan of filters or not, I would strongly recommend that you consider applying both Gaussian Blur and Surface Blur when working with portraiture. Often the camera can prove unrealistically sharp, which rarely flatters the sitter.

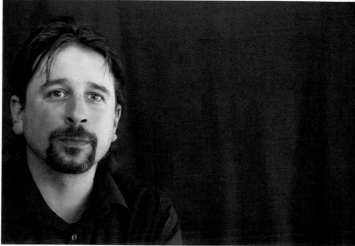

30 A DIGITAL MODEL MAKEOVER USING SURFACE BLUR

We have just seen how a general portrait can be improved using Gaussian Blur and Surface Blur. However, if you wish to create a 'digital makeover', then a more precise application of the Surface Blur filter will be required to remove spots or blemishes. Surface Blur is a 'Smart' Filter that is able to detect edges such as the mouth and eyes, and avoids sharpening those parts. The major risk is that it does the job too well, and does need to be tempered slightly.

Start image. This model is blessed with very good skin, but even she has some small blemishes. If this image was blown up larger than life-size, these would become far more apparent. In the world of advertising, for example, the size of the image is often greatly increased.

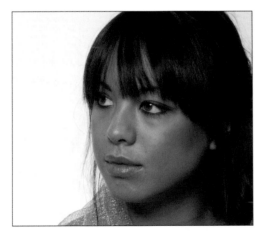

Step 1. Open the image and make a Duplicate Layer. Name this new layer 'Makeover'. Start by addressing any noticeable blemishes using the Spot Healing brush. Zoom around the face, zapping out any blemishes. You may also consider using the Healing Brush at this stage. Check Type in the Menu bar, and make sure that the Contents Aware button is selected. With the 'Makeover' layer active, convert it to a Smart Filter (*Filter > Convert to Smart Filter*). Zoom in on the face and use the Hand tool to navigate around the image.

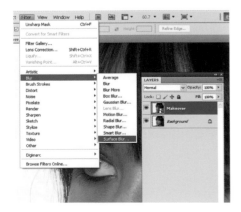

Step 2. Open the Surface Blur dialog (*Filter > Blur > Surface Blur*). Initially set the Radius to 40 pixels, although at this stage nothing appears to happen. Now adjust the Threshold slider; as you move it to the right, the smoothing effects become apparent. Try an initial Level of 50. In order to get an appreciation of how the filter has affected the entire image, hit 'P' (for Preview) on the keyboard. Note how the filter appears not to have affected edge detail such as the mouth and eyes. Hit OK.

Step 3. Select the Filter Effects mask thumbnail in the Layers palette (the little white box below the 'Makeover' layer) and then go to *Edit > Fill > Black* (or use the Masks Panel in CS5). This causes the image on screen to default back to the original skin texture. Select the soft Brush tool set to white and use an Opacity of 50% and Flow of 30%. The size of the Brush should be governed by the areas you wish to expose.

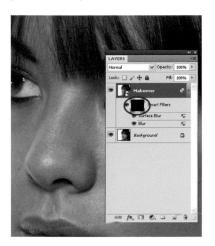

Step 4. Brush over the model's face taking care not to brush over the lips or eyes. To ensure that the Brush tool is being applied evenly, press Alt and click inside the Layer Mask, which will reveal a black-and-white image. Those areas highlighted white indicate the parts affected by the Surface

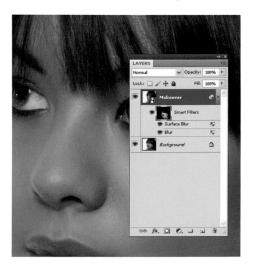

Blur filter. To return to normal view, hold down Alt and then click the Smart Filter Layer Mask thumbnail.

Step 5. A little bit of fine-tuning might be required at this stage. First, reduce the Opacity of the Smart Filter Layer Mask to 75%. Then change the Foreground Color to Black, reduce the size of the Brush tool, increase the Opacity to 100% and zoom in on the areas around the eyes, mouth and nostrils that may still have remained softened.

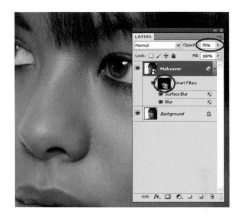

Finished image. The Hollywood makeover – a technique you can apply that remains totally under your control.

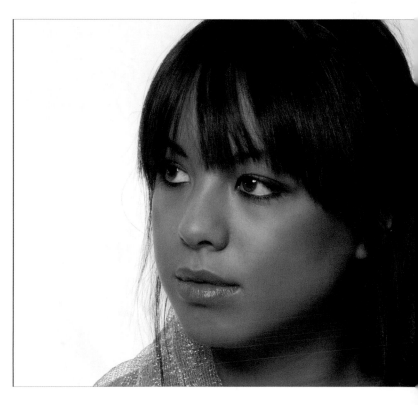

31 DIFFERENTIAL FOCUSING USING LENS BLUR

There are occasions after taking your shot when you realize it might have been improved had you used a wider aperture to throw parts of the image out of focus. If in hindsight you find that too much of your image is in focus, this can easily be remedied using Lens Blur.

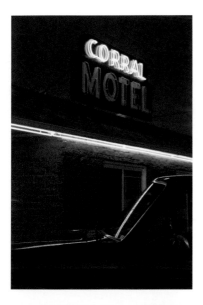

Start image. Hand-held and photographed at night, this image appears stuck between two stools. The background appears slightly out of focus, but not sufficiently to suggest that this has been a conscious decision. By throwing the entire background out of focus, a more purposeful visual statement can be made.

Step 1. I started by making a Duplicate Layer, and then made an accurate selection of the vehicle in the foreground, but excluded the side window, using the Magnetic Lasso tool feathered by 3 pixels. This selection was then Inversed (*Select > Inverse*), so the background became active.

Step 2. Go to *Filter > Blur > Lens Blur*. You will then be presented with a dialog offering a variety of options. The first, the Preview, gives the choice of Faster or More Accurate; choose the former, otherwise the process can prove monumentally slow, particularly if you are working with a large file.

Step 3. Select the iris you wish to work with from the Shape pop-up menu. Hexagon is a good option as it accurately replicates the distortion one would see from most lenses. By dragging the Radius slider to the right, you are able to determine the level of blur. Use the Blade Curvature slider to smooth the edges of the iris. Should you wish to rotate it, use the Rotation slider.

The Lens Blur filter allows you to apply the effect incrementally by using the depth map, but if the area to be thrown out of focus exists largely on the same focal plane, you can ignore this option.

Finished image. Successful photography is largely about directing the viewer's eye to where you want it to go and depth of field is one way of doing this. By using Lens Blur I have been able to place far greater emphasis on the vehicle in the foreground by throwing the background out of focus.

Step 4. When areas of a photograph are thrown out of focus, the highlights become more noticeable; this can be a blessing or a curse. To control it, use the Specular Highlights option. Use the Threshold slider first. It defaults to 255; unless you want to see dramatic burnout in the highlight detail, move it only very slightly to the left. The Brightness slider should also be used with similar caution.

Specular Highlights
Brightness 0
Threshold 254

Step 5. All images will have an overall grain (often referred to as Noise), however in those areas that have been blurred, this disappears, which introduces an element of inconsistency. In order to re-introduce grain back into the blurred areas, with the Gaussian option highlighted, drag the Noise slider, but by only 1 or 2 points.

Noise
Amount 2
Distribution
○ Uniform
⊙ Gaussian
☐ Monochromatic

32 CREATING THE 'BIG STOPPER' EFFECT

An imaginative use of the Radial Blur filter in Photoshop is to create a 'Big Stopper' effect in the sky. This mimics the effect of using a strong neutral density (ND) filter to create an ethereal, otherworldly feel. ND filters work by reducing the amount of light reaching the sensor, therefore an exposure that typically requires a shutter speed of 1/60 sec can be extended to many seconds, or even minutes. Used in a landscape situation, the results can be beautiful, with moving clouds producing evocative streaks of colour. Recreating the effect in Photoshop is simple.

Start image. This is the ideal subject to start with. The sky reveals plenty of cloud, offering good colour and tonal contrast. The landscape has a certain mystique that would be enhanced by using this interesting technique.

Step 2. With the Duplicate Layer active, make a Layer Mask by clicking the Add Mask icon at the bottom of the Layers palette. This will allow you to make subtle adjustments later in the process.

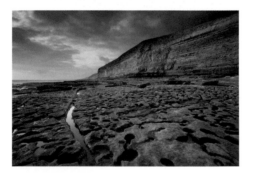

Step 1. Make a Duplicate Layer and then make a careful selection of the sky. This is done by using a combination of the Quick Selection tool and the Magic Wand tool set to a Tolerance of 30. In common with most selections of this type, it does help to expand the selection to avoid any telltale white lines – in this example I expanded the selection by 3 and then feathered it by 2 pixels.

Step 3. Select the thumbnail on the Duplicate Layer, and then go to *Filter > Blur > Radial Blur*. Within the Radial Blur window, select Zoom from the Method options. Set Quality to Best. Finally, enter the required Amount; in this example I opted for 70. While the Blur Centre defaults to a central position, use the cursor so that it more accurately reflects where the actual horizon is in the picture. Once completed, hit OK.

Step 4. The effects of this filter can sometimes bleed into unselected areas nearby. Ideally this should be removed by showing detail from the Background Layer. Click on the Layer Mask thumbnail and then select a medium soft Brush tool set to black. In this example, I carefully worked along the edge of the cliff and the horizon in order to remove any imperfections. Start by setting the Brush opacity to just 60%. Once you are happy with the results, flatten and save.

Finished image. Get this right and the results are indistinguishable from the real thing, but without the inconvenience of lengthy exposures. The wonderfully ethereal effect of Radial Blur introduces an added dimension to the image. This effect works equally as well on photographs featuring moving water.

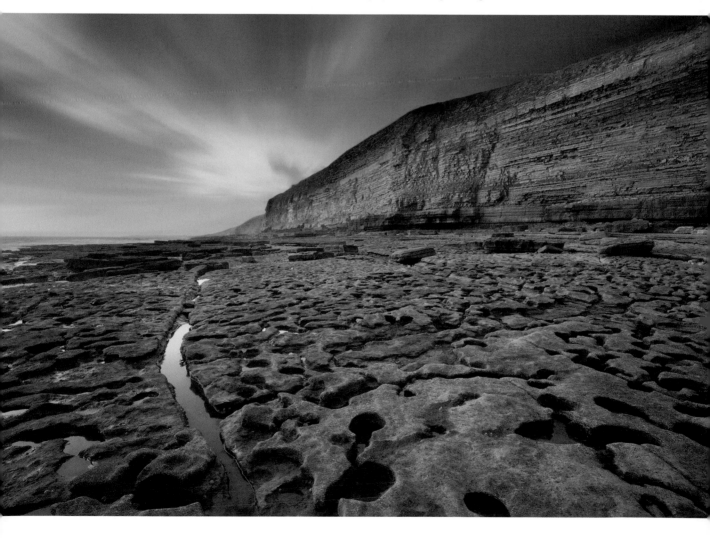

33 BAS-RELIEF EFFECT USING THE FIND EDGES FILTER

Bas relief is a time-honoured technique that exaggerates the sense of texture by making the image look as if it is heavily embossed. Traditionally this effect was created by combining a positive and negative of the same image slightly out of register. The filters in Photoshop vary and while some appear to have value, others are more esoteric; Find Edges is a case in point. If used 'undiluted', it can leave your image looking more like a sketch than a photograph, but used in conjunction with other techniques, it is possible to use it to create an interesting bas-relief effect.

Start image. This technique is best applied to an image with strong textures; this old abandoned vehicle serves the purpose well.

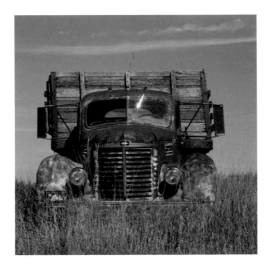

Step 2. While the edges will be very apparent, particularly in the more textured areas around the pickup and the grasses in the foreground, the sky will retain all the smoothness and subtlety of the original Background Layer. The tones, however, will appear too pale. To counter this, make an Adjustment Layer and select Levels. Use both the Shadow and Gamma sliders to increase contrast.

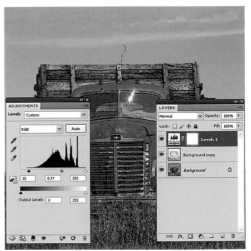

Step 1. Open the file in Photoshop and make a Duplicate Layer; with this new layer active, go to *Filter > Stylize > Find Edges* and the image will resemble something akin to a line drawing. To create a plausible bas-relief effect, apply Hard Light from the Blending Mode and reduce the Opacity to 40–60%.

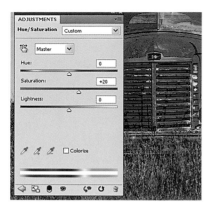

Step 3. The colours will still appear slightly bleached out; to counter this, make another Adjustment Layer and this time select Hue/Saturation. Click on the Saturation slider and increase by +20.

Step 4. Finally the sky still appears just a little anaemic; using Quick Mask and the Gradient tool (set to Linear) make a graduated selection from the top of the image to include most of the sky (see Using Gradient and Quick Mask in Chapter 1). Make another Adjustment Layer, select Curves and darken the sky from the top.

Finished image. The bas-relief effect not only heightens the sense of texture but also introduces an element of brittleness that increases the sense of pathos. It is important that this graphic effect is restricted only to areas of strong texture.

tip

Photoshop does have its own version of Bas Relief *(Filters > Sketch > Bas Relief)*, however the full-blown effect of this filter totally divorces the image from reality. Consider tempering its effects by applying the technique I have just described. The results are different – experiment and find out which one you prefer.

WACKY LINES IN KENEBEC PLUG-IN

An alternative you may wish to consider is a plug-in filter available from Kenebec (www.kenebec.com/filters), which the makers claim replicate many of the current Photoshop filters but improve on them. For example, their Wacky Lines filter does very much what Photoshop's Find Edges filter does, except that it offers considerably more control. When downloaded, you should find the Kenebec filters at the bottom of the Filters options, select *Kenebec > Wacky Lines*. The comprehensive dialog features a whole host of interesting options. It also offers a range of presets that are worth exploring. For best results, follow the steps in the main workshop, but apply Soft Light in the Blending Mode rather than Hard Light. (It should be noted however that they do not work in 64-bit Photoshop.)

34 SIMULATING A SPEEDING CAR USING MOTION BLUR

A classic technique for photographing a moving car is to pan your shot; if you pan at the same speed as the moving subject, it will appear sharp set against a blurred background, giving the shot a sense of movement. The problem of relying on an in-camera technique is that it is so easy to make a mistake. In the excitement you could jerk the camera just as you press the shutter, or the background may appear too light or too dark. It may require a number of re-takes which is inconvenient, or just impossible. A solution is to create the effect in Photoshop using Motion Blur.

Start image. While the car is undoubtedly interesting, the background certainly is not; taken in winter, the trees are not at their best, so blurring the background will help. It was important to include the driver in the shot; after all cars do not drive themselves and while the car is stationary, the impression you want to create is that it is being driven at speed.

Step 1. Make a detailed selection of the vehicle; in this example, the Polygonal Lasso tool feathered by 2 pixels proved the best option. Then set the Lasso tool to minus in order to remove the inside of the car from the selection. Including the driver has undoubtedly added interest to this image, but it does require a little more work. Save and then inverse the selection: (*Select > Inverse*).

Step 2. In order to ensure the blurring affects only the background, create a new layer by going to *Layer > New > Layer via Copy*. This becomes Layer 1. Note that the 'marching ants' have disappeared. With this layer active, select the Lock transparent pixels icon, then go to *Filter > Blur > Motion Blur*.

Step 3. The Motion Blur dialog offers two controls, Angle and Blur. Set the Angle first – as the car is going slightly uphill it was set at 2 degrees. The apparent speed of the car is governed by the Distance slider. In order to completely obliterate the background, 600 pixels was applied.

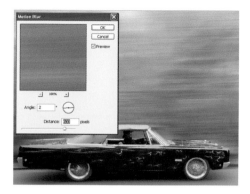

Step 4. The car appears to be moving, except the wheels are static. Activate the Background Layer and select each of the wheels in turn,

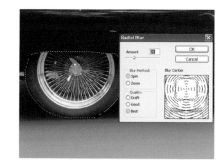

as they are subtly different. Having made a selection of the rear wheel, go to *Filter > Blur > Radial Blur* and select Spin in the Blur Method box. It is important to ensure that the Blur Center is carefully placed, consistent with the centre of each of the wheels. In each case an Amount of 25 pixels was applied here.

> **tip**
>
> While I have chosen to illustrate this technique using a car, it can be equally well applied to an athlete, a skateboarder or a galloping horse. The essential task is to make a good selection.

Finished image. In order to emphasize the illusion of speed I decided to crop a little from both top and bottom of the image. An added advantage of blurring the background is that it gives your imagination free rein; rather than a cluster of unattractive shrubs, it is easy to imagine that the driver is cruising down a beautiful tree-lined avenue.

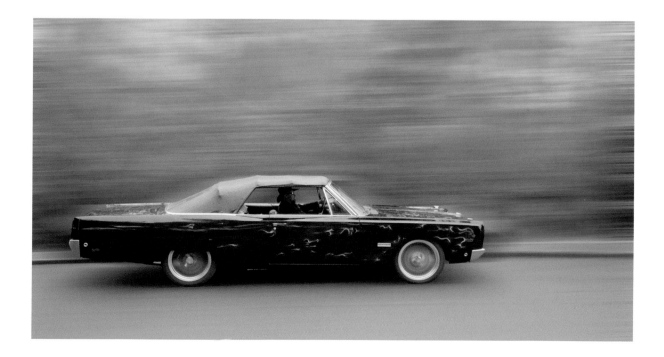

35 NOISE AND HOW TO OVERCOME IT

Noise is evident in all images taken with a DSLR camera, although its severity is dependent on various issues. It tends to be most noticeable in shadow areas where, instead of seeing smooth tonal gradation, one is aware of specks of colour. Problems relating to Noise are often only evident when you produce a print but, if ignored, can seriously reduce the quality of the image. Ideally you should take steps to avoid it at the shooting stage, but if that is not possible, there are post-camera methods that can be used to overcome it.

TIPS FOR OVERCOMING NOISE IN-CAMERA

- Noise is most apparent when using a high ISO, so wherever possible aim to use the lowest ISO rating, even if this means using a tripod.
- Noise will always be most apparent in the darker areas of the image so you should aim to overexpose slightly (1/3 stop usually does it). It is important that you do not overdo this and blow the highlights, so make sure you check the histogram as a matter of routine.
- Noise increases dramatically with exposures of 1 sec or longer, so if you are a fan of night photography, you need to be aware of this issue. Most DSLRs have a Noise Reduction (NR) facility for use when making long exposures.

Start image. This is a classic situation where Noise is likely to be a problem. Photographed at night, I was required to use a long exposure. Add to this the need to balance the exposure between the underneath of the pier and the illuminated areas in the middle distance and clearly something had to give.

tip

The Raw Converter offers an excellent option for reducing Noise. Set all the sliders to zero. Start by dragging the Color slider to the right until all the colour specks disappear, then move the Luminance slider until the white specks disappear. Finally, gently adjust the Luminance Detail, Luminance Contrast and Color Detail so that just the merest hint of Noise is still visible.

Start image (detail). Zooming in, the Noise becomes considerably more apparent. This would be very noticeable if produced as a print.

Step 1. When using any filter in Photoshop, always work on a Duplicate Layer; alternatively you may choose to convert your image to a Smart Filter (*Filter > Convert to Smart Filter*) then go to *Filter > Noise*. This ensures that any changes made will be applied non-destructively. You will be offered various options, including Despeckle, Dust and Scratches and Median, although the option we need here is Reduce Noise.

- **Preserve Details.** Use this in conjunction with Strength, as this slider introduces the Noise back into the image. The idea is to balance out these two controls so that the evidence of Noise is just barely visible.
- **Reduce Color Noise.** This should be applied if your image appears to suffer 'chromatic' or colour Noise. This shows up as colour banding or as coloured haloes.
- **Sharpen Detail.** This is another method for restoring sharpness where the process of Noise Reduction has softened the image.

Step 2. The Reduce Noise dialog offers two options, Basic and Advanced. I'm not convinced the latter offers much more so let's concentrate on Basic. Make sure that the Zoom option in the bottom of the dialog is set to a minimum of 100%. It is also important that the Remove Jpeg Artifact option is ticked. There are four sliders:

- **Strength.** This is the setting that most significantly reduces the appearance of Noise, however the more you apply the softer the image will appear. A balance needs to be struck.

Step 3. The Advanced option in the Reduce Noise dialog offers two tabs, Overall and Per Channel. With the latter selected, you are able to apply the adjustment to each of the channels independently, a facility that may prove helpful.

Finished image (detail).
After processing, Noise has been all but eliminated.

36 REFLECTED WATER USING MOTION BLUR AND RIPPLE

How often have you discovered a fabulous location and just wished that there had been a pool of water nearby to reflect it? Alternatively, think of those many occasions when you have encountered a stretch of still water, but there has been nothing worth photographing nearby. Using Photoshop filters and a bit of imagination, you can have both.

Start image. This shot of an interesting building located by the coast somehow needs another feature. Had there been a large pool of water nearby, the reflection it would have created might have added interest. The solution is to create a reflection.

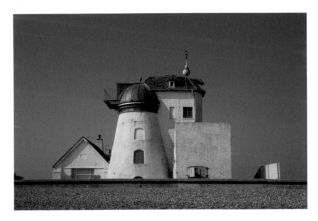

Step 2. Use the Move tool to position the 'Reflection' layer below the Background Layer, while pressing the Shift key. This should ensure perfect registration.

Step 1. Make a Duplicate Layer and call this new layer 'Reflection'. While this new layer is active, go to *Edit > Tranform > Flip Vertical*. The top layer will now appear upside down. In order to increase the working space, the Canvas Size needs to be extended below the existing file. Take a note of the depth of the current image and double this by going to *Image > Canvas Size*. Click the top centre anchor point and type in the increased depth required. In this example it was 14cm (5½in). Hit OK.

Step 3. With the 'Reflection' layer still active go to *Filter > Blur > Motion Blur*. Set the Angle to 0 to ensure that any movement remains horizontal. The Distance applied depends on the size of your file. Start off with 90. To create the ripple effect, go to *Filter > Distort > Ripple*, set the Size to Medium and use sufficient Amount to make the rippling effect visible. In this example I used 250.

Step 4. In order to create a bit of vertical movement, select the Motion Blur filter once again, but this time set the angle to 90 degrees and use a much smaller Distance; try between 5 and 15. This creates a better illusion of gently moving water.

the Move tool, it was positioned at the bottom of the composite to create the illusion that pebbles are visible through the shallow water.

Finished image. The great thing about this technique is that it can be applied in so many situations. Moreover, while I have opted to include the entire reflection in this example, there will be occasions when only part of it needs to be created.

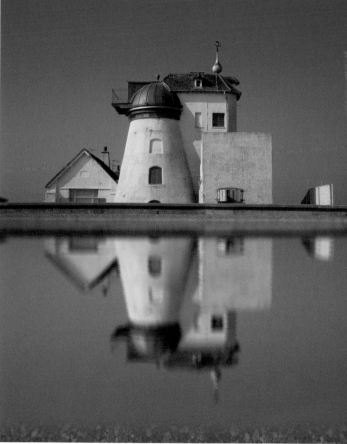

Step 5. When photographing a pool of water, usually you are standing on dry land. To create the illusion of the water nearest to the camera appearing shallow, with the 'Reflection' layer still active make a Layer Mask, then make a Gradient selection from the bottom upwards. Using the Eyedropper tool, take a sample colour from the pebble beach and then, with the Airbrush tool set to an Opacity of 25% and the Blending Mode set to Lighten, add colour. This gives the appearance that the water is becoming shallower.

Step 6. As a finishing touch, I made a small graduated selection of an image of pebbles, which had been photographed nearby. This became a new layer. Using

When trying this technique, start with a file that has a natural straight line. This will make the task of creating a reflection considerably easier.

tip

37 CREATING A GHOSTLY EFFECT USING RADIAL BLUR

The great appeal of using Photoshop's many filter options is that you can easily transform a relatively straightforward image into something truly creative. While it is often claimed that the camera can never lie, once you get an image into Photoshop your imagination can take over. With just a little know-how it should be possible to introduce into your picture making elements that transcend mere reality.

Start image. It is important to select an image that has the potential to look spooky or haunted. Taken in misty conditions, the weak sun hidden behind the trees could be easily interpreted as something more sinister.

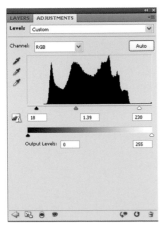

Step 1. In common with most images taken in these lighting conditions, this appears slightly flat and underexposed. First I made a Duplicate Layer, then an Adjustment Layer and selected Levels. In order to boost contrast I pulled both the Shadow and the Highlight sliders inwards and then lightened the midtones by moving the Gamma slider to the left (see Boosting Contrast Using Levels in Chapter 1).

Step 2. With the Duplicate Layer active, go to *Filter > Blur > Radial Blur*. In the Blur Method box, select Zoom. The processing takes time, but for the most dramatic results, opt for Best when selecting Quality. The focus of the Blur can be adjusted. While the dialog defaults to centre, it can be moved to either side. In this example I moved it to the right to sequence with the source of light.

Step 3. When filters are used, the effects are applied universally across the image, which is not what you always want. To overcome this, with the Duplicate Layer active, make a Layer Mask (*Layer > Layer Mask*) and, using a large soft Brush tool set to black, carefully paint in the areas you do not want to be affected by the filter by revealing the non-affected areas from the Background Layer.

Step 4. To emphasize the contrast between the blur and unaffected areas, only sharpen the unaffected areas. Activate the Background Layer, then go to *Filter > Sharpen > Unsharp Mask*. Try using an Amount of 70 and a Radius of 5. With the Background Layer selected, only the unblurred areas will be affected.

100 pixels and a selection was made in each of the two top corners. Using the Curves command, these areas were very slightly darkened (see Manipulating Contrast Using Curves in Chapter 1). Finally, to improve the overall aesthetics, the base of the image was cropped slightly, too (see Cropping in Chapter 4).

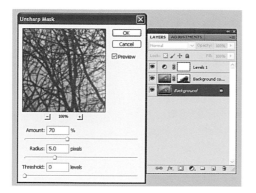

Step 5. To add to the sense of mystery in the image, a gentle vignette was added to the top corners. With the Duplicate Layer active, the Lasso tool was selected and then feathered by

Finished image. The ambiguous source of light and the swirling mist conjure a mysterious image. If overused, some filters appear tacky, but if used with care they can greatly improve the image.

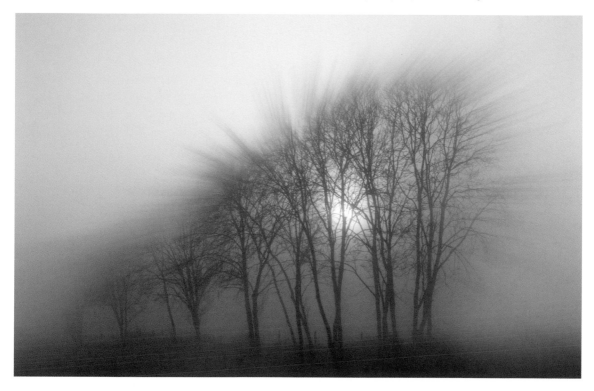

38 CREATING A RETRO COMIC-BOOK EFFECT

Photography can be fun and certainly creating a portrait in the style of a retro comic book shows its lighter side. Using just two standard Photoshop filters, a relatively mundane image can be transformed into something quite youthful, animated and zany. This technique can add life to the most boring portrait shot, something I'm sure most of us will have.

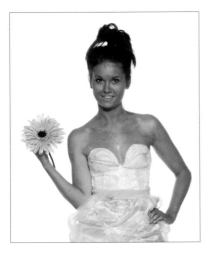

Start image. In order to make a feature of the comic-book pixilation of this technique, start with a low-resolution file; this might require severely cropping an image, or re-sizing with Resample to a smaller pixel size, which of course is entirely consistent with the comic-book style.

Step 1. First get rid of the white background and replace it with blue. To achieve this make a selection of the white background and then use the Paint Bucket tool set to light blue to fill in the selection. Don't worry if the selection is not perfect as this will be consistent with the effect you are after. It is also important to increase contrast; this is most easily done using Levels. Make an Adjustment Layer and pull in the Shadow slider to 15 and the Highlight slider to 220, while leaving the Gamma slider untouched.

Step 2. You now need to 'degrade' the image by introducing grain. With the Background Layer active, go to *Filter > Artistic > Film Grain*. In the dialog box, push the Grain slider to 5 and the Intensity slider to 10, while leaving the Highlight Intensity slider at zero.

Step 3. Make a Duplicate Layer and call it 'Retro Comic'. With this new layer active, some of the colour separation one commonly sees in comics can be introduced. To do this, go to *Filter > Pixelate > Color Halftone*. In the new dialog, set the Max Radius to 4, but leave the rest of the sliders at their default values. When you hit OK, the image will appear rather like a silk-screen print. To add just a bit more punch, apply Darken from the Blending Mode.

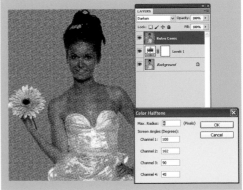

Step 4. Finally, a sequence of images in a comic are usually set within a white frame. To achieve the 'retro' look, this needs to be aged a little: select the 'Retro Comic' layer, then go to *Layer > Layer Style > Stroke* (this sequence will vary depending on the Photoshop edition you are using). A dialog will appear. Within the Structure box at the top, select 20 pixels and a Position option 'Inside'. To create an antique faded white colour, try Red 245, Green 235, and Blue 225. Hit OK.

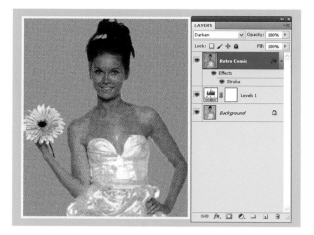

Step 5. Usually when I am trying to achieve a high-quality image, I am reluctant to use the Shadows/Highlights command for fear of introducing grain, but in this situation, that is precisely what I want to achieve. Make an Adjustment Layer and select Shadows/Highlights. By positively using the Shadows slider, not only are the darker tones opened up but an obvious tonal degrading is introduced, consistent with this technique.

Finished image. It does seem odd to deliberately 'degrade' an image, but sometimes it works. Using a youthful portrait has certainly helped, and despite the severity of the technique, her natural beauty still shines through.

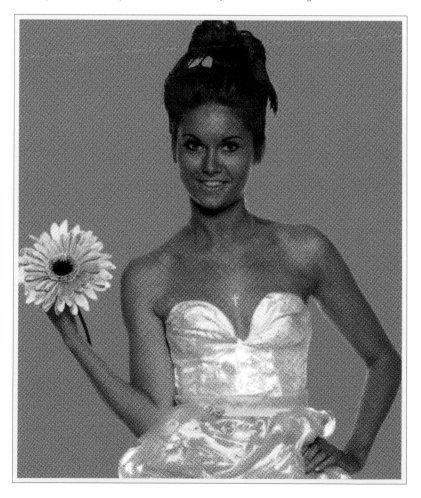

39 ACHIEVING THE POP ART LOOK

As photographers, we should be prepared to be influenced by all aspects of the visual arts, including painting. The Pop Artists of the 1960s were particularly iconic, and had themselves been heavily influenced by photography. It therefore seems appropriate that photographers now look at what they achieved and assimilate it into their own work.

Start image. The legendary Pop Artist Andy Warhol always featured visually powerful figures when producing his wonderfully iconic posters, so if you are going to try out this technique, select a portrait with plenty of attitude. Your start image should be clear-cut and simple. In this example, I was attracted by the iconic sense of dress, which lends itself particularly well to this sort of treatment.

Step 1. While the white background offers simplicity, it might prove a distraction later in the process, so the first task was to change it. A selection was made using the Magic Wand tool; there was no need to be too precise as any imperfections would be easily lost later in the process. This was replaced with a 'comic book' blue sky. If you don't have a suitable file, change the Foreground Color to blue, then use the Paint Bucket tool to fill in the white areas.

Step 2. Make a Duplicate Layer, then go to *Filter > Sketch* and select Halftone Pattern. For best contrast, make sure the Foreground Color is set to black. You may need to experiment at this stage, but it is pointless being timid or half-hearted. I selected Size 8 and Contrast 25 but this, of course, will be

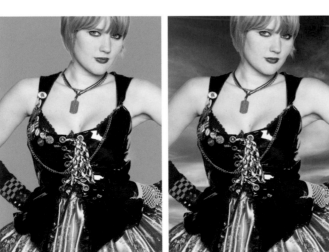

partly governed by the file size you are starting with. Make sure Dot is selected in the Pattern Type. Hit OK.

Step 3. With the Background Layer active, go to *Filter > Artistic > Cutout*. Once again it is a matter of experimenting, but a good starting point is Number of Levels 7, and Edge Simplicity 3. Keep the Edge Fidelity low as it has little to contribute. Hit OK and see what happens. Sometimes the colour distribution can appear a little strange, particularly in the area of the face; if so, then reduce Number of Levels.

Finished image. It is important that you appreciate what you are trying to achieve. While images such as this should never be compared with a finely crafted traditional portrait, it does nevertheless convey a youthful vibrancy consistent with the subject.

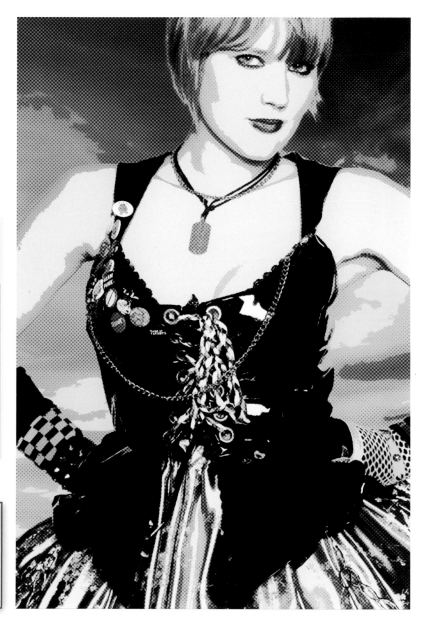

Images such as this often make excellent posters, or can be presented as a canvas print.

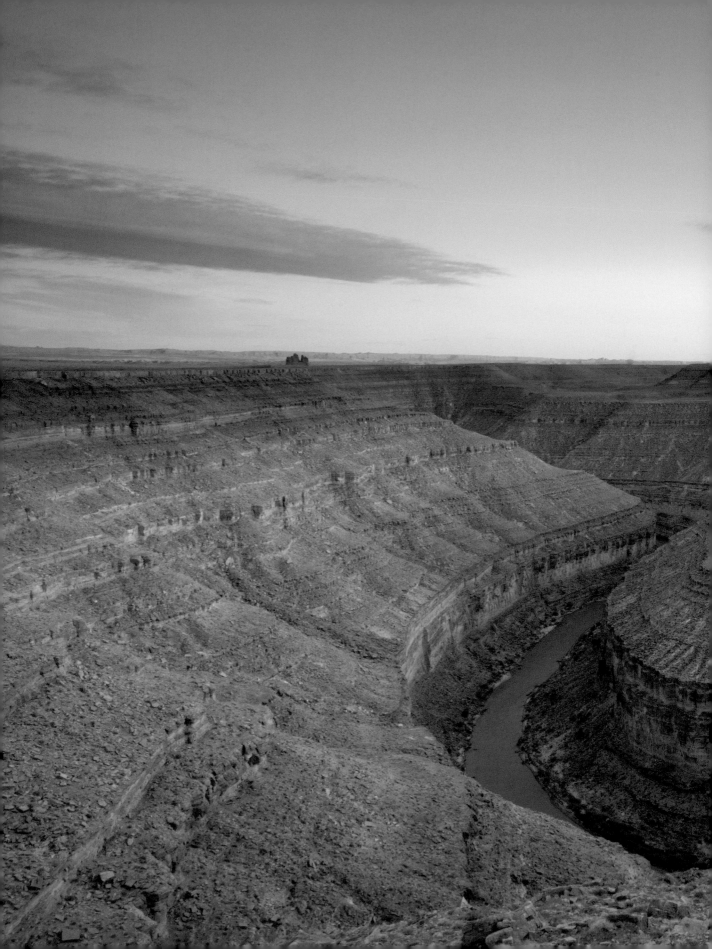

CHAPTER 4: FURTHER IMAGE MANIPULATION

Improving the image is not just about making colour or tonal changes; sometimes just a simple crop or a slight adjustment of the horizon is all that is required. You may decide to be more adventurous and present your image as a panorama. This chapter will guide you through these various techniques.

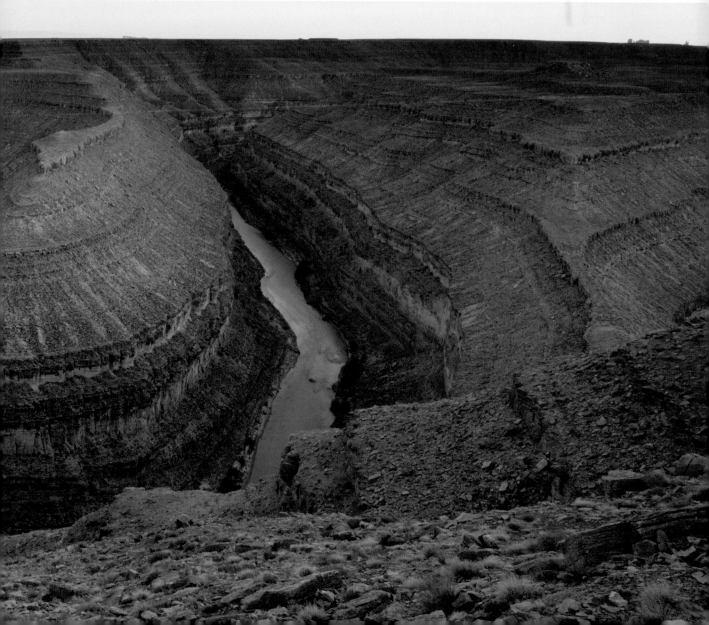

40 CROPPING

Don't always assume that you need to do something radical or complicated to improve your image; applying a simple technique such as cropping is often all that is required. The Crop tool is one of the most frequently used tools by Photoshop users, but not all fully appreciate its other uses. Not only does it allow you to trim your image, but it also allows you to resize, rotate and even distort your image should you wish to do so.

Start image. Capturing the excitement of the funfair requires that you respond quickly. However only after I had time to edit this image, did I appreciate that the young girl on the extreme right is looking out of the picture. Moreover, from a compositional standpoint, odd numbers such as 3 or 5 work better than even numbers. Cropping out the sixth figure should help.

tip

The main purpose of cropping is to improve the composition and while most cameras have adopted a rectangular format, the square can prove more suitable for some subjects. The square is viewed as a static shape, which suggests permanence and wholeness, and works well with landscapes.

Trimming your image. Select the Crop tool (or press C), then drag the cursor to define the area you wish to select. A dark overlay will indicate the area you have chosen to be cropped. The selection can be refined by selecting and dragging any of the bounding boxes. If you decide you do not want to proceed with the crop, press Esc.

Correcting perspective. While there are methods for achieving the same task (notably Transform), the Crop tool will allow you to correct slight perspective distortions. Make sure that the Perspective option is ticked. In this example, the white bar at the top of the picture is sloping down to the right. Moreover, the vertical structures directly behind the girls appear to converge. By dragging the top left bounding box and then pulling both the top left and top right bounding boxes inwards, these distortions can be corrected.

Finished image. Cropped and the converging verticals corrected, all done with a simple application of the Crop tool.

FURTHER USEFUL FEATURES OF THE CROP TOOL

- **The Crop Guide Overlay.** Cropping is largely done to improve the aesthetics of the image. By using the crop guide overlay (found in the Menu bar), you can select either a Grid or a Rule of Thirds guide, which will help you make a more informed crop. The Rule of Thirds guide can prove particularly useful as it helps you place compositional elements on the one-third intersections.
- **The Tool Preset Picker.** If you select this option it will show you a list of preloaded Crop tool presets. This might be useful if you wanted to ensure a

sequence of images were all the same size, perhaps for a 'joiner' you are planning.

- **Rotating the Canvas.** Once you have made your selection using the Crop tool, if you wish to rotate the image to correct an uneven horizon for example, allow the cursor to hover over one of the corner bounding boxes and it will change to a curved arrow. Click on the box and rotate the image until the correction is made. Once it looks straight, OK the crop.

41 REMOVING INTRUSIVE ELEMENTS USING CONTENTS AWARE

You are about to take the perfect landscape then notice a twig appearing in frame. You try a different angle, but somehow the strength of the composition is lost. How often have you waited for the perfect light only to have a figure walk into frame? By the time they have disappeared, so has the light. These problems can be solved using Contents Aware (Photoshop CS5 and beyond), which fills in areas that have been removed, matching texture, tone, colour and content detail.

Start image. This is the classic situation where, rather frustratingly, three separate figures appear within frame just as the light really starts to get interesting. This of course is a common problem with any well-known landscape location.

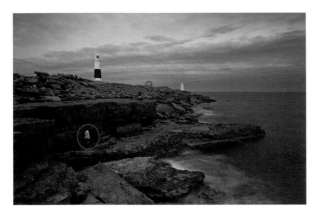

matched background… but not always. Occasionally you may need to make a slightly different selection to achieve a perfect match.

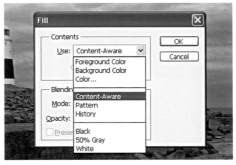

Finished image. It is important that you carefully check the replaced detail; normally the Contents Aware facility does a good job, but not always. You may need to make several attempts. Tidy up any remaining areas using the Clone tool.

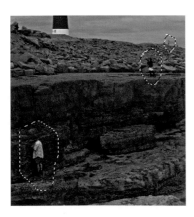

Step 1. Start by making a Duplicate Layer. Using the Lasso tool, draw round the parts of the image you wish to remove.

Step 2. Press the Delete button and the Fill dialog will appear (alternatively go to *Edit > Fill* or hit Shift F5). Click the Use drop-down and select Content-Aware – as if by magic, the offending intrusion will usually disappear to be replaced by a perfectly

42 REMOVING INTRUSIVE ELEMENTS MANUALLY

If your version of Photoshop does not have the Contents Aware facility, many difficult problems can be dealt with manually, by using *Edit > Copy / Edit > Paste*. What you are effectively doing is selecting and copying part of the image and using it as a patch over the area you wish to cover.

Start image. Often when concentrating on the image, we fail to notice small but annoying details; in this case, I failed to see the ladder on the left of this abandoned pier. To remove it, it is simply a matter of finding a matching area that can suitably be used to replace it.

Step 1. Using the Polygonal Lasso tool, feathered by 2 pixels, I selected an area of beach immediately to the left of the ladder and made a copy by going to *Edit > Copy*. I then created a second Layer by going to *Edit > Paste*. The 'marching ants' disappear, but if you look in the Layers palette, a new layer has been created.

Step 2. With the new layer active, I used the Move tool to position this selection carefully over the ladder. Part of the selection intruded over one of the pier stanchions, so another smaller selection was made using the Polygonal Lasso tool and the excess was removed using the Eraser tool. The two layers were then flattened.

Finished image. Essentially what I have done manually is the same as if I had used Contents Aware. I identified an area with the same tone, colour, texture and content as the part to be replaced, copied it, and moved it into place. Sometimes the tone might be slightly different, but as this new layer remains independent of the Background Layer, slight adjustments can be made to ensure a perfect match is achieved.

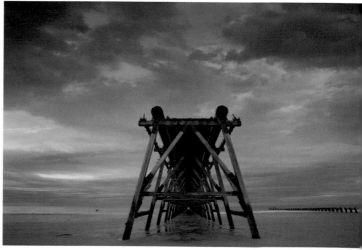

43 REMOVING INTRUSIVE ELEMENTS USING THE CLONE TOOL

It is sometimes easy to forget just how many advantages working digitally has, compared to using film. It would not be an exaggeration to suggest that photographers are now taking photographs we would never have considered before digital. Discouraged by possible intrusions, our initial response was to give up, but having the Clone tool available, we are considerably less cautious.

Start image. This is a typical situation where in the past I might have given the shot a miss. Photographed in the summer, there is a flotilla of boats littering this image, which is proving to be quite a distraction. The real frustration is that so many of the boats are adjacent to the structures. I took the image, nevertheless, safe in the knowledge that this can be rescued using the Clone tool.

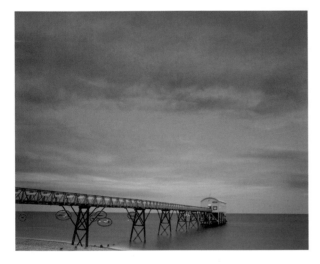

Step 1. When cloning, it always helps to work on a separate layer, so click on the New Layer icon at the bottom of the Layers palette and give it a name 'Clone'. The process of cloning can involve using a variety of tools, each with their own unique qualities.

Step 2. With the Clone layer active, start by removing those parts of the image that are not adjacent to the structure of the pier, by using the Spot Healing Brush tool. Make sure that the Sample All Layers box is ticked. If there is an element very close to a structure you wish to retain, make a selection that excludes the part you wish to remain unaffected, and then apply the Healing Brush tool.

Step 3. Another option is to use the Clone Stamp tool. Make sure that Current and Below is selected from the Options bar at the top of the screen and that Sample All Layers is

 99

ticked. Once again, if you are working close to an area you wish to be unaffected by the cloning, add a protective selection. Select a small soft Brush, click to establish a source and then remove the distracting boats.

Step 4. Cloning is a demanding skill and you will quickly appreciate the value of using a New Layer, which can be easily removed, should you make a mess of it and wish to start again. If you make a small mistake, either go to *Edit > Step Backward*, or select the Eraser tool and delete the mistake. Once you have completed your cloning, flatten and save in the usual way.

tip

By opening the Clone Source panel (found in the Menu bar at the top of the screen), you are able to rotate the Clone Stamp relative to the Source. It also gives you access to the Clone Overlay, which is a great help in aligning when cloning.

Finished image. Having cloned out all the small boats, the simplicity of this image becomes more evident.

44 CORRECTING SLOPING HORIZONS

In the excitement of grabbing the shot, or possibly thinking about the composition, it is very easy to end up with a sloping horizon; in fact if you are handholding your camera, it is virtually impossible to get right. I have made this mistake even when using a tripod. A crooked horizon is possibly the single most common error, particularly when shooting landscapes, so it is important to know how to correct it. There are several methods for achieving this.

Start image 1. This is a typical mistake we can all make. Captivated by the beauty of the scene and its ever-changing light, I was not aware that the horizon was sloping. Sometimes it is not that obvious even on the camera monitor. It wasn't until I got it onto the screen that I appreciated how bad it was.

Method 1: the Ruler tool. The simplest way to correct this is by using the Ruler tool. It appears in different parts of the Tools menu, but in more recent editions of Photoshop, it can be found hidden under the Eyedropper. It also helps to open the Info palette (*Window > Info*, or press F8). Click and drag the cursor along the horizon. This will create a white line. If you refer to the Info palette, the angle of the line will be displayed adjacent to 'A' in the top right of the palette. In this example it reads 3.3 degrees. This gives you a measure of the extent of the slope. To correct this, go to *Image > Rotate Canvas > Arbitrary*. A reading will appear in the Angle box. With the image corrected, colour wedges will appear around the borders of the image.

This is governed by the Background Color. Don't immediately crop them as you might lose critical edge detail. Providing your file is not too large, make a selection of each of the wedges in turn and apply Contents Aware (see Removing Intrusive Elements Using Contents Aware). This should fully reconstruct the edge detail.

Method 2: *Transform > Rotate.* A simple alternative to this is to use the Transform command. With the Layer you wish to work with active, go to *Edit > Transform > Rotate*, then click on one of the outside bounding boxes and carefully rotate the image. Use a Grid (*View > Show Grid*) to guide you. If you are working with just a single layer, then you will need to select it by going to *Select > All*, before accessing Transform. Make a selection of the white wedges using the Magic Wand tool and then select Contents Aware.

Finished image. This image has been substantially improved simply by straightening the horizon. Using Contents Aware, all the edge detail has been retained.

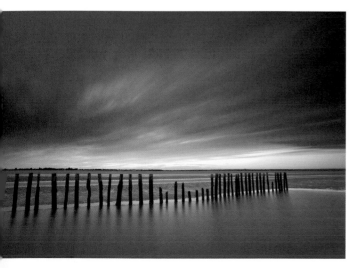

Method 3: *Transform > Skew.*
Start image. Sometimes it is not the entire image that appears crooked but just part of it. In this example, because of the angle I took the shot, while the bottom is straight, the buildings at the top appear to slope to the right.

Method. This can be remedied by going to *Edit > Transform > Skew*. Apply the Grid as a guide as this application will need to be done by eye. In this example, I selected the anchor in the top right corner and gently pulled it upwards until the roof of the buildings appeared horizontal. Double click inside the image and the task is completed.

Finished image. By using Transform, a rather unattractive slope has been corrected.

45 CORRECTING CONVERGING VERTICALS USING TRANSFORM

No matter how carefully we try to compose our images, there are frequently occasions when parts appear crooked; this is particularly noticeable when shooting architecture. The moment the camera is pointed upwards or downwards, a distortion called converging verticals (where the vertical lines appear to get closer together) will occur. This can create an unsettling effect. The best way to overcome this problem is to use Transform in Photoshop.

THE TRANSFORM MENU

Within the Transform menu there are six different options:

- **Scale.** This allows you to resize the image, by clicking and pulling one of the corner anchors. If you wish to retain the same proportions, depress Shift as you do this.
- **Rotate.** This allows you to make small rotational adjustments by clicking one of the corner bounding boxes and moving it with the cursor. It is one method you can use to correct a sloping horizon. There are further options at the bottom of the Transform menu that can be used if a 90 degree or a 180 degree rotation is required.
- **Skew.** This is possibly one of the most flexible commands within this menu, as you are able to apply adjustments to different parts of the image, by selecting various different anchors. It is probably the best one to use when correcting architectural distortions.

- **Distort.** Sometimes referred to as the 'stretching tool', this allows you to pull the image in any direction you require. Hold down Alt if you want the distortion to appear symmetrical.
- **Perspective.** From a visual standpoint, this has the effect of changing the focal length. By clicking and dragging one of the corner bounding boxes, you are effectively dragging the image closer to you as if you were zooming from a wide-angle to a long-angle lens. It is one method for overcoming converging verticals, but the process is fairly destructive.
- **Warp.** Very much a fun option; apply this and your image will be divided into nine sectors, each of which can be manipulated independently of the others. It works well with images that have no apparent straight lines, but is less appropriate when dealing with architectural shots. The results achieved are not dissimilar to the Liquify filter.

Start image. This is typical of the distortions many of us encounter when photographing an interior. In order to capture the imposing vaulted arches, I needed to point my camera upwards, resulting in the verticals appearing to converge. This effect has been exaggerated because I used a wide-angle lens.

Only attempt this technique if the verticals are slightly converging; correcting extremely converging verticals creates its own problematic distortions.

tip

Step 1. Using Transform is a 'destructive' process, so make sure that you work on a Duplicate Layer. To help guide your corrections, activate *View > Show Grid*. The default grid is not always suitable for all situations, so if you wish to change it go to *Edit > Preferences > Guides > Grid and Slices* and make your required changes in the Gridline Every and the Subdivisions boxes.

Step 2. With the Duplicate Layer active, go to *Edit > Transform*. Of the various options (see The Transform Menu box), I decided to use Skew. I clicked on the top right bounding box first and carefully dragged it outwards while at the same time comparing the corrected verticals with the grid. I then selected the top left bounding box and repeated the process. This can dislodge the first adjustment and there will be a need for some fine-tuning. When both sides are truly vertical, double click to activate Transform.

Finished image. Architectural interiors are always hard to photograph if you don't use a tripod. The distortion one encounters can easily be remedied by using one of the Transform options. To tidy up the image and present something more symmetrical, I used the Crop tool to remove part of the image on the left, and then balanced the image slightly by removing a small section from the top (see Cropping).

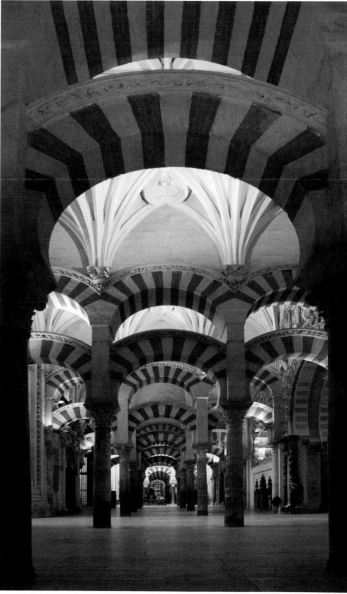

46 SHARPENING THE IMAGE

While sharpening your image might not appear to alter the appearance of your picture on screen, the benefits will become apparent when printing. All files are inherently soft and require some measure of sharpening, and while most DSLRs offer the option of sharpening in-camera (though this never applies to Raw files), it is something I suggest you resist. The sharpening is applied universally rather than selectively and cannot be reversed. By sharpening in Photoshop, you always have the option of working on a Duplicate Layer or creating a Smart Object.

THE SHARPENING PROCESS

The entire issue of sharpening and when to sharpen is complicated, but essentially there are three stages:

1. Sharpening from capture. This can be achieved using ACR (the Raw Converter). It is not recommended that you sharpen in both ACR and later in Photoshop, as this can lead to over-sharpening.

2. Creative sharpening. This refers to sharpening part of the image for artistic effect, for example the eyelashes of a model in a portrait. This is done when the image is opened in Photoshop. Photoshop offers various excellent sharpening facilities, which

are outlined in this workshop, however a very useful plug-in you may wish to consider is Photokit Sharpener by Pixel Genius, which can be downloaded from www.pixelgenius.com. The advantage of this is that it allows you to create editable layers.

3. Sharpening for printing. Whether you decide to sharpen from capture, or apply a creative sharpening technique, there is a need to size the image for outcome depending on the print size you require. Essentially this means that if you intend to print at three different sizes, then you will need to create three separate sharpened files specific to each size.

Method 1: Unsharp Mask. Photoshop offers various image-sharpening options; possibly the most popular of these is Unsharp Mask. To open this, go to *Filter > Sharpen > Unsharp Mask*. The dialog comprises three sliders: Amount, Radius and Threshold. Unsharp Mask works by increasing the contrast at the edges, however it is a process that can be overdone. Essentially, a 'halo' is produced between any light and dark edge, which becomes increasingly apparent the more it is applied. Use the Amount slider to control this.

- There is a certain measure of subjectivity when applying Unsharp Mask, although the general rule of thumb is to increase the level of Amount depending on the level of detail; the finer the detail, the more Amount is needed, and this can span anything from 100 to 400%.
- The Radius slider is used to determine the size of the sharpening halo. Only ever apply a small element of

Radius; the more Amount you apply, the less Radius should be added. Operate anywhere between 0.5 and 2.5 pixels.

- Threshold governs how far the halo spreads into areas of flat colour. For most purposes, leave the Threshold at 0; use it if the image appears too grainy, and only to a maximum of between 1 and 2 levels.

Method 2: Smart Sharpen. This option is available on all versions of CS2 and beyond. Go to *Filter > Sharpen > Smart Sharpen*. The two sliders Amount and Radius should be applied in the same way as in Unsharp Mask, however there are further options in the Remove menu. Gaussian is very similar to Unsharp Mask, while Lens Blur should be applied when fine detail is required. The third option, Motion Blur, has been added to remove camera shake. By selecting the Advanced mode, further options are added, namely Shadow and Highlight. Of these, the Shadow option is possibly the most useful. The appearance of Noise is always most apparent in the shadows and increases as the image is sharpened; this option counters this.

Method 3: Smart Filter. With the introduction of Smart Filters in CS3, many processes that initially could not be applied non-destructively can now be, by converting the active layer to a Smart Object. This is achieved by selecting the active layer and choosing Convert to Smart Object. As this becomes an independent layer, Smart Sharpen, Unsharp Mask or any other process can now be applied non-destructively. Better still, by making the Sharp Layers active (the white box just below the Background Copy in the Layers palette), the effects of the sharpening can be applied selectively by using a large soft Brush tool set to black, to paint in areas that you want to remain unsharpened.

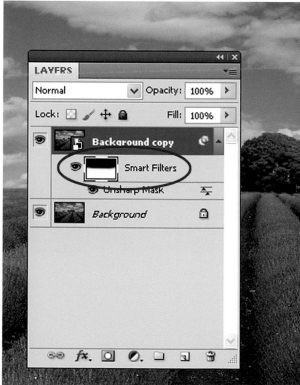

Method 4: High Pass Sharpening. Another excellent method for sharpening an image non-destructively is to apply High Pass sharpening**.** Make a Duplicate Layer, and with this new layer active, apply Overlay in the Blending Mode, which will appear to increase the contrast. Go to *Filter > Other > High Pass* (which brings the contrast back to normal) and then use the Radius slider to determine a setting that best suits the image. Once the High Pass filter has been applied, you can use the Opacity slider to reduce its overall effect. Once again, if you want the sharpening effect to be applied selectively, make a Layer Mask, select a soft large Brush tool set to black, and paint over those areas of sharpness you wish to see removed. In the illustrated example, it was the sky.

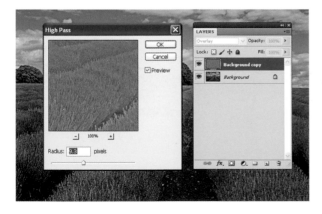

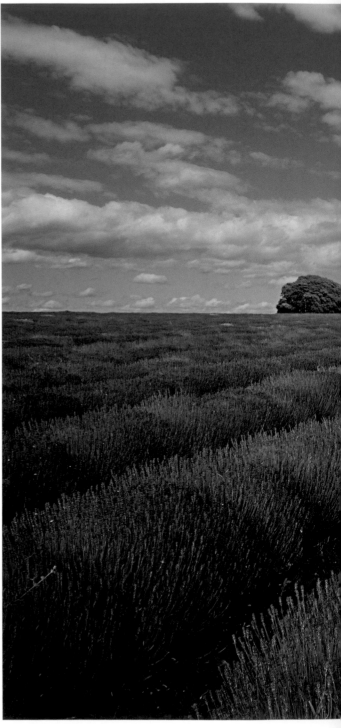

Finished image. A little more fiddly than some others, but my preferred option is to use the High Pass sharpening method. Being able to use it selectively has many advantages. In this example, only the lavender and the trees in the middle distance have been sharpened.

47 CONSTRUCTING PANORAMAS

Panoramic images are proving very popular, largely because many of us recognize this is a format that mirrors the way we look at the world. This is particularly so when viewing a new environment for the first time; awe-struck, we tend to survey the horizon. Perhaps as an acknowledgment of its growing popularity, some cameras now come with a 'stitching' facility built in, although this process is often done far more effectively in Photoshop.

Start images 1–3. Taken in my local barber shop, I mounted the camera on a tripod with a swivel head. It also has a built-in spirit level so that I could guarantee that each of the files was perfectly horizontal. I ensured that each image overlapped by at least 25 per cent. In order to make sure that the illumination was consistent, I bounced light off the ceiling using a handheld flashgun. It helps if each of the files is shadowless.

tip

Store all the required images in the same folder. Ideally, access your images using Bridge as this allows you to use your Raw files. It helps to reduce the size your images prior to stitching, otherwise the final composite might prove very large indeed.

Step 1. Go to *File > Automate > Photomerge*. Select Browse within the Photomerge dialog, hold down the Shift key and select all the images you wish to work with. On the left side of the window are the layout options, which allow you to align the files together in different ways. The Auto option usually works well in most situations, but if you find that you are not satisfied with your first attempt, consider using either the Perspective, Cylindrical or Spherical options. You are also able to create quite sophisticated collages or deal with files that need repositioning, but those options are not required here.

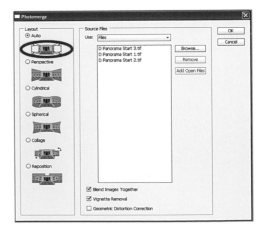

Step 2. Ensure that the Blend Images Together box is ticked; this ensures that the colours and tones remain consistent throughout the new file. It also helps to tick the Vignette Removal option, particularly if the corners have darkened slightly. It is unlikely that you need to select the last option, Geometric Distortion Correction. Once you have made all the required selections, click OK.

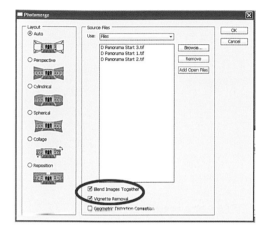

Step 3. When the 'stitching' process is complete, there will inevitably be some irregularities at the edges that need further attention. The immediate instinct is to crop, but that might well compromise the overall design. Flatten the image and if your version

of Photoshop has Contents Aware, use it to reconstruct the missing parts (see Removing Intrusive Elements Using Contents Aware). If you do not have this option, try one of the various Clone tools (see Removing Intrusive Elements Using the Clone Tool). Often when stitching buildings or interiors together, there will be some distortions. This can be partly remedied by using *Transform > Skew*. Sometimes this task is most effectively done before flattening the image so that each of the layers can be adjusted in turn.

Finished image. There is something quite special about a panoramic image because it encourages you to examine it with great care. It creates a visual narrative that tells us so much more about the subject. Moreover, with this style of work you can never entirely predict what you will capture; there is bound to be an element of serendipity. As each of the files was taken moments apart, I had no idea that the white van outside the shop would pass as I took that shot.

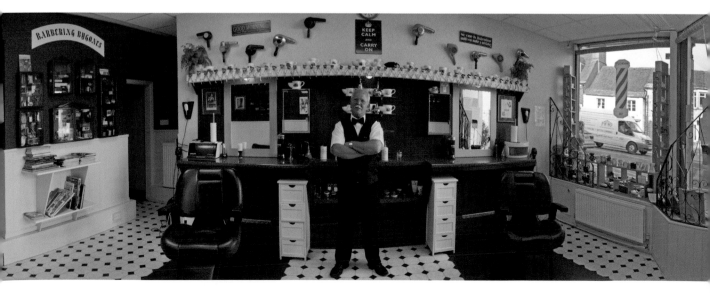

48 MAKING ADJUSTMENTS USING ADOBE CAMERA RAW

Having focused largely on Photoshop, it is appropriate to consider the Raw Converter, which is capable of achieving many of the functions of Photoshop. The value of shooting Raw cannot be overestimated. Unlike a JPEG, a Raw file involves no compression and is capable of delivering a better colour and tonal range. But there is another advantage; you can make changes non-destructively, so you can reverse any processes without degrading the image in any way.

NAVIGATING THE CAMERA RAW INTERFACE

Unlike JPEG and TIFF, Raw files are not generic; it is merely a term to describe the data that is captured directly from the camera's sensor, which varies depending on the make of camera you are using. In order to be able to process a Raw file, you need to use a Raw Converter. Whether you are using the Photoshop version of the Raw Converter or one that is camera specific and downloaded from Adobe, the interface is reasonably generic. Many experienced Photoshop users make as many changes as they can using the Raw Converter, but then proceed to use Photoshop when more specific tasks are required. When using Photoshop, Raw files are accessed by using Bridge; go to *File > Browse in Bridge*.

BASIC COLOUR AND TONAL CONTROLS

White Balance. When shooting in most situations, I tend to use the camera's automated white balance (AWB) facility, which normally proves very accurate. Just occasionally it gets it wrong, which is where this function can prove so useful. By scrolling the White Balance presets, a variety of options will become available. Some, such as Daylight or Cloudy, make very little difference to the As Shot option, but where mistakes are most likely to occur is when shooting under tungsten or fluorescent lighting. You have the option of using the Temperature and Tint sliders instead to create your own custom white balance, or using the Eyedropper and selecting a known neutral grey tone.

Exposure. Possibly the most used of all the sliders in ACR, this allows you to incrementally lighten or darken the image. As you move the slider to the right it gets lighter, while moving it to the left darkens it. Exposure governs where the lightest pixels will clip. All the tonal values relative to this new white point will be adjusted.

Blacks. This option works as a counter to Fill Light and has the capacity to darken shadow detail. If you use it, do so sparingly. Once again it is important that you check the histogram when using this slider.

Recovery. This is an absolute gem of a tool. The golden rule when shooting Raw is to overexpose slightly but in some circumstances, this can lead to blown highlights. When you open your Raw file, areas of overexposure are clearly illustrated in the preview window as red. By dragging the slider to the right, the blown highlights will incrementally decrease.

Brightness/Contrast. Used in conjunction, these two sliders play a similar role to the Brightness/Contrast command in Photoshop. The tonal balance of the image is possibly better achieved by using the Exposure slider.

Fill Light. This slider recovers detail in the midtones; it achieves this without detrimentally affecting shadow detail. As you move this slider, watch what it does to the histogram at the top of the dialog. Be careful when using this option, as it can leave your image looking a tad flat.

Clarity. The role of this tool is sometimes confusing, largely because when you adjust the slider, little seems to happen. It mainly affects the midtones, by increasing local contrast, playing a role not unlike the Midtone Contrast slider in Photoshop's Shadows/ Highlights command. In order to put this option to best use, incrementally increase the setting until a faint halo appears near the edge detail and then reduce it.

Vibrance. This is a particularly useful slider, as it allows you to increase the saturation of all lower saturated areas without affecting higher saturated colours.

Saturation. This functions in a very similar way to Saturation in Photoshop's Hue/Saturation command. Essentially you are able to adjust the saturation across the entire image from -100, monochrome to +100, double colour saturation.

ADVANCED COLOUR CHANGES

HSL/Grayscale. While this facility allows you to make selective colour changes, its primary use is as a means of converting a colour image to black and white. Under the HSL/Grayscale tab is the Convert to Grayscale tick-box. With this selected the image converts to grayscale. This allows you to create a black-and-white image from a colour file. With the image in grayscale mode, you are able to control the tonal values by adjusting the Channel sliders. It is important to appreciate that when you open your file into Photoshop, it will remain as a grayscale file and therefore certain commands will be unavailable unless you convert it back to RGB.

NOISE REDUCTION AND SHARPENING

Noise Reduction. The Raw Converter has two sliders for NR, Luminance and Color. Each addresses a different type of Noise. Luminance deals with grayscale noise, i.e., the noise that makes the image look 'grainy'. The Color slider addresses the problem of Chroma noise. In Camera Raw, the Color slider defaults to 25, so some colour Noise reduction is automatically applied. One rarely needs to add more.

Sharpening. Linked with Noise Reduction is a Sharpening facility. If you intend to do all your sharpening in Photoshop, then turn off the small amount of default sharpening in Raw, otherwise you risk the image becoming over-sharpened.

Split toning. While you can make interesting colour adjustments with the image in RGB, this facility is far more effective when used with a grayscale image. The tradition of split toning emanates from the darkroom where two distinctively different toners were used on the same print. If you wish to give this a go, retain the Balance slider at zero. Select a Hue you wish to use in the highlights and drag the Highlights Saturation slider to the right. To counter that hue, select one for the shadows and

drag the Shadows Saturation slider until some measure of balance between the two separate hues is achieved. If you do not have access to Photoshop, then this is a useful method for achieving a split-toned image, but better results can be achieved in Photoshop (see Sepia Toning in Chapter 2).

LENS CORRECTION

This offers three functions: Transform, Chromatic Aberration and Lens Vignetting. These are designed to overcome problems created by possible lens defects. The most likely of these is Chromatic Aberration. This results in fringes of colour appearing at the edges of objects in a photograph due to the inability of the camera lens to deal with all wavelengths of light equally. To overcome this, set the Zoom level to 200% and identify the colour of the fringing. Then using the Fix Red/Cyan Fringe or the Fix Blue/Yellow Fringe sliders, this can easily be removed.

The Lens Vignetting slider can be used when there is an apparent fall-off of light in the corners due to a lens aberration, although with the ever-improving standard of lens manufacture, this is not a common problem. If it does occur, carefully drag the Amount slider to the right. Generally this option is used to increase the appearance of vignetting for purely aesthetic purposes. This is achieved by dragging both the Amount and Midpoint sliders to the left.

Chromatic Aberration	
Fix Red/Cyan Fringe	0
Fix Blue/Yellow Fringe	0
Defringe:	Off

Lens Vignetting	
Amount	0
Midpoint	

THE ACR COMMANDS

In common with Photoshop, the Adobe Camera Raw interface features several useful commands.

R: ---
G: ---
B: ---

f/16 0.50 s
ISO 400 24-105@35 mm

Basic

Toolbar. This includes a Zoom tool, White Balance tool, Hand tool and Crop tool. The most recent versions of Photoshop also contain a Graduated filter, which allows adjustments to be made incrementally (see Using Gradient and Quick Mask in Chapter 1).

Histogram. This should always be referred to when making any colour or tonal changes.

Info palette. Once again very similar to the Info palette in Photoshop, this gives you detailed pixel readings for each of the colour channels. It also provides all the camera details concerning the ISO rating, shutter speed and aperture used.

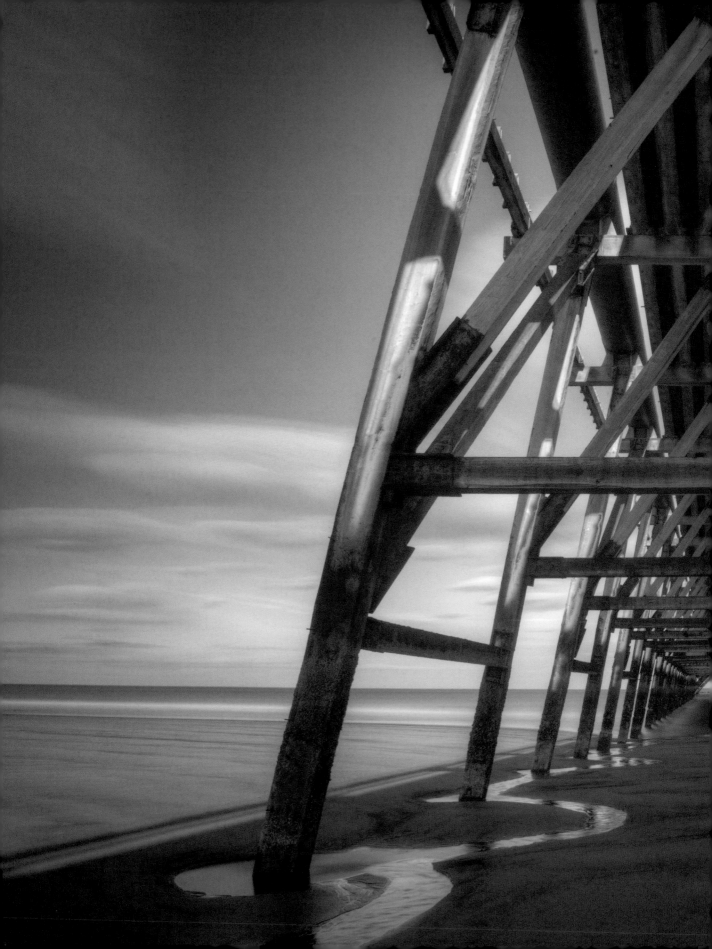

CHAPTER 5: RETRO PHOTOGRAPHY

Because of its many advantages, photographers around the world are enthusiastically embracing the digital revolution, but as a consequence many quirky but interesting traditions are in danger of being forgotten. Ironically, Photoshop allows us to access these wonderful techniques, which many of us were reluctant to try when using film. All that is required is a bit of know-how and a sense of fun.

49 CREATING A PINHOLE CAMERA DIGITALLY

A tradition that is enjoying something of a renaissance is the pinhole camera, which really does explore the simplest elements of photography. Working digitally this can be done in one of two ways. You can either convert your camera to a pinhole camera, or you can replicate the effects of a pinhole camera in Photoshop.

USING YOUR DSLR AS A PINHOLE CAMERA

The principle of the pin box is a very simple one insofar as the lens is replaced by a lightproof screen with a small pinhole, which serves as a constant aperture. There are various ways of achieving this, but possibly the simplest is to use the camera's lens cap. Start by drilling a small hole into the middle of the lens cap; clean the edges as carefully as you can. The hole is still likely to prove too large, so tape a piece of aluminium foil on the inside of the lens cap and then make a small hole in the centre using a pin. It is important that you get this dead centre. There is of course no need to focus as the effective aperture setting is very small indeed. Getting a correct light reading will be a matter of trial and error, but that is part of the fun.

Start image. Because of the very small aperture of a pinhole camera, the exposures are lengthy, so start with an image that required a longer than normal exposure. The effect in this image was achieved by using a neutral density filter.

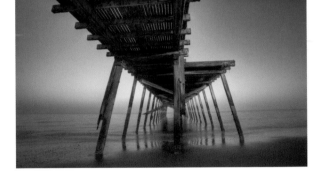

Step 1. Open the file and make a Duplicate Layer. When using long exposures on colour film the colours were often distorted as a result of reciprocity failure, so this needs to be mimicked digitally. To do this, make an Adjustment Layer, select Curves, and then select Cross Processing from the Curves drop-down menu. Reduce the effect by applying 30% Opacity.

Step 2. The tiny apertures used on a pinhole often create distortions similar to an ultra wide-angle lens, resulting in the distortion of vertical lines. This is easily mimicked; with the Duplicate Layer active, go to *Filter > Distort > Twirl*, but apply an angle of no more than 5 degrees.

Step 3. Another defining characteristic of the pinhole effect is the softness, particularly at the edges. This can be achieved by going to *Filter > Distort > Diffuse Glow*. Start with Graininess 8, Glow Amount 10 and Clear 16. Once applied, reduce the Opacity to 50%. In order to restrict the glow just to the periphery, make a Layer Mask, select a soft large Brush tool set to black, and remove the effects of this filter from the centre of the image.

Step 5. I made one further Adjustment Layer, selected Curves, but this time slightly lightened the image (see Manipulating Contrast Using Curves in Chapter 1). As a final touch, and with the Duplicate Layer active, I introduced a small amount of Noise by going to *Filter > Noise > Add Noise*; just 10% was added.

Step 4. Another characteristic of a pinhole image is the vignetting. To achieve this, select the Elliptical Marquee tool and draw a large circle in the centre of the image, hold down Shift to force a circle and feather by 250 pixels. Inverse the selection, make an Adjustment Layer, select Curves and pull the curve downwards to incrementally darken the corners.

Finished image. There is a strange beauty about images taken with a pinhole camera, although the distinctive characteristic of this wonderful technique can be easily mimicked in Photoshop. The resulting image's imperfections should be celebrated rather than regretted.

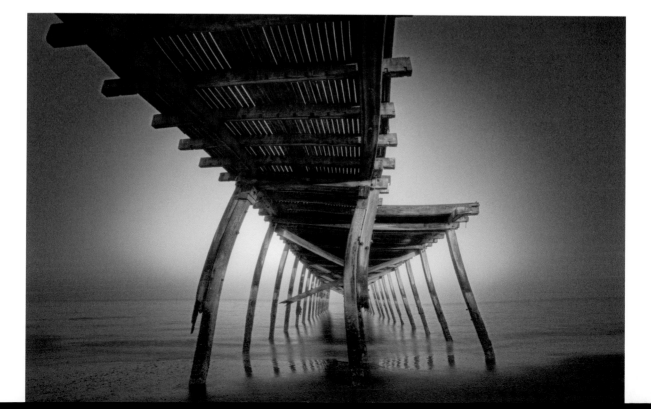

50 CREATING THE LOMO EFFECT

Despite the specifications of DSLR cameras, there is a craze among photographers to use cheap Lomo film cameras, with all their faults and distortions. While we applaud the results that can be achieved using modern cameras, what we crave is something a little less perfect. The Lomo camera reveals idiosyncratic qualities in which ordinary scenes can appear slightly surreal. If you wish to achieve the Lomo effect without using film, the effects can be recreated in Photoshop.

WHAT ARE THE DEFINING CHARACTERISTICS OF THE LOMO CAMERA?

- The colours can often appear distorted, as if the film has undergone cross-processing.
- The film grain often appears greatly exaggerated.
- The colours are more deeply saturated than normal.
- And possibly most telling of all, many of the shots taken on a Lomo camera reveal vignetting; this is particularly apparent on shots requiring long exposures.

These characteristics are not entirely consistent, which is part of the charm of using these cameras, so when creating your own Lomo effect in Photoshop, you may choose to minimize one characteristic, while exaggerating another. To inform and inspire you, it might also help to visit the Lomo website at www.lomography.com to see what kinds of effects these cameras can achieve.

Start image. Most kinds of images work well with this technique, but especially those with a strong blue sky.

Step 1. Taking the last on the list of Lomo characteristics, start by creating a vignette. Create a Duplicate Layer then name this new layer 'vignette'. With this layer active go to *Filter > Lens Correction > Custom*. Select the Vignette slider and drag it towards Darken. With earlier versions of Photoshop, this is accessed by going to *Filter > Distort > Lens Correction*. Try not to overdo this part of the process.

Step 2. Create another layer by dragging the 'vignette' layer to the New Layer icon and name this new layer 'blur'. With this new layer active, go to *Filter > Blur > Gaussian Blur* and add just 2 pixels. This affects the entire image; to restrict the effect just to the edges make a Layer Mask, select the Eraser tool, choose a large soft Brush, reduce the Opacity and then carefully work from the centre outwards, ensuring that none of the filter effects are lost near the edges.

Step 3. Now to introduce the grain; activate the 'vignette' layer and then go to *Filter > Artistic > Film Grain*. Apply Grain of 6 and Intensity of 3, although when mimicking unpredictable techniques such as the Lomo effect, there will always be some latitude.

Step 4. Now comes the important part, changing and saturating certain colour channels. Make an Adjustment Layer and select Curves then scroll the RGB menu and select the Green channel. Click on the midpoint of the diagonal and drag it slightly upwards. Next, select the Red channel and slightly increase the contrast by creating a gentle 'S' curve. Repeat this process with the Blue channel. When applying this technique there will be room to impose your own aesthetic judgment.

Step 5. To complete the task, make a new Adjustment Layer but this time select the Gradient Map; this will cause the image to appear in black and white. To bring colour back to the image, apply Overlay from the Blending Mode. The image will appear too contrasty at this stage so use the Opacity slider to reduce its severity. If you are happy with what you see, flatten and save.

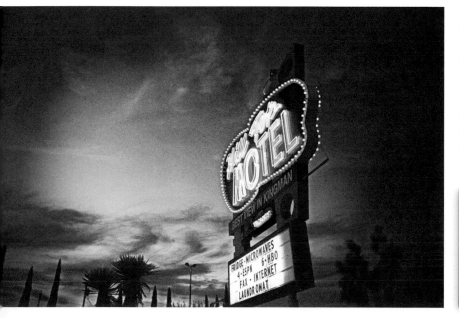

Finished image. Photography should not just be about presenting flawless, technically perfect images, and occasionally the idiosyncratic qualities of Lomo cameras can introduce a new dimension to your work. The charming effects they create are easily simulated in Photoshop.

tip

This technique works best when using a simple, clear-cut image.

51 MIMICKING THE CROSS-PROCESSING EFFECT DIGITALLY

Another retro technique that is gaining popularity is one known as 'cross-processing'. Also known as 'xpro', it is a procedure in which colour film is deliberately processed in the 'wrong' developer, resulting in strange colour shifts. Images appear oversaturated, grainy and often with an obvious colour cast. There are numerous Photoshop options for simulating these effects. More recent versions of Photoshop have a cross-processing option in the Curves drop-down menu, although you may prefer a more hands-on approach. If so, here is one way of going about it.

Start image. Often an image revealing clouds and a blue sky shows this effect off to best advantage.

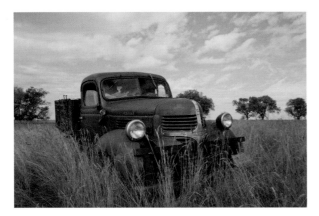

Step 1. Open up your image and start by gently increasing contrast and saturation. Don't overdo this, as the later stages of this technique will further enhance this. Then change the

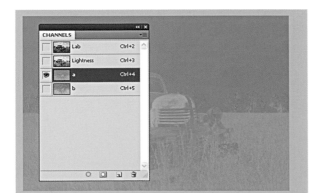

colour Mode to Lab by going to *Image > Mode > Lab*. Make a Duplicate Layer and with this active, open the Channels palette (*Window > Channels*), and select the 'a' channel from the dialog. Your image will appear as a very low-contrast black-and-white image. Go to *Filter > Blur > Gaussian Blur* and set the Radius to 10 pixels. Once completed, re-introduce all the channels by clicking the Lab thumbnail at the top of the dialog.

Step 2. This is where the colours need to be distorted, which can be done using various Photoshop options. With the Duplicate Layer still active, make an Adjustment Layer and select Levels. Now select 'a' from the Channels menu at the top of the Levels dialog. Move the Input Levels inwards to between 75 and 100, but leave the Output Levels slider untouched. The image will assume a strong green/blue bias.

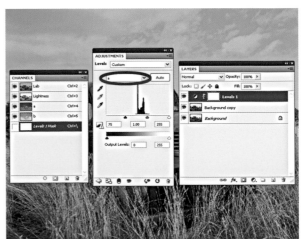

Step 3. Reactivate Levels, but this time select the 'b' channel in the Levels dialog. While it is important to retain the Output Levels at 255, try experimenting with the Input slider in order to achieve the desired result. With techniques such as cross-processing, there is a fair measure of latitude. In this example I tried Input levels 90 and 1.4, but once again I left the Output Levels untouched.

Step 4. With the Duplicate Layer still active, in order to re-introduce more saturated colours, select either Overlay or Hard Light from the Blending Mode. Degrading the image slightly also helps to add to that characteristic 'distressed' look of a cross-processed image. To achieve this add 10% Noise (*Filter > Noise > Add Noise*). Once you are happy with the results, convert your image back to RGB, flatten and save.

Alternative result. This has been achieved by using the Cross Processing option from the Curves drop-down menu. I leave it to you to decide which you prefer.

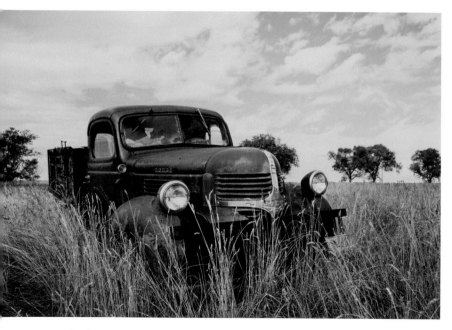

Finished image. If you are seeking an alternative way of presenting your work, why not try the cross-processing method? It is a technique that is finding favour with many contemporary graphic designers.

52 DISTRESSING THE IMAGE

Continuing the theme of deliberately degrading the image, producing a 'distressed' or 'grunge' image might prove the ultimate statement. Not all images should convey harmonious tranquility and in fact many can benefit from doing the reverse. To heighten this 'edgy' feel, tones and colour are distorted, marks and scratches are added and if a frame is included, it should be rough and ready. This style of photography has become hugely popular in recent years and is frequently employed by graphic designers as a way of adding intangible mystique.

Start image 1. Sometimes an image can offer contradictions, a sort of visual oxymoron one might say. In this example, we are presented with a pretty young woman set against an area of industrial wasteland. The normal convention would be to present the model in the most flattering lighting possible, but here an entirely different approach is required.

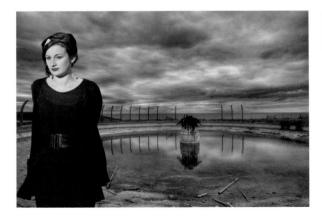

Start images Layers 1 & 2. In order to get some texture into the image, you will need a couple of different texture layers. Here I used a piece of rice paper, and with a very dry brush, applied black paint to a sheet of copy paper. Both images were scanned but could just as easily have been photographed if you do not have a flatbed.

Step 1. Open the file with the model, which becomes the Background Layer. Open the Brushstrokes file and using the Move tool drag it over the Background layer. Name this new layer 'Brushstrokes'. If the 'Brushstrokes' layer is larger than the Background Layer, use *Transform > Scale*. This allows you to register the brush marks more effectively with the Background Layer.

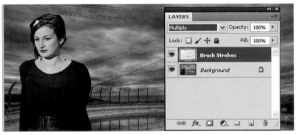

Step 2. Open the rice paper file and drag it over the 'Brushstrokes' file. Name this new layer 'Paper'. Apply Soft Light in the Blending Mode and reduce the Opacity to 70%. Slightly soften the brush marks by going to *Filter > Blur > Gaussian Blur* and apply a Radius of 2 pixels. Some of the marks were overlapping the portrait, so with the 'Paper' layer still active I made a Layer Mask, selected a soft Brush tool set to black and carefully removed the part of the layer that obscured the face.

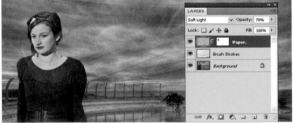

Step 3. The next stage is largely subjective; sometimes it helps to heighten the colours, but in this example I chose to do the opposite. With the Background Layer active, I made an Adjustment Layer, selected Hue/Saturation and reduced Saturation by -35. I then made a second Adjustment Layer, selected Levels and slightly increased contrast by drawing in the Shadow and Highlight sliders.

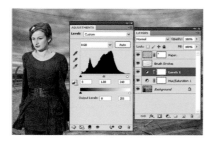

Step. 4. Finally, a 'grungy' border was added; this can be achieved in various ways, some of which are described in the section on adding borders (see Adding Further Borders and Edges). To achieve this one, I used the Brush tool set to white, and then selected Oil Heavy Flow Dry Edges set to 143 pixels, to roughen up the edges.

tip There are many websites that allow you to download free borders. Try: www.graphicssoft.about.com and www.online-image-editor.com

Finished image, example 1. When producing images of this nature, there is a fair degree of latitude. While some may prefer to heighten the colours, others prefer to subdue them instead. Starting with the same image you may end up with quite different results.

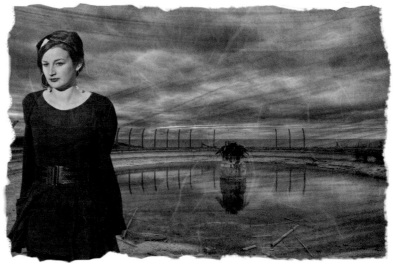

Finished image, example 2. The outcome here is quite different. Rather than use the 'Brushstrokes' layer, I opted to use Photoshop's Rough Pastels filter instead. It also features a different border; it is great to have options.

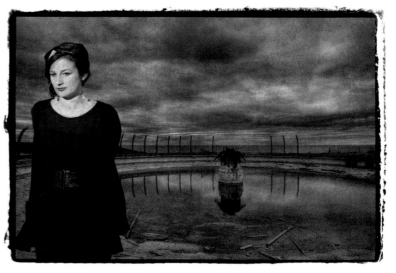

53 ADDING A POLAROID BORDER

An aspect of traditional photography that I greatly miss is Polaroid. What made the Polaroid image so special were the distinctive edges. Exposing the film triggered an immediate chemical reaction so when the film was peeled back, traces of the dye bled out onto the edges, creating the hallmark Polaroid effect. This product has virtually disappeared, but thankfully it is one that can be mimicked in Photoshop, particularly if you have old, rejected Polaroid film to work with.

Start image. This is a technique that suits just about any image.

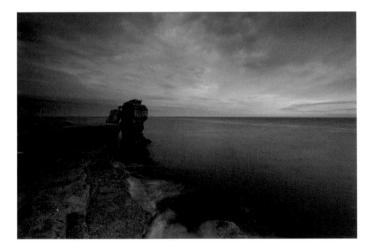

Step 1. Your first task is to get a good copy from the original Polaroid. This can be achieved by using the macro setting on your camera. Even if you are not able to get the image perfectly square, this can easily be corrected using Transform in Photoshop. If you have one, a better solution is to use a flatbed scanner. Set a resolution so it is compatible with the image you wish to use. If the edging appears damaged or frayed, this can easily be remedied by cloning, using the Patch tool.

Step 2. If required, remove the existing image from the Polaroid. Make a selection of the emulsion surface using either the Magic Wand or Quick Selection tool feathered by 5 pixels. Fill the selection with black using the Paint Bucket tool. Resize both the image to be imported and the Polaroid layer so that they are compatible, although further slight adjustments might still be required later on. If you wish to use an image with a lighter background, an alternative is to fill the emulsion area with white and to blend the layers using Darken in the Blending Mode.

Step 3. With both images on screen, *Edit > Copy* the image to be imported, then *Edit > Paste Special > Paste Into* the Polaroid file. If you look in the Layers palette, this now becomes the Background Layer while the imported image becomes Layer 1, although Layer 1 will have disappeared behind the Background Layer. Using Screen from the Blending Mode, the image will reappear showing a Polaroid border.

Step 4. It is unlikely that both files will match perfectly as the format of the original Polaroid differs from that of the imported image; a decision needs to be made about which layer to resize. As I want this to look like an authentic Polaroid image, I decided to retain its dimension and make the image fit the Background Layer. To do this, I activated Layer 1, and went to *Edit > Transform > Scale*, and while depressing Shift, adjusted Layer 1 until I established the best possible fit.

Step 5. When producing a Polaroid, light can bleed in, particularly during the chemical reaction, which results in soft highlighted strips at the edge of the image. To mimic this, use the Rectangular Marquee tool feathered by 5–10 pixels, and then make an Adjustment Layer, select Curves and gently pull the diagonal line upwards. By this stage, your image should look like an authentic Polaroid.

Finished image. Including the Polaroid edge has created an interesting and stylish image.

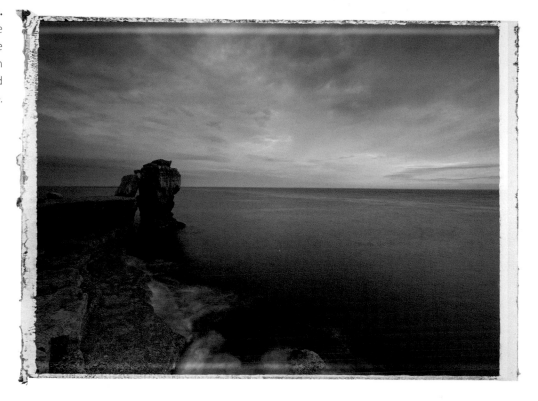

54 ADDING FURTHER BORDERS AND EDGES

It is not always necessary to create something as elaborate as a Polaroid border, as even the simplest of edges can add panache. There are numerous ways of achieving this, and there are even websites from which you can download sample borders. There are so many different kinds of borders that I could devote an entire chapter to the subject, so let us just concentrate on one or two formal borders, then something more alternative.

Simple key line method. Open the file you wish to use, then go to *Image > Canvas Size*. Select the colour you wish to use from the Canvas extension color drop-down menu, and then increase both the Width and the Height by the required amount. Hit OK and a simple colour border of your choosing will appear.

Simple key line finished image. In this example I have decided to use a black border, but of course you can select any colour you wish.

Multiple key lines method. This is of course an extension of the simple key line. Using the image with a black border, return to Canvas Size, select white, and then increase both the Height and Width. This introduces a white border around the black border. Repeat the process one further time, but this time select black (or possibly even another colour). Essentially you can continue doing this ad infinitum although you don't want the border to dominate the image totally.

Multiple key lines finished image. If you wish to add multiple key lines, they do look most interesting if they are presented as different thicknesses.

CREATING A FILED-OUT FRAME DIGITALLY

There was an interesting darkroom tradition of filing back the negative carrier so that part of the film rebate showed through at the printing stage. It not only appeared stylish, but it was often viewed by others as the photographer's own unique hallmark. Creating your own frame in Photoshop is not difficult.

Step 1. Start by creating a new white file, with approximately the same dimensions and resolution as the images you wish to use it with. Using the Rectangular Marquee tool, draw a rectangle close to the edge of this new file. Set the Marquee tool to minus and feathered by 5–10 pixels, then apply a second selection slightly smaller than the first. Finally, select the Paint Bucket tool set to black and fill the selection. This becomes your black frame.

Step 2. Use the Eraser tool to gently 'nibble' at parts of the outside of the frame. The Eraser tool can be set to either Hard or Soft. Don't worry too much about which parts are erased, as the process should mimic the filing out of the frame. Often these borders had small irregular parallel dark lines closely adjacent to the frame. These can be created by repeating the process described in Step 1.

Step 3. With the frame image active, use the Magic Wand tool to select the white area inside the frame, expand the selection by 8 pixels and feather it by 2. Open the file you wish to work with and resize it to approximately the same size as your frame. Go to *Select All > Edit > Copy*, then activate the frame layer and apply *Edit > Paste Special > Paste Into*. The frame will become the Background Layer and the image becomes Layer 1. If the image does not fit perfectly, go to *Edit > Transform > Scale* and make adjustments.

Finished image. Here is another stylish border you may wish to add to some of your images.

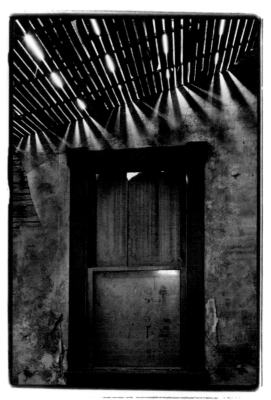

tip

In Step 3, it is important that the selection slightly overlaps the black border otherwise a telling white line will show at the end.

CHAPTER 6: COMPOSITES AND FURTHER SPECIAL EFFECTS

In many ways, Photoshop was designed to allow the user to make sophisticated montages and composites. Unlike traditional photography, you are now able to make very accurate selections, which makes the task of importing elements from one file into another considerably easier. It is important that you carefully note the details of each of your files to ensure that, should you wish to make a composite, the elements match in terms of lighting, colour temperature and viewpoint.

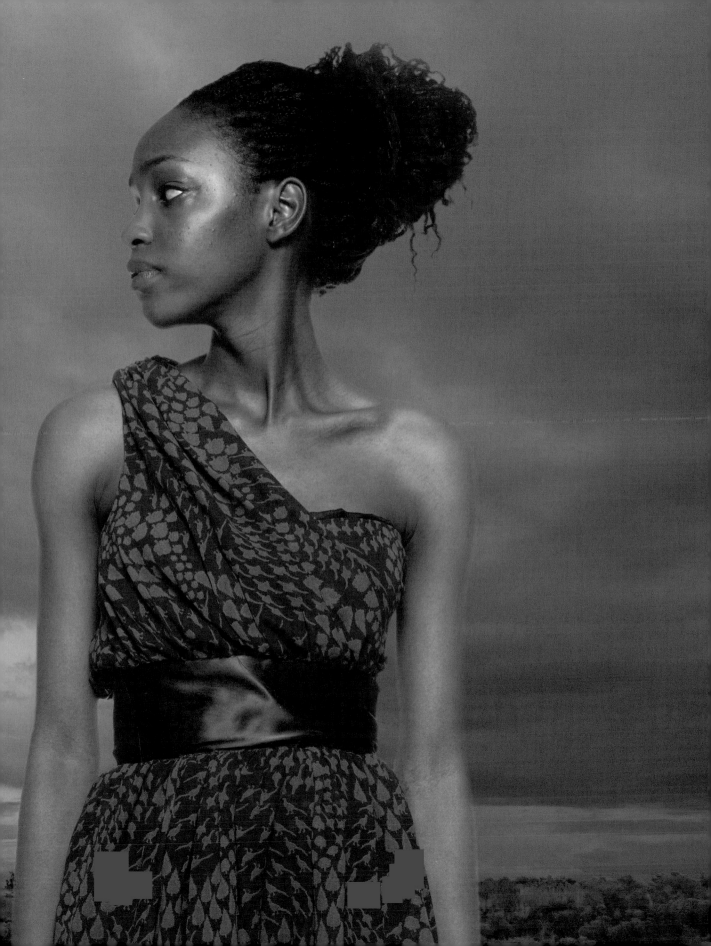

55 DROPPING IN A SKY

So often when photographing a landscape, all that is missing is a truly fabulous sky. Alternatively, how often have you witnessed a spectacular sky, but have looked in vain for a suitable foreground to complement it? Getting these two elements together can often prove challenging, but with a little know-how you can composite a sky from one file with the foreground of another.

KEEPING A 'SKY BANK'

Given the nature of our busy lives, most of us are unlikely to visit impressive landscapes on a daily basis, however interesting skies are much more available. It should be possible to photograph an attractive sky on virtually any day, but the important part is to 'bank' it for later use. With each sky I photograph, I note whether it was taken in the morning or in the evening, and whether the lighting was backlit or frontal, because the elements within composites need to be compatible. When shooting your skies, find a location that has an uninterrupted horizon so that you can get the best possible angle. Even if you are in the middle of town, point your camera upwards to exclude all the surrounding buildings.

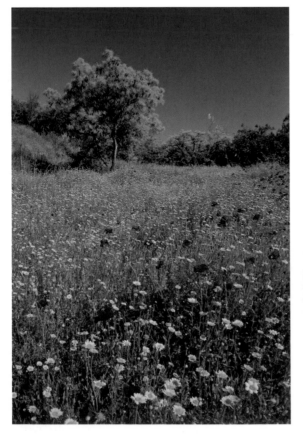

Start image 1. Taken on a beautiful summer's day, this landscape epitomizes all that I enjoy about this time of year. While there was plenty of interesting detail in the foreground, I wished that there had been some cloud in the sky.

Start image 2. When taking this shot I was aware that the foreground had little to offer, but realized that the sky could be used elsewhere. Both this and the landscape file were taken in the middle of the day with the sun over my left shoulder.

Step 1. Your first task is to make an accurate selection of the sky you wish to replace. As it is even both in terms of colour and tone, this is an easy task. Use the Magic Wand tool set to Add to selection, and start as close to the horizon as you can. If the colour and tones of the sky are similar to the foreground, reduce the Tolerance; start with 20. Once you have successfully selected the areas nearest the horizon, increase the Tolerance and 'mop up' the rest of the selection.

Step 2. Don't forget to select the small areas of sky that appear through the trees. Having made your selection, go to *Select > Modify > Expand* and increase the selection by 3 pixels. This prevents the telltale white line appearing along the join. Feather the selection by 2 pixels (*Select > Modify > Feather*).

Step 3. Open Start images 1 and 2. First, with Start image 2 active, go to *Select All > Edit > Copy*. Now activate the landscape image and go to *Edit > Paste Special > Paste Into*. The Landscape file now becomes the Background Layer, while the sky becomes Layer 1.

Step 4. With the sky layer over the Background Layer, slight adjustments might be required. Use the Move tool to reposition the sky as accurately as you can. If the sky file is too big or too small, with Layer 1 active, go to *Edit > Transform > Scale*, and with the Shift key depressed, scale up the sky by dragging one of the four outside bounding boxes.

tip

If the landscape appears too dark for the new sky, make an Adjustment Layer, select Curves, and make the required tonal changes (see Manipulating Contrast Using Curves in Chapter 1).

Finished image. By adding a new sky featuring wispy clouds, an otherwise uninteresting part of the image has been improved. It helps to use a sky that is compatible.

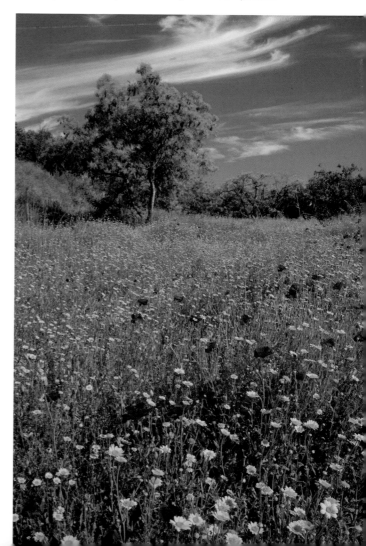

56 BLENDING IN A SKY

The previous workshop looked at dropping in a sky from a different location, but how often have you been in a landscape with impressive skies all around, but not exactly where you want to take the photograph? You wait, hoping that something will change, but alas, not on this occasion. The answer is to take both, with a view to blending the two elements in Photoshop. The advantage of this is that the lighting and colour temperature is likely to be broadly consistent in both files.

Start image 1. It was not the greatest day to take photographs, but I was drawn to this beautifully elegant, old Victorian pier. I kept hoping that the lighting would improve, but in fact it got steadily worse. To add mystery to the shot, I used a 'Big Stopper' neutral density filter, which substantially increased the required shutter speed.

Start image 2. As I looked to my left, there was a brief period when the sun broke through the clouds producing this impressive sky, but sadly not over the pier where I

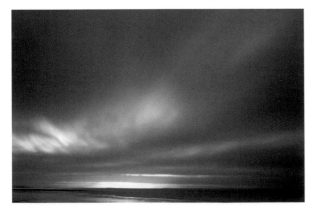

wanted it to be. The solution was to shoot it with the aim of blending it with the pier in Photoshop. To ensure consistency, I used a 'Big Stopper' with this as well. It was also important that I used the same focal length with both shots.

Step 1. Open the sky file, then make a gradient selection by first selecting Quick Mask and the Gradient tool set to Linear (see Using Gradient and Quick Mask in Chapter 1). As most of the sky is required, start with the cursor at the bottom of the image and drag it just a quarter of the way up. Click the Quick Mask icon once again and a selection will be made. Save the selection.

Step 2. I realized that I wanted to include more sky in this new composite, which requires extending the canvas size upwards. With the landscape file active, go to *Image > Canvas Size*, click on the bottom middle of the nine sections and add the required Width and Height.

Layer while the sky becomes Layer 1. Use the Move tool to manoeuvre Layer 1 into position. The blend should appear quite plausible at this stage, although a bit of tweaking will still be required.

Step 3. With both files on screen, select the Move tool and, while pressing the Shift key, drag the selected part of the sky file over the landscape. The landscape file becomes the Background

Step 4. With Layer 1 active, make a Layer Mask, select a large soft Brush tool set to black. Use the Airbrush option set to 50% Opacity and carefully remove parts of Layer 1, working from the bottom upwards to reveal the pier and horizon from the Background Layer. If your two files are largely compatible (which in this case they are), this part of the process should be minimal.

Step 5. Having decided on the final dimensions of the image, I cropped the exposed white canvas at the top of the image. In order to overcome the warm colour cast created by using a 'Big Stopper' filter, I made an Adjustment Layer selected Photo Filters and opted for Cooling Filter (82). I reduced the Density to just 12%.

Finished image. There will be occasions when photographing a landscape that you will see an interesting sky, but not where you want it. If the lighting proves contrary, take a shot of the sky with a view to blending it into your landscape using Photoshop.

57 PRODUCING SUNBEAMS

There are certain natural phenomena that add a special 'wow' factor to a picture and one of those is an unexpected burst of sunbeams. They tend to be ephemeral and difficult to predict – often when we do see them, we do not have our camera with us, or they disappear before we are able to take a shot. Fortunately, they are very easy to mimic in Photoshop.

SELECTING A SUITABLE IMAGE

For this technique to be its most effective, you need a start image that includes a fleeting glimpse of the sun; it is pointless trying this effect if this source of light is totally absent. Your image will also require elements that allow the sunbeams to filter through; this could be a single tree, a church window, or perhaps a group of broken clouds in the sky. Sunbeams are probably most eloquently displayed within a misty landscape, so if you have files that were taken in foggy conditions, but that lack a certain magic, this might make an ideal subject to work with. Follow the steps of this workshop to create compelling sunbeam pictures.

Start image. While there is a hint of sunbeams in this image, I missed that magical moment when there had been an even more impressive burst. By making a few adjustments, I should be able to recreate that lost moment.

Either way, while the rays of light are heightened, the remaining landscape appears too contrasty. The effect needs to be restricted to just the beams.

Step 2. In order to restrict the Hard Light effect, add a black Layer Mask by selecting the Layer Mask icon at the bottom of the Layers palette while at the same time depressing Alt. With the black Layer Mask active, select a soft Brush tool set to white. Using an Opacity of 50%, carefully work on lighter beams of light without straying into the darker areas. This is important otherwise the selected darker areas will show through on the final image.

Step 1. First, enhance the rays that currently exist. To achieve this, create a Duplicate Layer and then select Soft Light from the Blending Mode. If you find that the effect is too subtle, try using Hard Light instead.

Step 3. To create further sunbeams use the Polygonal Lasso tool feathered by 30 pixels, then make a selection; if you want to make several beams, set the tool to Add to selection. You are aiming to create a wedge shape, with the apex emanating from the light source. Create as many 'beams' as you wish, but make sure that they all radiate from the same source. Select an area within the image that is relatively dark in order to achieve maximum contrast. Make an Adjustment Layer, select Curves and lighten the selections (see Manipulating Contrast Using Curves in Chapter 1).

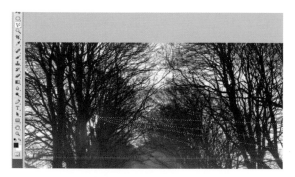

Step 4. Finally, it was important to lighten the mood of the image, but without unduly affecting the subtle highlights. To achieve this I made one further Adjustment Layer, selected Curves, but made sure that the lighter part of the curve was pegged. In this way I was able to restrict the adjustment just to the darker areas.

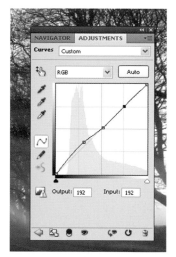

Finished image. Aim to keep your results plausible by erring on the side of subtlety. By enhancing the beams that already exist, and then just adding a couple more, I have been able to create the vaporous lighting I had seen moments earlier.

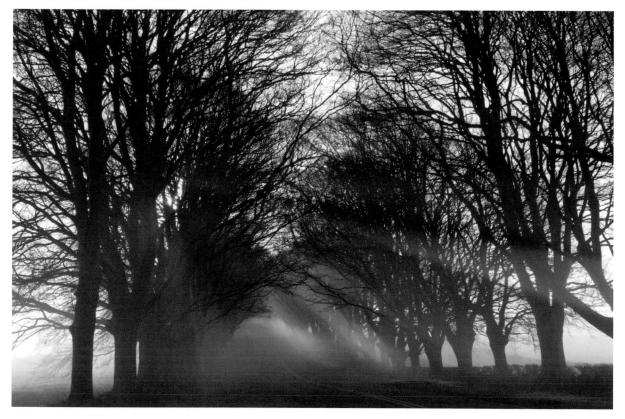

58 CONSTRUCTING A NARRATIVE

One of the great aspects of photography is the capacity to tell a story. We all know how frustrated children can become when the weather prevents them going out. A simple technique that conveys this message is to create the effect of a boy looking through a rainy windowpane; the implication, of course, is that the weather is preventing him doing what he most enjoys. This can easily be done using Blending Modes, a much-valued range of tools for creating composites.

Start image 1. A portrait of Josh; a keen sportsman, I had no difficulty persuading him to wear his favourite Rugby shirt. It was important to ensure that the background was both light in colour and uncluttered. Encouraging the model to stare balefully outside rather than looking directly into the camera certainly helped.

Start image 2. When shooting this pane of glass, it was important that it also appeared relatively uncluttered. Taken indoors, I made sure that the background was comprised entirely of sky. Using a macro lens helps to feature just the raindrops. If rain proves illusive, try spraying droplets of water onto a sheet of glass.

Step 1. Open the file with the model and make this the Background Layer. Then open the window file and, while pressing the Shift key, drag it over the Background Layer to become Layer 1. Experiment with the various Blending Mode options – the results depend very much on the tonality of the two images you are working with. Adjusting the Opacity of Layer 1 can also offer another control. In this example, both Overlay and Hard Light offered interesting possibilities. I opted to continue with Overlay.

Step 2. Tonally, the corners of the background appear too bright and require toning down. I made a selection using the Lasso tool feathered by 100 pixels. I then made an Adjustment Layer, selected Curves and darkened them (see Manipulating Contrast Using Curves in Chapter 1).

Step 4. Finally, one or two of the raindrops appear on unfortunate parts of his face especially around the mouth and eyes. With Layer 1 active, I made a Layer Mask and then carefully removed several droplets using a soft Brush tool set to black and an Opacity of 40%.

Step 3. Relative to Layer 1, the portrait still requires a little more contrast, so with the Background Layer active, I made one further Adjustment Layer, selected Curves and applied a gentle 'S' curve.

tip

Experiment with the Blending Modes. If you select Hard Light, for example, the image lacks the contrast of the finished image below but is more consistent with the quiet tones one might expect with this kind of subject.

Finished image. You could develop this image further. In reality, if the lens is focused on the droplets, then the figure in the background will be out of focus; similarly if the portrait is sharp, then try defocusing the foreground by applying Lens Blur. It really is a matter of how far you wish to go.

59 PRODUCING DROPLETS OF WATER

From a visual standpoint, flowers and plants are always enhanced when sprayed with water – it is a technique often used by advertising photographers as the droplets lend a sense of freshness and vitality to the subject. The problem is that it is very difficult to ensure that the droplets are distributed evenly. They invariably start to run and quickly become a mess. One solution is to create the effect in Photoshop.

Start image. While these three white lilies appear wonderfully sculptural set against a dark background, I sensed that adding a few droplets of water might add further interest.

Step 2. Now numerous further droplets need to be created. With the first droplet still selected, go to *Edit > Copy / Edit > Paste* and reposition the duplicate droplet near by; note that this has created a second layer. With this second layer active, you can use Transform to resize it should you wish. Continue this process of creating a droplet, and copying it until you have the required distribution.

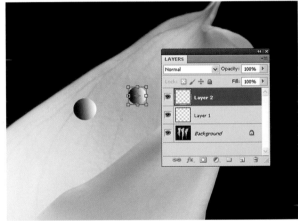

Step 1. By their very nature, the droplets need to be small, so start by zooming in on a small part of the flower. Create a new layer, by clicking the Create New Layer icon, and select the Elliptical Marquee tool. Carefully drag the Marquee tool to create a circle, then select the Gradient tool set to Linear Gradient, Black to White. Draw a line from one edge of the selection to the other. Note that for illustrative purposes, the droplet I have created in this project is unrealistically large; aim generally to keep them small.

tip
Every time you copy and paste a droplet it will automatically create its own layer. It is very important that the direction of the gradient remains consistent with each droplet that you create.

Step 3. With all the droplets created, merge all the droplet layers by highlighting them, and with the Shift key depressed, go to Merge Layers in the Layers drop-down menu, taking care not to include the Background Layer. Go to Overlay in the Blending Mode, and the droplets will cease resembling droplets of mercury and look more like water.

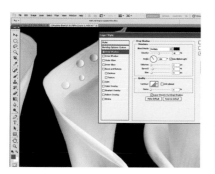

Step 4. With the droplet layers still active, the next task is to add depth. Go to *Layer > Layer Style > Drop Shadow*, and set the Angle of the shadow so that it appears adjacent to the lightest side of the droplets. In this case as the lightest side is to the right, I added an angle of 130 degrees. The Opacity was reduced to 40% while I restricted the Distance to 2 pixels, Size to 4 pixels and Spread to 9%.

Step 5. The final touch is to slightly distort the droplets as they appear unnaturally regular. With the droplets layer still active, go to *Filter > Distort > Wave*. The dialog will offer various options; a good starting point is Distance 2 pixels, Wavelength 1–300, Amplitude 1–200 and Scale, Horizontal 2%, Vertical 20%. If you are happy with what you see, flatten and save.

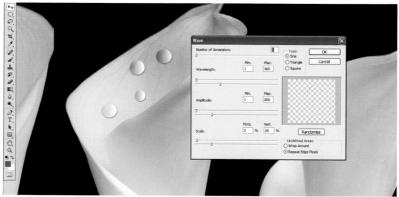

Finished image. While creating the droplets was a relatively laborious task, the results certainly made it worthwhile. If you feel that after flattening the image, there are insufficient droplets, you can quite easily add more at a later stage.

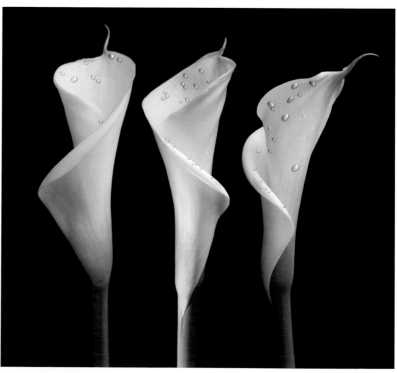

60 CREATING A COMPOSITE BY MAKING SIMPLE SELECTIONS

When creating a composite, it does help to have some idea of what you are aiming to achieve, and then to photograph the required elements so that the task of putting them together is much easier. Composites rarely work merely by 'cobbling' together several unplanned files, as the scale and lighting are likely to prove incompatible.

Start images 1 & 2. When photographing these two poppies, I knew that I wanted to use them in a sky composite, so I quite purposefully placed a sheet of dark cardboard behind each of them to ensure that the task of selection was made much easier.

Start image 3. I have quite a collection of sky pictures I can use for composites. It is important that they are free from other distracting elements. In this case, I slightly cropped the top of the sky in order to achieve a panoramic format, which allows me to place the two poppies side by side without the need to overlap them.

Step 1. Open Poppy 1. To ensure that the bloom is clearly distinguished from the black background, use Curves to lighten the image slightly and then use the Magic Wand tool set to a Tolerance of 20 and feathered by 2 pixels to select the background. To select the flower, inverse the selection.

Step 2. No matter how accurate you are with your selection, composites often leave the telltale white edge. To overcome this, contract the selection (*Select > Contract*) by between 2 and 4 pixels, depending on the size of the file. With both files on screen, use the Move tool to drag the selected poppy over the sky; don't worry about resizing at this stage. The sky picture becomes the Background Layer, while the Poppy image becomes Layer 1. Name this 'Poppy 1'.

Step 3. Open the Poppy 2 and repeat Steps 1 and 2. This will become Layer 2; name this new layer 'Poppy 2'. Poppy 2 appears to be looking out of the picture, so with this layer active, go to *Edit > Transform > Flip Horizontal*. Both poppies will now appear to be facing inwards.

Step 4. Both poppies look a little small in the frame; with 'Poppy 1' layer active, go to *Edit > Transform > Scale*. Select one of the corner bounding boxes and, with the Shift key depressed, increase the size of the image by dragging outwards. Don't worry if you overlap at this stage. Then activate 'Poppy 2' layer and repeat this process. Finally, use the Move tool to carefully manoeuvre the two poppy layers into a more pleasing design.

Step 5. If you work with care then any traces of a join should not be evident, however parts of the composite might appear unrealistically sharp. To soften the edges, use the Blur tool set to 50% Strength with a small soft Brush.

Finished image. When photographing close-ups of flowers, because of the limited depth of field you can rarely make a feature of the background; by creating a composite, you can.

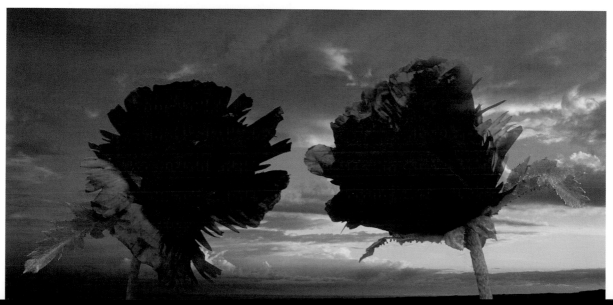

61 CREATING A COMPOSITE USING BLENDING MODE

It is often assumed that in order to create a composite you need to make a precise selection from another source, however some 'light touch' montages can be constructed just by using Blending Mode. This is particularly the case when the two files you are aiming to composite share similar qualities in terms of colour, tone and content.

Start image 1. This shot of a beautiful stretch of coastline with the cloud formations gently reflecting in the wet sand just needs one further element in the frame that can serve as a focal point.

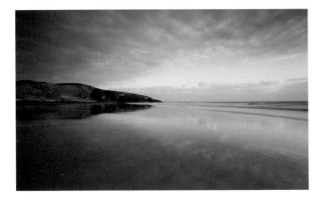

Start image 2. A shot of a man on horseback was taken on another beach on a different day, but despite that, there are strong visual similarities. The activity of riding a horse along a beach is common practice and the reflection in the sand is entirely consistent with Start image 1.

Step 1. I opened Start image 1; while the balance between the detail in the sky and the sand has been reasonably well retained (achieved by using a graduated neutral density filter at the taking stage), the image is unevenly illuminated from left to right. This is easily remedied by making a gradient selection, selecting Curves and gently pulling the Curve upwards so that the entire landscape appears balanced.

Step 2. Start image 2 was opened and tightly cropped to include just the horseman and the reflection. Both images were then set side by side on screen and, using the Move tool, image 2 was dragged over image 1. Start image 1 now becomes the Background Layer, while start image 2 becomes Layer 1. In this example I needed to use

Darken in the Blending Mode, although you may need to experiment to find the best Blending Mode for your image. With Layer 1 still active, I used Curves to slightly lighten the rider, which also helped to remove traces of the original background.

Step 3. The rider is in the ideal position on the right, except that he is riding out of, rather than into the picture. With Layer 1 active, I went to *Edit > Transform > Flip Horizontal*. Using the Move tool, I repositioned the rider, between two reflected clouds, and slightly increased the size by going to *Edit > Transform > Scale*.

Step 4. The Blending Mode has not got rid of all traces of background from Layer 1. With this active, make a Layer Mask and use the Brush tool set to black to remove any bits of unwanted background, taking care not to erase the rider.

Finished image. This simple composite has been created without any selections just using the Blending Mode and the Brush tool. This will not work with all composites, only where you have a good contrast between the subject and the immediate background; compatibility between the two files is also required.

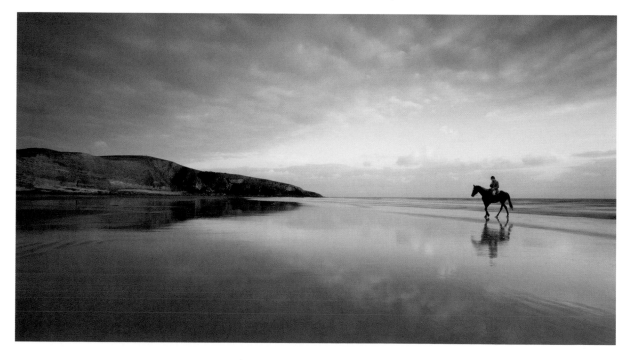

62 CREATING A COMPOSITE USING REFINE EDGE

One of the advantages of Photoshop is its capacity to make composites. The process usually involves making a careful selection and then pasting it into a new background – the sophistication of the composite is governed by your ability to make an accurate selection. Cutting around flyaway hair, for example, can prove particularly challenging. With the addition of Refine Edge (in CS5 and beyond), it is possible to make extremely accurate selections, giving your imagination full rein.

Start image 1. This model was taken in a studio environment with all the advantages of controlled lighting. A fan was used to create a bit of movement in both her hair and clothing to simulate the effects of an outside breeze.

Start image 2. When joining two images together, it usually pays to keep elements simple.

As the selection is fundamental to the success of this exercise, it is important to make it as accurate as you can. Zooming in on the more difficult parts undoubtedly helps.

Step 1. The first task is to make an accurate selection of the model; as the background is relatively uncomplicated, this should be easy. Use either the Quick Selection tool to select the model, or alternatively try the Magic Wand tool set to a Tolerance of 15 and select the background instead (you will need to Inverse the selection if you go down this route). Whichever tool you find most useful, ensure that it is set to Add to selection.

Step 2. Zoom in on the area you suspect will require the most work – in this example it will be the area around the head – and then select Refine Edge, which appears in the Menu bar at the top of the screen. The View Mode gives you various options that allow you to choose the background best suited as a working space. In this example I find the white background the most convenient. One of the View Mode options in Refine Edge is On Layers, but I prefer not to use that, as I like to have several options available.

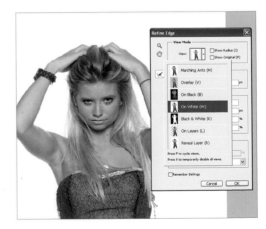

Step 3. Make sure that Smart Radius is ticked, then move the Radius slider slightly to the right. Experiment with the Smooth, Feather and Contrast sliders in the Adjust Edge box, just to see which works best for the task in hand (the general rule of thumb is to use these cautiously). Tick the Decontaminate box and use this slider only if the colour of the rim-lighting surrounding the model is distinctly different from the file you wish to export into. As the colour and tones in start image 2 are similar to those in start image 1, I chose to ignore this option.

Step 4. Using the Edge Detection brush, carefully go round the figure, and particularly in difficult areas such as hair, until you have achieved the perfect selection. The process does require time to reconfigure each stage, so be patient. When you are happy with what you see, hit OK.

Step 5. With both files on screen, use the Move tool to drag the selected figure over the sky file. This then becomes the Background Layer, while the figure becomes Layer 1. Should you wish to make any colour or tonal adjustments to either of the layers, make the changes at this stage. Similarly, should you wish to increase or decrease the size of the figure relative to the Background, this can easily be done using *Edit > Transform > Scale*.

Finished image.
Choosing the right elements and making an accurate selection both help to make a successful montage. Refine Edge makes this task considerably easier. It is a matter of personal choice, but I always prefer that my composites appear plausible.

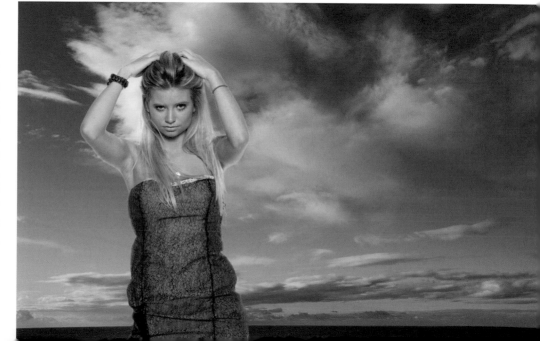

63 MAKING SELECTIONS USING CHANNELS

Only the most recent versions of Photoshop contain Refine Edge; if yours does not, then there is an equally effective method for making sophisticated selections. It helps to start with a file where there is a reasonable contrast between the subject and the background. The best composites are usually those that are planned and where each of the contributing elements has been taken with the final outcome in mind.

Start image. A fan was used to create a bit of movement in the model's hair. By photographing her against a simple white background, the task of selecting was made far easier.

Step 2. The next task is to greatly increase contrast; to achieve this, go to *Image > Apply Image* and try using the various Blending Modes. In this example I used Linear Burn, although Multiply often works as well. To increase contrast further, with the Blue Copy layer still active, use the Contrast slider in the Brightness/Contrast command.

Step 1. Open the file into Photoshop and then open the Channels palette (*Window > Channels*). By closing the respective eye icons, find which of the channels offers the greatest contrast; after experimenting, I found it was the Blue channel. A copy of this is made by dragging the Blue channel layer to the Create New Layer icon at the bottom of the Channels palette.

Step 3. With the Foreground/Background Colors set to default, use a small hard Brush tool set to black to clean up any areas of white still remaining within the selected area. Similarly, clear up any areas of black within the white area using the Brush tool set to white. To complete the selection, drag the Blue Copy layer down to the Make Selection icon at the bottom of the Channels palette. The white area will be selected; to make a selection of the dark area inverse

the selection (*Select > Inverse*). By clicking the RGB channel the subject will reappear in full colour, complete with the 'marching ants' denoting a selection. Feather the selection by 2 pixels.

Step 5. Zoom in to the model and identify those areas revealing unwanted detail; this is most likely to be in the areas near the hair. Select the Clone Stamp tool set to small and soft edge. Using an Opacity of just 25%, Alt-click on an area on a background area free of hair. Using the Clone tool, carefully paint over the areas where the old background can be seen between the hair, with the replacement samples. To complete the composite, soften the edges that appear over-sharp with the Blur tool set to 10 pixels using a Strength of 40%.

Step 4. Open the landscape file and with both files on screen, use the Move tool to drag the selected figure over the background file, then resize using Transform. The landscape file becomes the Background Layer while the figure becomes Layer 1. There might still be traces of the background from Layer 1; to remove them, lock the layer by going to the Lock Transparency Pixel button at the top of the Layers palette.

Finished image. Using Channels is a very effective method for making selections. While I have chosen to illustrate this technique using a figure, it can be used when selecting any complex shape such as a bush or a tree.

tip

Having selected a Channel, if necessary increase the contrast by applying the Brightness/ Contrast Command.

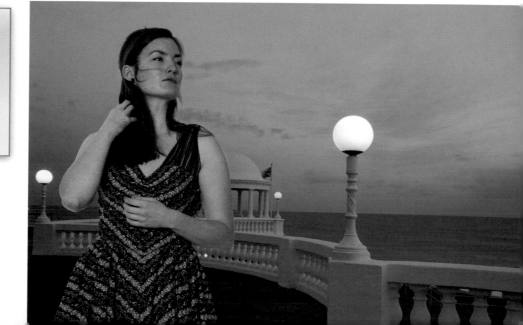

64 CREATING A COMPOSITE WITH MULTIPLE LAYERS

The more layers you intend to use in your composite, the more likely it will be that you need to shoot images specifically for the task. It is relatively easy to find two or possibly three elements that can be hashed together, but as you increase the number of files you wish to use, then clearly issues such as lighting and scale become ever more important.

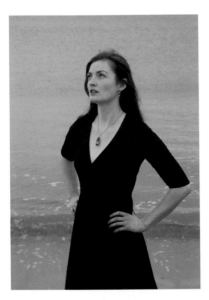

Start image. When I took this image, I already had in mind what I wanted to do; to set the model within a dark and threatening landscape with a cluster of birds circling overhead. Her upwards gaze certainly got me off to a positive start.

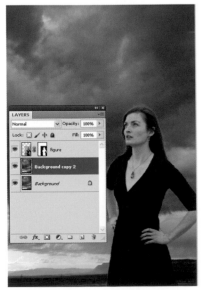

Step 1. I opened the file containing the sky. I made a Duplicate Layer then opened the file with the model and, having made a selection using the Magic Wand tool and Refine Edge (see Creating a Composite Using Refine Edge), dragged it over the sky file; I renamed this new file 'figure'. The model appeared slightly too large within the frame so, with the 'figure' layer active, I resized using *Edit > Transform > Scale*.

Step 2. It was important to create a lighter part of the sky to accommodate the circling birds. With the Duplicate Layer highlighted, I made a rough selection with the Lasso tool feathered by 100 pixels. I then made an Adjustment Layer, selected Curves, and carefully lightened the selected area (see Manipulating Contrast Using Curves in Chapter 1).

Step 3. There was a bright area in the bottom left of the sky which distracted the eye. I made a rough selection using the Lasso tool feathered by 50 pixels and then selected the Shadows/ Highlights command. Using the Highlights slider I added an Amount of 15%.

Step 4. I opened one of the bird files. It was important that the birds appeared silhouetted against the lighter part of the sky, so I made an Adjustment Layer, selected Curves, pegged the darkest quarter but then lightened the rest of the image by slightly dragging the diagonal line upwards. The file was flattened, and I then used the Move tool to position this new file. By applying Darken in the Blending Mode, the bird blended faultlessly into the sky.

Step 5. Step 3 was repeated with each of the subsequent bird files. As each of the layers were independent, it was possible to resize and in some cases rotate files, so that a pleasing composition was achieved. It also helped to slightly reduce the Opacity of each of the bird files, so that they appeared to 'bed in' to the background more effectively.

Finished image. By using various selection tools in conjunction with the Blending Mode, it should be possible to composite numerous files to create an imaginative yet plausible scene.

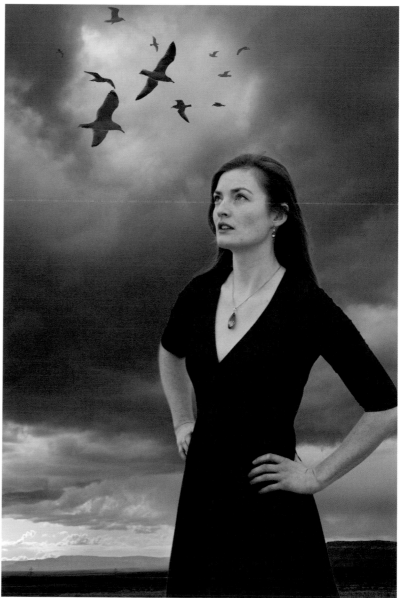

65 GENERATING A REFLECTION

Compositing a figure becomes more difficult when the entire figure is used. To ensure the figure does not appear as if it is floating, its apparent 'weight' must be considered. If you photograph people walking along a wet beach their reflections are likely to appear; if you take a shot of a person inside a building, the shadow will be governed by the ambient light source. These issues must be addressed if you want to create a convincing composite.

Start image. Walking along this beach, I was struck by how perfectly the sky was reflected in the pristine wet sand; it was almost a mirror image. As beautiful as it appeared, I sensed that this tranquil scene required one further element to truly sustain interest.

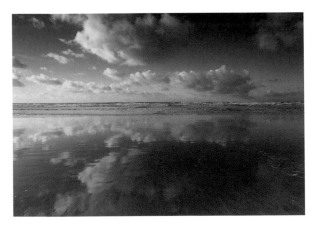

Step 1. Having selected a suitable file, I made a careful selection using both the Quick Selection tool and Refine Edge (see Creating a Composite Using Refine Edge). As the colour and tone of the model's T-shirt was similar to the background, I used the Polygonal Lasso tool

feathered by 2 pixels to finish the task. The selection was then saved (*Select > Save Selection*).

Step 2. I opened the image of the beach. With both files on screen, I used the Move tool to drag the selected figure over the beach image. This became the Background Layer, while the figure became Layer 1. I renamed this layer 'Figure'. The model appeared too large within the frame so I resized her (*Edit > Transform > Scale*). I was unhappy with the direction the model was facing, so I flipped the file (*Edit > Transform > Flip Horizontal*).

Step 3. To create a reflection, make a copy of the 'Figure' layer by dragging it to the Create New Layer icon and naming this new layer 'Reflection'. With this new layer active, go to *Edit > Transform > Rotate 180 degrees* and then use the Move tool to reposition this file directly below the standing figure. To achieve a reflection, flip this layer (*Edit > Transform > Flip Horizontal*). All the elements should now be in place.

Step 4. It is important that the feet from the 'Figure' layer and those from the 'Reflection' layer are in contact. With the 'Reflection' layer still active, I went back to Transform but this time I selected Rotate and, by selecting one of the outside bounding boxes, carefully repositioned the reflected figure so that the feet appear to touch. I then applied Soft Light in the Blending Mode.

Step 5. With the 'Reflection' layer still active, make a Layer Mask and reduce the Saturation by -30. The reflection will still appear too sharp at this stage, so go to *Filter > Distort > Ripple* and apply 100% Amount and Size Large. Finally, while the inclusion of a reflection goes a long way towards creating a plausible composite, there will inevitably be some shadow directly below the standing model. To achieve this, with the 'Figure' layer active, load the saved selection and then inverse it (*Select > Inverse*). Now activate the Background Layer, select a soft black Brush tool set to Soft Light and, applying an Opacity of just 10%, carefully add a small amount of shadow just below the feet.

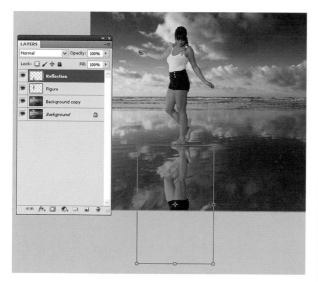

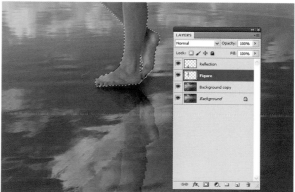

Finished image. Composites need not be difficult to do. I have chosen to feature just a single figure, but once you have mastered this technique, there is nothing to stop you adding several.

When creating a montage, you are at liberty to place the figure wherever you like. Don't forget about the 'rule of the thirds'.

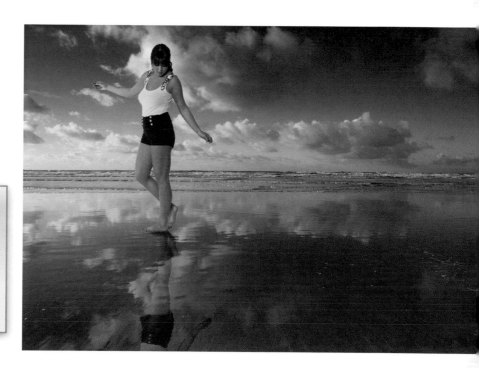

66 CREATING A SHADOW ON A HARD SURFACE

If you want to create a convincing composite that includes a figure then it is important to add a shadow. Every object has a 'weight' so if it is presented without a shadow it will appear to float. The nature of the shadow will be determined both by the angle of the ambient light and by its intensity; matters can also be complicated if there are several sources of light.

Start images 1 & 2.
Starting with a figure photographed against a simple, plain background makes the task of selection much easier. Because of the potential for backlighting, this background makes an excellent location for creating shadows.

Step 2. At this stage, because of the lack of shadow, the figure appears to be floating. A duplicate of the figure was made and this new layer was named 'Shadow'. With the 'Shadow' layer active, it was inverted 180 degrees and flipped horizontally using Transform.

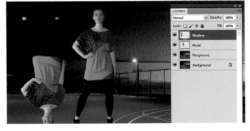

Step 3. The 'Shadow' layer was carefully positioned so that the inverted feet appear to be touching the feet in the 'Model' layer. If you overlap slightly that should not be a problem, as this can be dealt with later. It is important to establish the main source of light in the Background Layer; in this example, there are several lights behind the model, therefore any shadows should appear in front of her.

Step 1. The model file was opened in Photoshop and a careful selection was made using the Quick Selection tool. The selection was saved (*Select > Save Selection*). The Background file was opened, a Duplicate Layer made (which was named 'Playground'), and then the selected model was dragged into the destination window. This new layer was named 'Model'. As the 'Model' layer was too large it was resized (*Edit > Transform > Scale*).

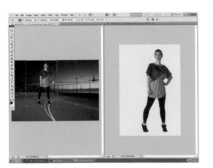

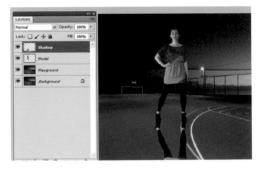

Step 4. The 'Shadow' layer is darkened by reducing Brightness/Contrast to 0. Ensure that Legacy is ticked. This should create a perfectly black shadow. Then go Transform, select Skew and manipulate the corner bounding boxes so that the shadow attenuates from the feet outwards.

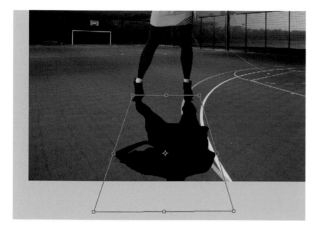

Step 5. With the 'Shadow' layer still active, apply Soft Light from the Blending Mode. The colour and texture of the ground should re-emerge. Now, make the 'Model' layer active, load the saved selection but then reactivate the 'Shadow' layer and use the Eraser tool to carefully remove any traces of the shadow overlapping the model.

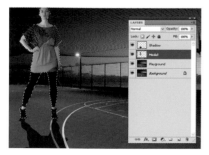

Step 6. The shadow needs softening. With the 'Shadow' layer still active, make a rough selection of the lower part of the shadow, feathered by 100 pixels, and apply Gaussian Blur; 35 pixels is usually sufficient. As both feet are in contact with the ground, the shadow needs to be most prominent directly below them. With the 'Model' layer active, load the selection again and then inverse it. This will ensure that any additional shadow will not creep over onto the model. With the foreground colour set to black, use a small Brush tool set on Soft Light, but with a considerably reduced Opacity (try 10%), and carefully add more tone.

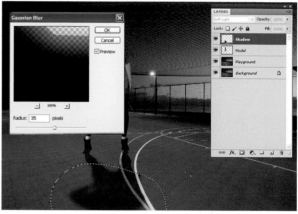

Finished image. A composite will always appear more convincing when the entire figure is included. Careful thought needs to be given to the direction of the shadows, as they should be diametrically opposite the source of light.

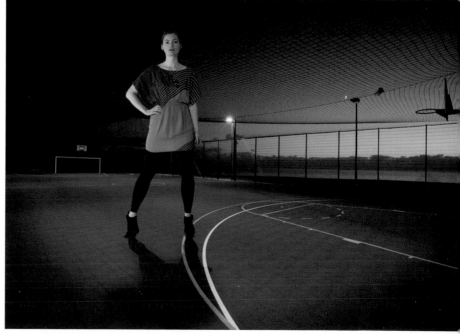

67 CREATING A SHADOW ON A SOFT SURFACE

There are different sorts of shadow. In strong low-light conditions, the shadow cast onto a firm surface appears hard-edged, but when the sun is masked by cloud, it appears more nebulous. If you are creating a composite, regardless of the lighting conditions, including a shadow adds that all-important sense of weight.

Start image. A beautiful landscape; all it now needs is a figure standing among the flowers.

Step 1. A Duplicate Layer was made of the Background and this new layer was named 'yellow field'. A suitable file featuring a figure was opened, a selection was made using the Quick Selection tool and Refine Edge, and the figure file was then dragged over the landscape file and resized using Transform. At this stage, the figure looks like an unconvincing cutout. This new layer was called 'model'.

Step 2. The first task is to remove the harsh line at the bottom of the model's thighs. With the 'model' layer active, select a soft Eraser tool set to 70 pixels and carefully remove a small part of the bottom of the 'model' layer to reveal detail from the 'yellow field' layer. This makes it appear as if she is standing within the flowers.

Step 3. The natural light is coming from the left. A new layer was made, with this layer active and using the Polygonal Lasso tool feathered by 20 pixels, a rough selection was made to the right of the figure, approximating the shape of the shadow she is likely to cast. As this is created under soft lighting conditions, there was no need to be too precise.

Step 4. With the new layer still active, select a soft Brush tool set to black; use an Opacity of just 20% and select Soft Light in the Blending Mode. Apply the Brush tool to create the shadow, starting from the model's legs and working outwards. As you do, reduce the Opacity to 14%. The model now appears to have 'weight'.

Step 5. Finally with the 'yellow field' layer active, use the Clone Stamp tool to select an area of flowers. Then, with the 'model' layer active, clone the join between the flowers and the figure.

Finished image. Adding shadows allows you to create complex composites. In this example, I have introduced just one further element, but many more could easily have been added. The essential point is making sure that the lighting is consistent. If the background layer is lit from the right, then any additional elements should also be.

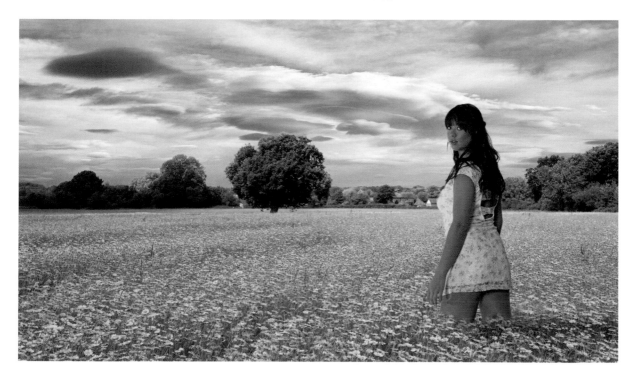

68 CREATING A RAINBOW USING THE GRADIENT TOOL

After a heavy shower, we are often rewarded with a wonderful rainbow. They are, however, amazingly elusive and no sooner have you got your camera out they seem to disappear. Think of the times when you have seen one, but it appears over a dreary landscape. How often have you been driving along a motorway and witnessed the mother of all rainbows, but have been unable to stop? The solution of course is to create one in Photoshop.

Start image. Clearly, it does help to start with a file that was taken under the same conditions in which one would normally expect to see a rainbow. This was taken after a heavy downpour, just as the sun was beginning to break through the clouds.

Step 1. A new layer was created and given the name 'rainbow'. The Gradient tool was selected, then using the cursor, the Gradient Editor was opened by clicking on the Gradient Picker in the Options bar. A rainbow effect does not appear within the standard presets. To access it, click on the small arrow in the top right of the Gradient Editor dialog and then select Special Effects, second from the bottom.

Step 2. A dialog will appear asking 'Replace current gradients with gradients from Special Effects'. Click OK and a new, smaller set of Gradients will appear. Select Russell's Rainbow. You will be offered the opportunity of adjusting the width of each of the colour bands in the slider panel at the bottom of the dialog, but in the first instance leave it untouched. Click OK.

Step 3. In order to ensure that the rainbow curves, select Radial Gradient from the Options bar at the top of the screen. To create the rainbow effect, drag the cursor along the horizon, starting at one of the edges. A very intense rainbow effect will appear over the entire image. It might not appear where you want it, but it can be repositioned using the Move tool. If you want to alter the angle, apply *Edit > Transform > Rotate*, click on one of the outside bounding boxes, and use the cursor to change the angle.

Step 4. In order to reduce the intensity of the rainbow, select Screen from the Blending Mode; also try reducing the Opacity to 70%. In order to soften the bands, go to *Filters > Blur > Gaussian Blur* and add a Radius of 60 pixels. In order to remove the rainbow effect overlapping the landscape, make a Layer Mask, select a large soft Brush tool set to black, and carefully remove the unwanted parts of the rainbow. Reduce the brush Size and the Opacity the closer you get to the horizon.

Step 5. Often when we see an intense rainbow, a second more faded one appears nearby which seems to mirror the first arc. To create this interesting 'double rainbow' effect, make a Duplicate Layer of the Rainbow layer and name it 'Rainbow 2' and, with this new layer active, use the Move tool to reposition it. A second rainbow will always appear outside the first one. Finally, subdue the 'Rainbow 2' layer by reducing the Opacity to 16%, and applying Lighten from the Blending Mode.

To add a hint more drama, the two bottom corners of the landscape were selected and darkened using Curves (see Manipulating Contrast Using Curves in Chapter 1).

Finished image. A wonderful landscape and a fantastic rainbow display. Getting those elements together can prove elusive, even for the luckiest photographer, but with the help of the Russell's Rainbow option within the Gradient Special Effects, this task is made easier.

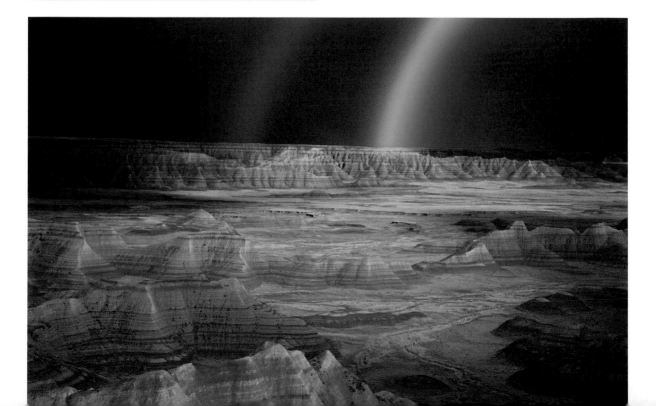

69 PRODUCING THE ILLUSION OF LIGHTNING

Lightning flashes are relatively common, although the chances of witnessing an electrical storm over an interesting landscape are less so. Moreover, a flash of lightning occurs in a matter of milliseconds, so capturing it is extremely difficult. It is often far better captured at night, with the camera attached to a tripod. The downside of this of course, is that the landscape is likely to be poorly illuminated. Fortunately this phenomenon can be created in Photoshop using the Gradient tool and the Difference Clouds filter.

Start image. You are most likely to witness lightning during thunderstorms, although it can also occur just before or after one. Clearly, you need to start with an image featuring dark and threatening clouds. I caught this just at the tail end of a storm.

Step 1. Create a new file (*Edit > New*) while ensuring that the background defaults to white. Size it appropriate to the file you wish to work with. In this example I set it at 1000 x 350 pixels at 300dpi. With the Foreground/Background Colors set to black and white, select the Gradient tool set to Linear, and drag the cursor across only part of the width. The wider the drag, the more irregular the flash will appear.

Step 2. Go to *Filter > Render > Difference Cloud*. Then invert this by going to *Image > Adjustments > Invert*. At this stage, the image should start to resemble a flash of lightning. Open Levels and drag the Gamma slider to the right so that it appears against an almost uninterrupted black background. To complete this part, call up Hue/Saturation (*Image > Adjustments > Hue/Saturation*) and with Colorize ticked, add a Hue of 205.

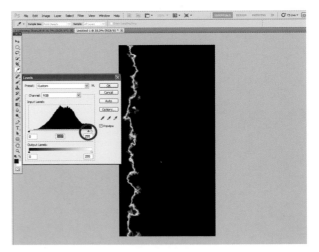

Step 3. With both files on screen, use the Move tool to drag the lightning layer over the landscape. It depends on the size of the destination layer, but generally it is unlikely to be a perfect fit. With the lightning layer active, go to *Edit > Transform > Scale* and adjust the size of this file. Use Screen from the Blending Mode and a plausible flash will appear over the landscape layer. There may be one or two unwanted extraneous white areas appearing at this stage, which can easily be removed using the Eraser tool.

Step 4. A characteristic of lightning is that it frequently forks; to create this effect, make a new flash layer (by following steps 1 and 2), drag this new layer adjacent to the existing lightning layer, rotate and position it so it appears to fork from the larger flash. At this stage, be as ambitious as you want and add further layers until you achieve the design you are after. As each of the flashes remains as a separate layer, you are able to make subtle changes as you go along. Use the Opacity slider to reduce the intensity of some of the layers so that they appear more distant than others.

Step 5. The final task is to increase the sense of atmosphere. The area of the sky affected by the lightning will be considerably lighter than the rest. To achieve this, make a rough selection of the area of sky with the lightning flashes and feather this by 200 pixels. Lighten the selection using Curves. Now inverse the selection and again using Curves, darken the remaining part of the image. On a similar tack, the area of landscape directly below the illuminated sky would also appear lighter. This was similarly selected and lightened using Curves.

Finished image. This is what this landscape might have looked like had I been fortunate enough to capture it during an electrical storm.

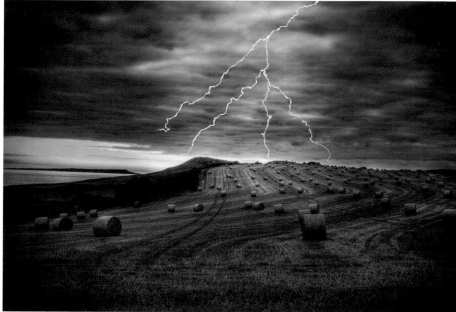

70 PRESENTING IMAGES IN SEQUENCES

There are occasions when we take a sequence of shots, each subtly different. Usually we do this because we are uncertain about presenting the images individually, fearing perhaps that they are just too minimal. An option many photographers favour is to group the images together. This not only serves to strengthen each of the images, but it encourages the viewer to identify rhythms that are not so apparent when viewing the images separately.

Step 1. You may have taken dozens of images and deciding which to use is your first task. This is best done in Bridge. With all the images saved into one folder, you have the opportunity of viewing all the possible files and deciding which will best contribute to the overall design. At this stage, consider the format of your final image, whether you want it in landscape or portrait format, and how many images you wish to include.

Step 2. I decided that I wanted to present each of the images in a square format. It is of course important that all the files are cropped consistently to the same dimensions. This is most effectively done by selecting the Crop tool and then adding the desired Width and Height in the Menu bar at the top of the screen. When cropping, think carefully about which parts you wish to save and particularly whether

they will contribute to the overall design of the image.

Step 3. You now need to create a Background Layer, which will govern the overall dimensions of the final image. Think about how large each of the panels will be, and how many there need to be. The gap you wish to add between each of the panels, and the outside border, will also need to be factored in. Go to *File > New*. The New File dialog will appear; type in the preferred height and width and

set the resolution consistent with the images you wish to import. Finally, the Background Contents normally defaults to white. As I wanted to work with a black file, I set black as my default Background Color before I opened this dialog.

Step 4. Resizing each image individually is both time-consuming and unnecessary. With all the files stored in a single folder, go to *File > Scripts > Image Processor*. In the Image Processor, select the required folder and simply add the File Type (JPEG or TIFF), then add the required Width and Height to the Resize to Fit box. Click Run and all the files within the folder will be consistently resized.

Step 5. Open the file you wish to become the Background Layer. It will help at this stage to introduce a Grid by going to *View > Show > Grid*. If you wish to change the column size of the grid, go to *Edit > Preferences > Guides > Grids and Slices*. Each of the dune files was opened in turn and carefully positioned using the Move tool.

Step 6. It is important to appreciate that your composite comprises seven separate layers at this stage and big changes can still be made. First, if you wish to reposition a file: with that layer active, select the Move tool and change it. Sometimes, flipping a file horizontally improves the overall design. Once again with that layer active, go to *Transform > Flip Horizontal*, and only that layer will be affected. When you are totally satisfied with the overall design, flatten and save.

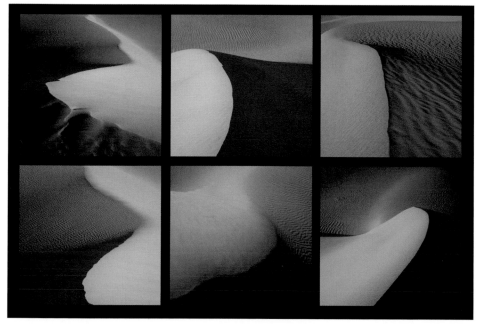

Finished image.

Often when we are photographing, we become fascinated by related details. When presented individually, they may appear to lack interest, but once they are grouped together, each of the images serves to support the other.

71 MAKING A CONSTRUCTED IMAGE

When working with Photoshop it is often assumed that the image source must always be photographic but that need not always be the case. Interesting images can also be captured using a flatbed scanner. Used as a macro lens, it is easy to 'photograph' small man-made or natural forms. Once captured, these scans can be merged with other more conventional photographic files.

THE PROCESS OF SCANNING

When scanning using a flatbed scanner, the objects need to be placed face down on the platen. Most flatbeds have a cover that can be removed. While it is possible to keep the cover in place with very flat objects, if you are scanning anything thicker than 12mm (½in) it is advisable to take the cover off. With it removed, the scanner should theoretically be able to pick up details of the room, but in reality the light fall-off is so great, the background appears black.

Start image 1. A thunderously dark sky, taken using a conventional DSLR camera.

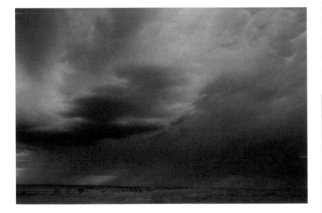

Step 1. The same principle was applied to this sky file. A portion from the right side was selected using the Rectangular Marquee tool feathered by 25 pixels and *Edit > Copy / Edit > Paste* was applied. With the new layer active, it was flipped horizontally and repositioned to create a mirror image. The sky was cropped to create a square (see Cropping in Chapter 4) and then flattened to make a single layer.

Start image 2. This dead fly was scanned using a flatbed scanner, at a resolution of 2400dpi. The left side of the fly was slightly damaged at the scanning stage, so the right side was selected using the Rectangular Marquee tool feathered by 10 pixels, then *Edit > Copy / Edit > Paste* was applied and the new layer flipped to create the left side.

tip

This style of photography is totally removed from reality so allow your imagination a free rein. Experiment, and if it looks pleasing to the eye, just go for it.

Step 2. I duplicated the sky file and called this new layer 'Sky'. The image of the fly was opened into Photoshop and with both images on screen the fly file was dragged over the 'Sky' layer. This new layer was named 'Fly'. The two layers were then blended using Multiply in the Blending Mode.

tip

The white background from the 'Fly' layer very slightly showed through. This was removed by firstly creating a white Layer Mask and then using a soft Brush tool, set to black, to paint out any traces.

Step 3. With the 'Fly' layer still active, an Adjustment Layer was made and Levels selected. The entire image was slightly lightened. The Elliptical Marquee tool was then used to select an area around the fly and this selection was inversed and feathered by 200 pixels. A second Adjustment Layer was made, Curves selected and the four corners were darkened to create a vignette.

Step 4. To introduce a graphic element, with the 'Sky' layer active, draw a circle using the Elliptical Marquee tool and go to *Edit > Stroke*. In the Stroke dialog, select a Width of 80 pixels, colour #b0c4a6, Location 'Inside', and apply Overlay. Reduce the Opacity to 50%. To complete the design, using the Rectangular Marquee tool, a selection was made 80 pixels within the perimeter of the square, and the same Stroke specifications were applied, except this time the Location was set to 'Outside'.

Finished image. When using Photoshop, there is no need to be constrained by photographic reality. Try something with a more graphic nature instead.

72 CELEBRATING TEXTURE USING THE BLENDING MODE

As we have seen in the previous workshop, there is not always a need to be 'realistic'. While it is possible to start with a simple motif, Photoshop allows you to weave in numerous layers, which gradually divorce the subject from reality. Sometimes, seemingly innocuous elements can be fused together to create truly exciting images. One effective way of achieving this is by using the various Blending Modes.

Start images 1–4. A sheet of crumpled copy paper, captured using a flatbed scanner; a sheet of fibre-impregnated rice paper, also captured using a flatbed; two teasels photographed against a light background; detail from the side of a rusting vehicle, copied, inverted and reduced so that both layers become partially visible. All the images were resized and cropped to a standard dimension prior to starting.

Step 1. Open Start image 1 and make a Duplicate Layer. Open Start image 2 and, with both files on screen, drag it over the crumpled paper layer, naming this new layer 'Rice paper'. Apply Exclusion in the Blending Mode; this increases the texture and changes the colour from blue to brown; it also inverses some of the tones.

Step 2. Open Start image 3 (teasels), and with both files on screen, drag image 3 over the 'Rice paper' file. Name this new layer 'Teasels'. Now apply Overlay from the Blending Mode and a rather attractive blend between the teasels and the two paper layers occurs. Use curves to subtly lighten the entire image (see Manipulating Contrast Using Curves in Chapter 1).

Step 3. Use the grid to help create an arch over the teasels; go to *View > Show > Grid*. Use the Elliptical Marquee tool, feathered by 2 pixels, and draw a circle around the teasels, ensuring it is equidistant from the edges. Now select the Rectangular Marquee tool set to '+', feathered by 2 pixels, and draw a rectangle adjoining the bottom half of the circle; you now have your arch. At this stage dispense with the grid.

Step 4. Open Start image 4 and go to *Edit > Copy*. Minimize this file, open the composite file and apply *Edit > Paste Special > Paste Into*. Start image 4 will now appear within the selected area. If the contrast is too great, reduce the Opacity.

Step 5.
Introducing text can add a further dimension to a composite. The expression '*ex nihilo nihil fit*', meaning 'nothing comes from nothing', personally appeals. Make a new layer and select the Horizontal Type tool set to white, Trajan Pro Regular, 60pt. Design this to fit the top edge. Having achieved this, three further duplicates of this new layer were made and positioned and inverted on the three remaining outer edges using the Move tool and Transform. The Opacity of each layer was then reduced.

Finished image. The Blending Modes have their own unique characteristics and it is worth spending time familiarizing yourself with them. You should be able to create interesting composites without ever having to make a selection. Having an open-ended approach certainly helps.

tip

It is important to appreciate that the Blending Modes I used here were compatible with a specific tonal range. If my start images had been darker, I would have used a different set of modes.

73 CREATING A 'JOINER' OR 'STILL MOVIE'

In normal photography the image is made in a single exposure, usually in a very short period of time and from a fixed viewpoint. But when looking at a scene, we usually build an impression in our mind's eye that is made up of many glimpses seen from different vantage points. These concerns have been of interest to many photographers, but came to widespread attention in the 1970s when David Hockney started working on his 'joiner' photo-collages.

Photographs supplied by Graham Dew

PREPARING THE SHOOT

You don't need any special photo equipment to make a joiner, and even quite simple cameras will give a stunning result. I used my compact camera to make the 'Spring Trees' picture, mainly because I wanted my panels to be 1:1 square format. There are several compact cameras and compact system cameras that allow you to change aspect ratio, but few DSLRs give you this option.

It can help if you have some idea of the potential number of panels that you might include in your picture. The hedgerow had some 24 trees on the edge of the field that I was working in. I decided that I would shoot a pair of trees in each frame, so I would need to build a picture that would be 12 panels wide and perhaps 8 panels high, requiring at least 100 frames to give me enough material for the completed picture. The normal resolution of my camera in square format is 2736 x 2736 pixels, or over 230 x 230mm for an individual panel. This would mean that at full resolution the image might end up being almost 720 megapixels and about 3 x 2m (9¾ x 6½ft) in size! Obviously this is an unmanageable size for most purposes, so it made sense to set the camera to a lower resolution, in this case 1536 x 1536 pixels, the smallest I could set on the camera. I also shot all the pictures in JPEG format.

To make a successful 'still movie' you really need to embrace the fact that you will need to move around when you take the pictures that are going to provide material for the finished picture. In the case of 'Spring Trees' I had three essential planes that I wanted to depict; the line of trees in blossom, the sky striped with lovely cirrus clouds, and the graphic white lines of chalk crisscrossing the bright green wheat crop that was emerging.

BUILDING THE IMAGE IN PHOTOSHOP

To start working on the composite still movie, it is best to start in Bridge. It helps to organize all the images for the joiner into a subfolder in your normal file organization, or you can work from a collection if you prefer. Bridge gives you access to some very useful tools in the form of scripts, which will make the building task much easier.

Select all the files you want to include by Shift-clicking a range or Ctrl-clicking individual panels. From the Menu bar select *Tools > Photoshop > Load Files into Photoshop Layers*. Photoshop will then import all of your pictures into one Photoshop file, with each imported image on its own layer. This new file will have the same pixel dimensions as each individual constituent image, and the layers will have the same name as the imported files.

Step 1. To start work on the image you will need to expand the canvas size of the new composite file. To do this, go to *Image > Canvas Size*. You will probably have a good idea of how many frames you need for your image. For the 'Spring Trees' project it was originally 12 x 8 panels. I had shot

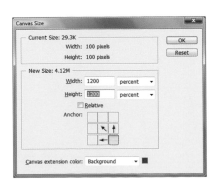

more images than I needed for the final picture but I wasn't sure which ones I wanted to use. So I made the canvas 12 times bigger both vertically

and horizontally by entering 1200% in the Canvas Size dialog box, which gave me plenty of space to act as a scratch area to 'park' unused panels.

Step 2. Photoshop allows you to perfectly align your panels to each other. To do this you need to set up the Snap function. From the Menu bar select *View > Snap* and check

this on. The Snap function will snap to a variety of image features. Select *View > Snap To* and make sure Layer and Document Bounds are on; all other options should be off. Next go to the Tool panel and click on the Move tool. Make sure that the Auto-Select box is ticked, and that the drop-down for this option is set to Layer. This means that as you click on any panel it becomes automatically selected and you can start moving the panel immediately. If you have a stack of panels, the one at the top of the stack is selected.

Step 3. Now for the fun part! Select the first image from your stack and slide it into some free space on your extended canvas. Drag the next panel from the stack and place it near or adjoining the first one and start to build up the image. Once the image is built up you can start to make normal tonal and colour adjustments as you would for any other Photoshop image.

tip

As you build up your image you will probably want to move a large number of panels together. To do this, draw a bounding box and Photoshop will select all the layers that are partially in that box. This is also an easy way to highlight layers, which can then be grouped together or given the same colour label to help identify them.

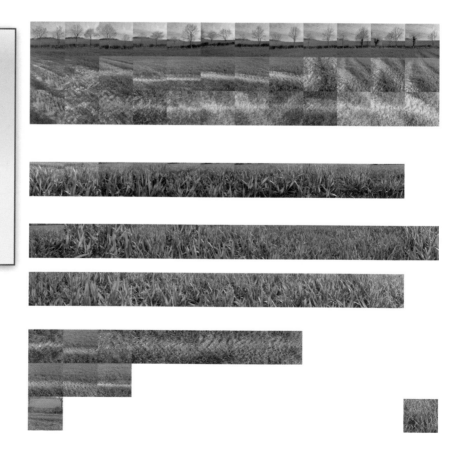

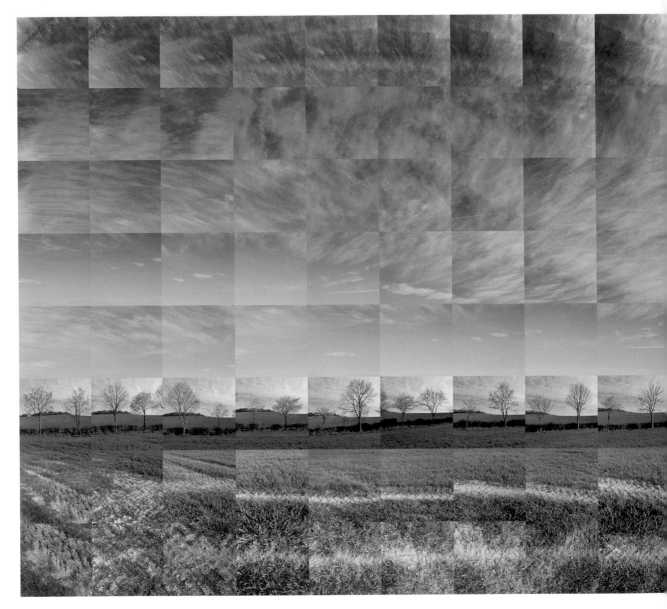

Step 4. At some point, you will need to save the image. It is likely that your file will be very large, and may even need saving in the PSD format. To reduce the size of the image, make sure that you delete any unwanted layers, and crop the completed image tightly. How big do you realistically want your image to be? It is likely that you will be able to resize the image down to a size that your printer or an external bureau can handle.

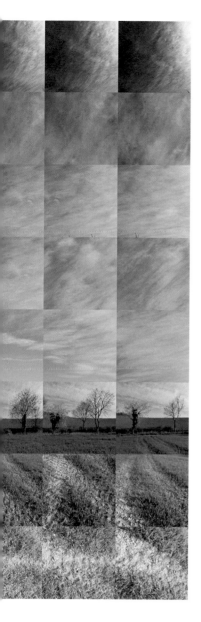

Finished images 1 & 2. My original edit of 'Spring Trees' (left) was 12 panels wide. On reflection, I felt that the trees looked rather small in the image, so I edited the joiner to be 7 panels wide by 6 panels high (below) to emphasize the trees. Finally, ensure you make a large print of your still movie to hang on the wall or set as the desktop background or screensaver on your computer. The thing about still movies is that you just want to keep on looking at them!

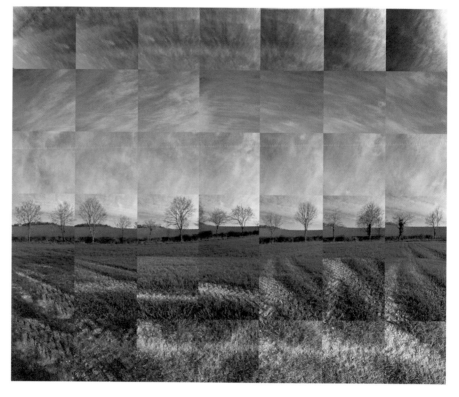

tip

Make sure you take plenty of pictures when photographing for joiners. It always helps to have spare images to change the composition of the final joiner slightly, and it is very frustrating if you miss a key image.

74 CREATING A MIRROR IMAGE

The mirror image or the visual palindrome is an eye-catching compositional feature, although it is something we rarely see occurring naturally in a landscape; it is much more common in the built environment. It creates a beautifully simple pattern, which immediately introduces structure.

Start image. I was initially drawn by the loose pattern created by these upright conifers, but the longer I looked, the more I was convinced that this image would benefit by imposing a more structured composition. The first task was to decide which side reveals the most attractive features. I opted for the left side.

Step 1. Open the file into Photoshop and make a Duplicate Layer. Use the Rectangular Marquee tool feathered by 10 pixels to make a selection, making sure that the edge of the selection extends to the middle of one of the upright trunks.

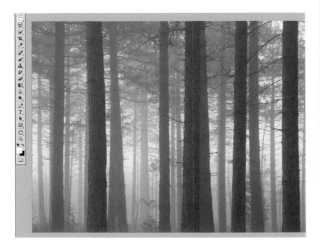

Step 2. With the left side selected, apply *Edit > Copy / Edit > Paste*. This new layer becomes Layer 1. With this active, go to *Edit > Transform > Flip Horizontal*. Using the Move tool, carefully manoeuvre this layer to the right of the image, taking care to match the texture in the upright trunk.

Step 3. The image lacked contrast; in order to improve this, I made an Adjustment Layer, selected Levels, and then dragged both the Shadow and Highlight sliders inwards while making sure that no detail was lost. The midtones were lightened using the Gamma slider (see Boosting Contrast Using Levels in Chapter 1). Finally the image was flattened, and any small imperfections in the central upright were removed using the Clone tool (see Removing Intrusive Elements Using the Clone Tool in Chapter 4).

Finished image. At first glance, this image appears entirely plausible, as regular patterns can exist in nature; it is only on closer inspection that one becomes aware that this must have been constructed.

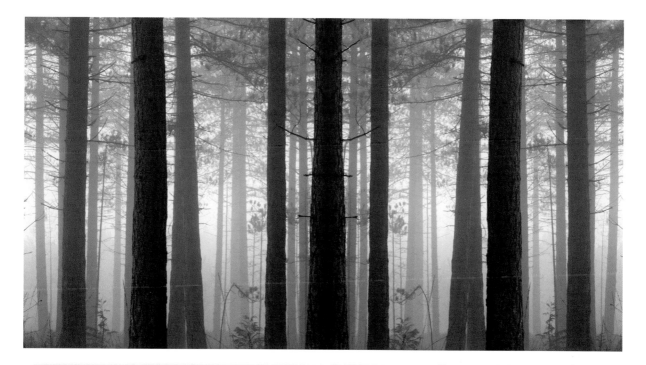

PARTIAL MIRRORING

Copying and flipping can easily be applied to a simple image but there are occasions when making just a partial copy and flip applied to a more complex image creates equally interesting results. Here, while there were many redeeming features in the original landscape shot, I found the distribution of the ferns and the unsightly rocks on the left side less attractive than on the right. The flowing stream in the foreground was particularly attractive and was a feature I wished to retain. In this example, the right side was selected, copied and pasted, then flipped and carefully positioned to cover the less attractive left side. Unwanted aspects were then removed by painting onto a Layer Mask with a black Brush to reveal the Background Layer.

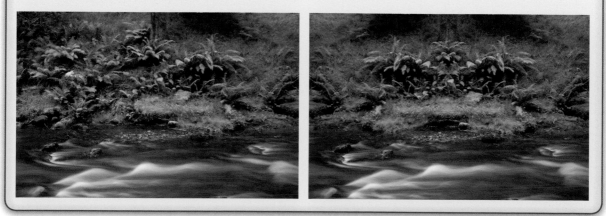

75 JOINING TWO LANDSCAPES

The landscape is constantly changing; while the foreground might appear dramatic, the sky might not. Similarly, there will be occasions when the sky appears dramatic, while the lighting in the foreground is flat. The solution is to blend together the best elements from the various files. If they have been taken from the same position, using the same focal length and aperture, then joining them together is child's play. Seascapes are particularly easy to blend.

Start image 1. When I took this shot, I was particularly keen to capture this small cluster of rocks in the foreground. The sky was interesting, but I sensed that it could still get better, so I decided to wait a little longer.

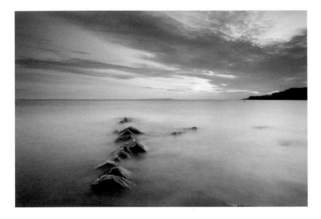

Start image 2. This next shot was taken just 11 minutes later, yet in that relatively short period of time, the change was remarkable. As I had anticipated, the sky became more fiery, however the tide was coming in, forcing me backwards; consequently I lost the lovely grouping of rocks

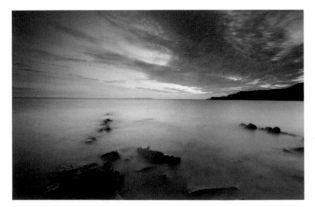

that was the focus of my previous shot. What I really wanted was an amalgam; the rock formation from the earlier shot and the beautiful sky from this one. In Photoshop, that shouldn't be a problem.

Step 1. Open the fiery sky file and make this the Background Layer, then make a Duplicate Layer and name this 'Sky'. Open the file with the interesting rocks and name this 'Sea'. Using the Move tool, drag the 'Sea' file over the 'Sky' file.

Step 2. While the two files look similar, they were taken at two different locations, as I needed to move back to take the second. It is important that the two horizons match. In the Layers palette select the Opacity slider and reduce it to 50%. This allows you to see how misplaced they are. With the 'Sky' layer active, use the Move tool to reposition the horizon relative to the horizon in the 'Sea' layer. Once this is achieved, restore the Opacity to 100%.

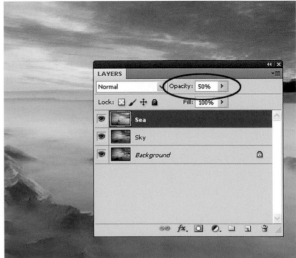

Step 3. Activate the 'Sea' layer, then add a black Layer Mask; click on the Layer Mask icon at the bottom of the Layers palette while depressing the Alt button. This will temporarily block the 'Sea' layer and only the 'Sky' layer will be visible. With the Layer Mask active, select a large soft Brush tool set to white and to 100% Opacity, and remove the lower part of the 'Sky' layer to reveal the rocks from the 'Sea' layer. Reduce the size of the Brush tool and the Opacity as you work closer to the horizon.

Step 4. When creating a composite it is important to remember that the colour of the sky is reflected in the landscape; in this case the water should assume a gentle magenta/orange hue. Normally when making colour or tonal changes an accurate selection is required, but in this example the colour should softly bleed over a large area. With the 'Sea' layer active, I used the Lasso tool to select an area of water directly below the fieriest part of the sky and feathered by 150 pixels. I made an Adjustment Layer, selected Color Balance, and then added more Red, Yellow and Magenta until I achieved a hue consistent with the sky.

tip

Don't worry if you slightly stray over the horizon as this will reveal detail from the 'Sea' layer which should be compatible; however if you wish to rectify it, change the Brush to black and paint out the error.

Finished image. By blending the sea from image 1 with the sky from image 2, I have been able to merge the best features from both. This technique should encourage you to wait and see what happens, even if you think you already have your shot in the bag.

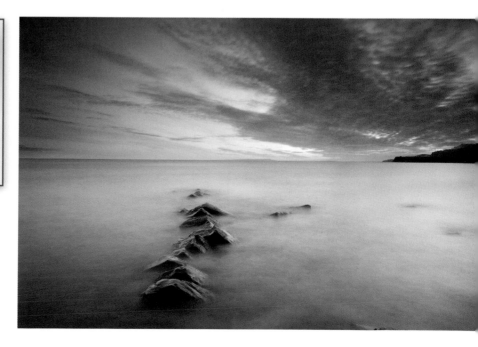

INDEX